THE WALLED
GARDEN

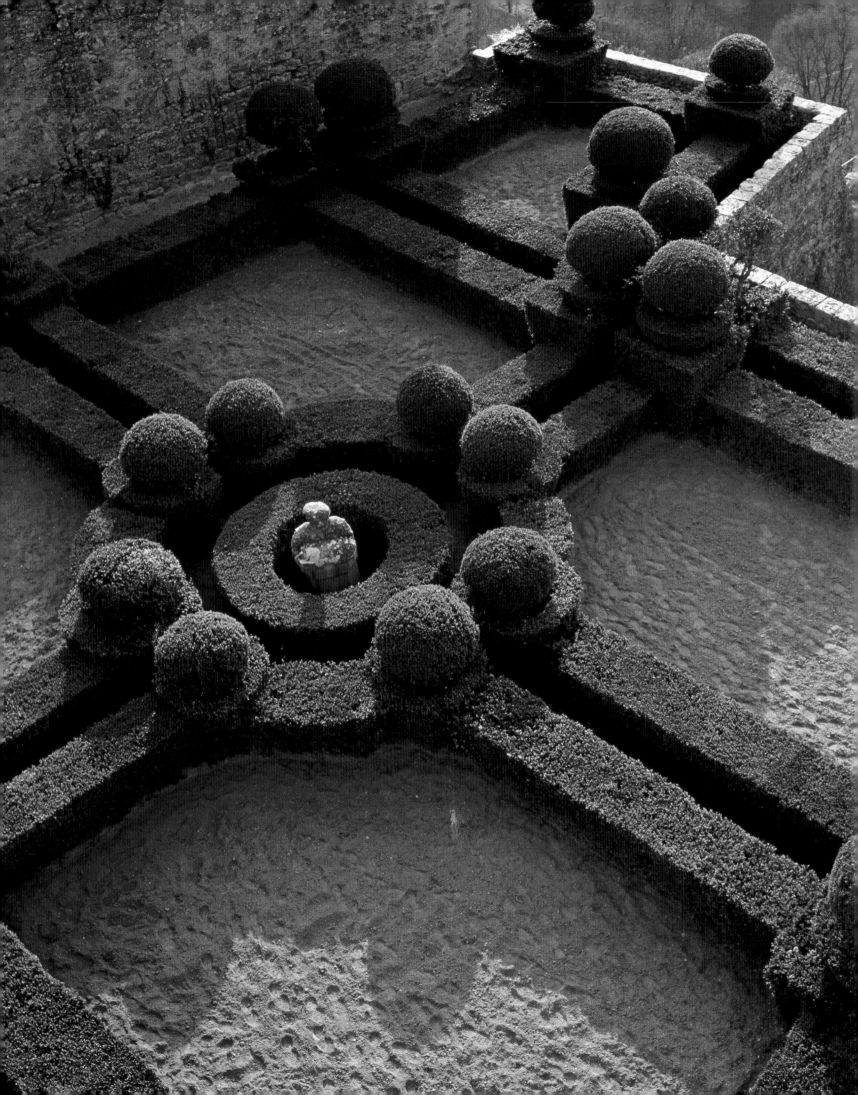

LESLIE GEDDES-BROWN

THE WALLED GARDEN

MERRELL

LONDON · NEW YORK

To Kate, a great gardener

First published 2007 by Merrell Publishers Limited

Head office
81 Southwark Street
London SE1 0HX

New York office
740 Broadway, 12th Floor
New York, NY 10003

merrellpublishers.com

British Library Cataloguing-in-Publication data:
Geddes-Brown, Leslie
The walled garden
1. Gardens – Styles 2. Gardens – Styles – Pictorial
works 3. Gardens – Design 4. Gardens – Design –
Pictorial works
I. Title
712.6

ISBN-13: 978-1-8589-4363-3
ISBN-10: 1-8589-4363-9

Produced by Merrell Publishers Limited
Designed by Maggi Smith
Picture-researched by Emily Hedges
Copy-edited by Richard Dawes
Proof-read by Sarah Yates
Indexed by Hilary Bird

Printed and bound in Singapore

Front cover
Château de Bosmelet, Normandy, France
(see pp. 90–93)

Back cover, clockwise from top left
Ryoan-ji, Kyoto, Japan (see pp. 30–33); Columbine
Hall, Suffolk (see pp. 102–105); Château Canon,
Gironde, France (see p. 40); Hadspen, Somerset
(see pp. 78–81); Hortus Conclusus, Chelsea Flower
Show 2004, London (see pp. 158–61); Buckland
Abbey, Devon (see p. 108)

Frontispiece
Château d'Ansouis, Provence, France

CONTENTS

INTRODUCTION

When starting this book, I first had to work out what constitutes a walled garden. This was surprisingly difficult because, while nearly everyone will have a good idea of what the phrase means, few will have tried to define it. Indeed, I have been forced to conclude that a walled garden is not necessarily a garden surrounded by a wall; there are many gardens with walls not for reasons of gardening or design but simply to define the boundaries. The most obvious examples are town gardens. Though often surrounded by walls, they are definitely not walled gardens. Nor do larger gardens that are entirely walled come within my definition, because here again the walls' purpose is to mark the boundary. I see a proper walled garden as combining at least three of four main considerations. These are the four Ps: privacy, protection, practicality and pleasure.

The real walled garden is generally, but not always, part of a larger scheme. I have in mind areas that might be as small as an allotment or as big as 3 hectares (7½ acres), partitioned off as part of a larger garden for various reasons: to give privacy; to provide protection from weather or animals; because the design within the walls is so different from that outside that the two areas should not be seen in the same eyeful; or because what goes on within – growing vegetables, for example – is not elegant.

One example of the walled garden is an intimate space surrounded by a landscape garden and made secret so as not to conflict with the wide, open spaces and 'natural' countryside of the parkland. Such gardens are essentially English, but have been copied worldwide. Another kind is the walled garden that is part of a complex formal scheme where, within a few hectares, woodland, vistas, topiary and water are grouped but – essentially – not seen all together. This formality is Italian in style, for in Italy even modestly sized gardens try to accommodate as many such features as are feasible. And, in such gardens, the wall is often breached at certain points so that wonderful vistas of cities, hills,

lakes and olive groves are included in the scheme. So a walled garden may not even have four walls yet will still be private, exclusive, secret and beautiful.

Chinese walled gardens include breaches in the walls for the same reason, but the holes are quatrefoil or moon-shaped rather than rectangular. They are essentially frames, used to emphasize a particular outside element – a rock, a tree branch, a temple – that adds to the pleasure of those contemplating the beauty contained within the walls.

The European monastic walled garden was made either for practical reasons – to provide herbs for the sick or vegetables for the community – or for calm contemplation. At its centre was a cloister with a peaceful lawn or fine tree. This is yet another kind of walled garden: one surrounded by the walls of buildings. It was inspired by the peristyle gardens of Roman villas, such as those at Pompeii, where a courtyard surrounded by columns was made into a cool area containing flowers and fountains, and by Islamic gardens, which also employed the courtyard principle.

From the earliest times – and the walled garden goes back as far as gardening itself – walled enclosures were secret, ideal for solitary contemplation, private talks or romantic dalliance. Medieval illustrations show lovers' trysts among roses and fleurs-de-lis, while the ladies of Middle Eastern harems had fine gardens to themselves, as did Japanese geishas.

In the temperate climate of Western Europe it is easy to see that walls gave protection from wind and rain, but in the hot countries that lie around the Mediterranean, and in such ancient lands as Persia, Sumer and India, the purpose of the walls was to create a cool resting place. Such gardens traditionally had many scented flowers and climbing plants, and often pavilions, which encouraged breezes and provided shade. Another essential was running water, and elaborate, expensive work was carried out to bring it from distant rivers or melting

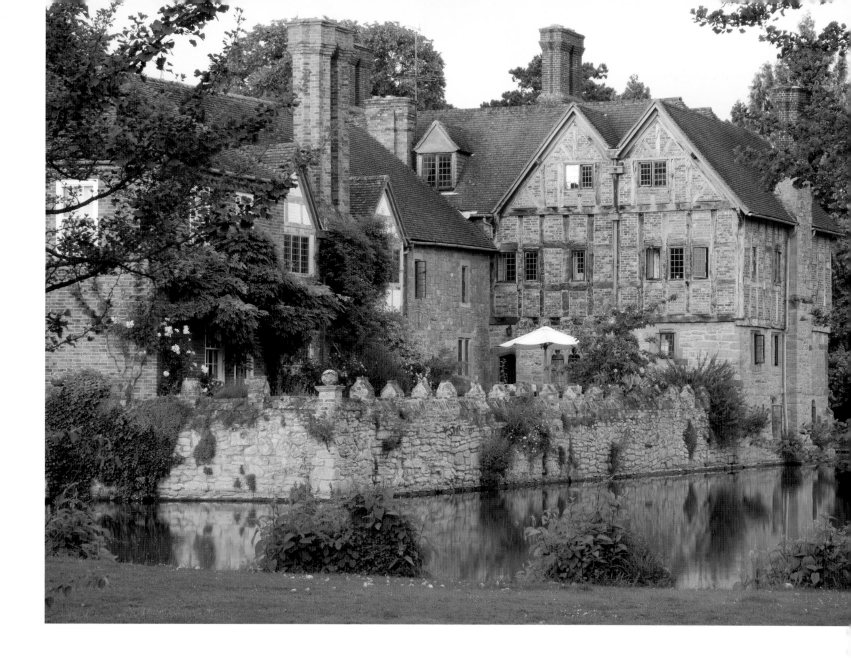

mountain snow to provide fountains, rills and pools that not only reduced the heat but also offered the calming sound of splashing. Some gardens even had tiny streams running down railings and stairs to cool hands and feet. At night the gardens were filled with lamps – one Turkish grandee attached candles to the back of live tortoises for ambulant lighting – and used for banquets in the cool air with the stars above.

I have imposed another limitation by leaving out all gardens that are 'walled' by hedges rather than inanimate barriers. A real walled garden has walls that feel massive and permanent and are of at least waist height. In fact, the taller they are the better, so that nothing outside can be seen other than the tops of trees and the sky (unless, of course, one wants to allow a view out through a gateway or some form of window). Nor should the walls be transparent, and for this reason I exclude fences.

Walls give privacy and protection for humans as well as plants. The enticing walled courtyard at Birtsmorton Court in Worcestershire is a suntrap surrounded by a moat.

Garden walls can, however, be made variously of willow hurdles (even though these are unlikely to last a decade), wooden planks (set vertically or horizontally), solid wooden panels, flint, stone and even rock (here I am thinking of an American herb garden bounded on one side by massive natural boulders). Nowadays garden walls are also made from such materials as glass and shiny and matt metals, or rendered and painted in brilliant colours. Walled gardens are not just about history; they are one of the most interesting areas of development in contemporary garden design.

This revival has been as unexpected as it has been delightful, because no one pretends that walled gardens are low-maintenance. In the 1980s the National Trust in England and Wales was so despairing of the costs of looking after its many derelict walled gardens (and re-creating such a garden for the fun of it can be enormously expensive) that it was turning these lovely spaces into car parks. In this, I suppose, it was fulfilling one historic purpose of the walled garden: to hide necessary unpleasantness. However, since then, historic walled gardens have been

returned to their former glory in such places as Audley End in Essex, where English Heritage took on the mammoth task of reviving melon and cucumber houses and gardeners' bothies. Unfortunately, it then handicapped itself by organically planting authentic nineteenth-century vegetable varieties that were, in many cases, blight- and pest-ridden.

Once people saw the delights of walled gardening, new versions were created. At Alnwick Castle, Northumberland, there is a much-publicized multi-million-pound walled garden, designed by the Wirtz family for the Duchess of Northumberland. Other ambitious and costly projects include one at Broughton Grange in Oxfordshire planted by Tom Stuart-Smith (pp. 82–85) and, at Scampston Hall in North Yorkshire, Piet Oudolf's regeneration of a tired old walled garden, which was just beginning to mature at the time of writing (pp. 150–53). Scampston's walls contain a charming delicatessen and café and, as at Alnwick, there has been a resultant increase in tourism.

One reason for this awakening interest is that walled gardens have belatedly been found to be extremely effective. If sensibly sited, they provide a microclimate that will increase warmth and reduce frosts, or provide cool and shade where necessary. Tender plants can be nurtured within, while on the walls espaliered fruit

trees, such as peaches and figs, and scented climbers will provide delights for the table, or swathes of blooms and aromatic leaves. The walls also reduce the shredding effects of high winds, which are extremely damaging to large-leaved exotics. One example is a tiny walled garden on Holy Island, off the coast of Northumberland (pp. 126–29). Without the walls, the plants would not survive.

A further reason for the new popularity of the walled garden is that it allows variety. When the landscape craze began to sweep Europe in the eighteenth century, a style promoted and paid for by nobles and gentlemen, the vegetable garden was confined within high walls. This was partly because vegetables were regarded as too homely to play a role in a grand scheme (indeed, they often felt that gardeners, too, should be kept out of sight), and partly because high walls give vegetables extra protection from frost and marauding animals. In these gardens beans, lettuces and potatoes were regimented in straight lines, and flowers that were seen as too colourful (typically gladioli, carnations and dahlias) were grown for use in arrangements in the house or for gentlemen's buttonholes. After the Industrial Revolution, huge walled gardens were filled with hothouses and greenhouses to keep exotics alive, along with the engine houses that produced the necessary heat. Ironically, this expansion led to the downfall of the walled garden.

The decline began after World War I devastated the European male population. In the Edwardian heyday of large produce gardens, a property might have required a dozen gardeners, but now, with a shortage of workers and consequently higher wages, the owners of such gardens could no longer afford to be self-sufficient. Like the rest of the world, they went to the greengrocer and the florist, and the produce garden fell into disuse. Its revival has been driven in large part by a desire for food that is organic, fresh and from a reliable source. Hotels and restaurants are creating their own produce gardens, while the 'gentleman farmers' who are taking over from the professionals as agriculture in Britain continues to decline are doing so because they prefer to spend money providing their own food.

An advantage of a walled garden is that it can be used to grow plants that are difficult or impossible to grow outside. For example, someone who is desperate to cultivate acid-loving azaleas and rhododendrons in a garden with alkaline soil can go to the lengths of removing all the unsuitable earth within the four walls and replacing it with acidic soil. The garden becomes a kind of giant plant pot. Similarly, with the present interest in exotics, the walled garden is becoming home not only to fairly

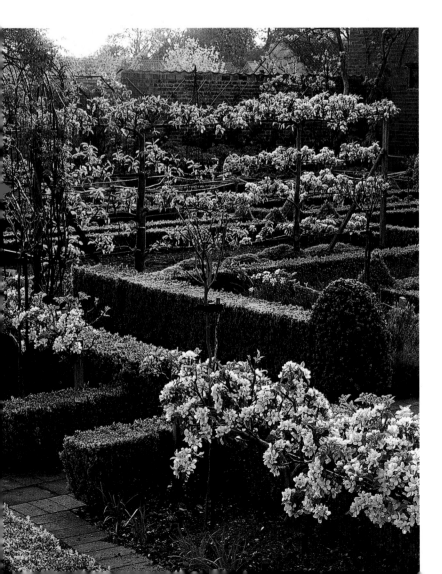

Walls offer protection for tender flowers and fruit. Espaliered apples at the Old Rectory in Sudborough, Northamptonshire, are both productive and decorative.

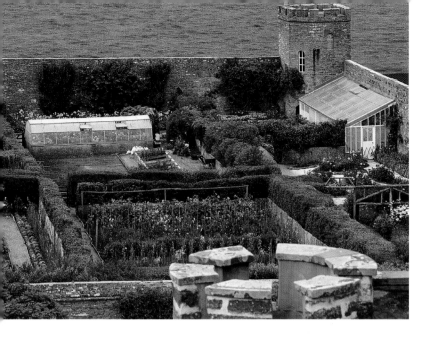

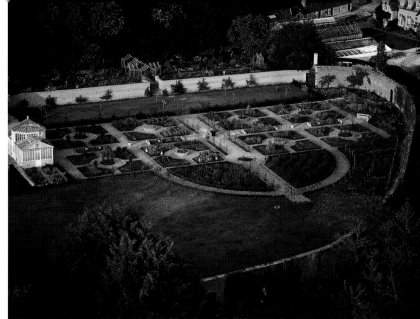

tender plants, such as bananas and palms, but also to outrageous colour combinations and styles. You can walk from an English landscape or an Italian-style vista into a tropical jungle where giant pandas might stalk among bamboos and young monkeys climb palm trees. There is nothing to stop the two co-existing, for many exotic-looking plants are perfectly hardy, although they do not cohabit easily with old-fashioned roses.

Other current gardening enthusiasms lend themselves to private, secluded areas. With care, it is possible to create (though I wouldn't) a small desert in a walled garden, planted with alarming-looking but fairly hardy cacti and other amenable succulents.

The fashion for creating Japanese and, increasingly, Chinese gardens within walls makes more sense, because walls have always been important to both. In fact, the combination of raked gravel, water dripping from bamboo pipes, a tea house, a tiny temple and a few natural, characterful boulders involves no gardening in the strict sense of the word, and the only tool needed is a rake.

So, following the model of the celebrated garden created at Sissinghurst in Kent by Vita Sackville-West and Harold Nicolson in the early twentieth century (pp. 130–33), the walled garden becomes one of the rooms in a garden of many. And, because most gardeners like to tinker with styles of layout and choice of plants, its revival is not mere fashion. To my mind, garden design is gradually overtaking plantsmanship. While this does not stop hobbyists and collectors obsessively seeking the last remaining undiscovered orchid in the wild or trying to hybridize a blue rose (luckily without success so far), it does mean that twenty-first-century gardens will be seen more as rooms than as external spaces. One may be like a tiny Versailles, another a cottage plot filled with roses and rhubarb, and yet another a take on minimalism where only five irises fill the spaces among the walls and gravel. Each of these can exist in a plot of less than 0.2 hectares (½ acre), and each, in its own way, can fulfil a wish: for formality, for naiveté or for absolute calm.

Above In the far north of Scotland, where the late Queen Mother's Castle of Mey is sited, the climate is severe. The high walls that surround the vegetable garden are not simply decorative.

Above, right Graceful walls curving around the garden at Daylesford House, Gloucestershire, produce a microclimate inside. The garden paths are designed to echo the walls' shape.

A walled garden need not be large, but the walls should be more than just a boundary. In Christopher Bradley-Hole's Garden from the Desert, shown at the Chelsea Flower Show, London, in 2003, the walls are an important part of the whole design.

THE HISTORY OF THE WALLED GARDEN

To the ancients, heaven was a garden. The Garden of Eden is the obvious example, a place so serene and innocent that only those without sin could live there. In the Greek translation of the Old Testament this garden is described as *paradeisos*, a word derived from the ancient Persian *pairi*, meaning 'around', and *daeza*, 'walled'. Paradise was the first walled garden.

It is easy to see why paradise was pictured in this way. For those living in barren lands, in deserts that were cold at night and unbearably hot by day, a lush green oasis was not just a place of serenity for the soul but also essential to life. Yet it seems that the walled gardens of ancient times were quite unlike what most of us would imagine. Vita Sackville-West, whose own walled gardens at Sissinghurst are almost as famous as the Hanging Gardens of Babylon, reacted coolly when she visited Persian gardens in the 1920s. 'Ever since I have been in Persia, I have been looking for a garden and have not yet found one. Yet Persian gardens enjoy a great reputation. Hafez and Sa'di sang frequently, even wearisomely, of roses. Yet there is no word for rose in the Persian language' Whereas we think of green lawns and luscious *Rosa* 'Albertine', 'there is no turf in this parched country; and as for herbaceous borders, they postulate a lush shapeliness unimaginable to the Persian mind. Here, everything is dry and untidy, crumbling and decayed; a dusty poverty, exposed for eight months of the year to a cruel sun. For all that there are gardens in Persia. But they are gardens of trees, not flowers: green wildernesses.'

'Imagine [that] you have ridden in summer four days across a plain; that you have then come to a barrier of snow-mountains and ridden up the pass; from the top of the pass you have seen a second plain, with a second barrier of mountains in the distance, a hundred miles away ... then when you come to trees and running water, you will call it a garden' (*Passenger to Teheran*, 1926). In this description Sackville-West manages to disinter the historical paradise: a place dusty and dreary to us, but Eden to the exhausted traveller.

The first walled gardens – and they were always walled, against not only hungry desert mammals and rodents, but also treacherous drifting sand – could be huge. In 4000 BC the Sumerians walled whole hunting parks. This culture's *Tale of Gilgamesh*, dating from 2700 BC, talks of the 'pure joy' of the shade of cedars under which shrubs and scented plants lived out of the sun's glare.

About two thousand years later, when the Sumerians had made Babylon their capital city, King Nebuchadnezzar II built there the Hanging Gardens, one of the seven wonders of the ancient world. He made them for his wife, Amyitis, daughter of the Median king, because she was used to the meadows of the river delta to the north. The Hanging Gardens were layers of terraces standing on vaults of brick. An ingenious system irrigated the terraces with water from the River Euphrates, allowing plants to survive the sun by surrounding the roots with moist earth. It was the equivalent, says Penelope Hobhouse in *The Story of Gardening* (2002), of today's urban gardens that are based on large planters filled with compost and watered by electric pumps.

The Assyrian king Sennacherib irrigated his gardens at Nineveh so that palms, olives and vines would grow there. 'The gardens with their vines, fruit, sirdu wood and spices waxed prodigiously', he recorded. 'The cypresses, palms and all other trees grew magnificently and budded richly.' There speaks a proud gardener in the mid-seventh century BC. We know much about the gardens of these vanished civilizations because stone carvings from the period still exist, showing landscaped hills, ornamental trees and stone pavilions. Sennacherib's grandson, Ashurbanipal, for example, is pictured lounging on a sofa in an ornate pavilion, with servants fanning him and grapes dangling from entwined vines above his head.

The tomb paintings of ancient Egypt tell a similar story. Egypt, at least around the River Nile, had a less harsh climate than central Asia, but, even so, careful management of water was

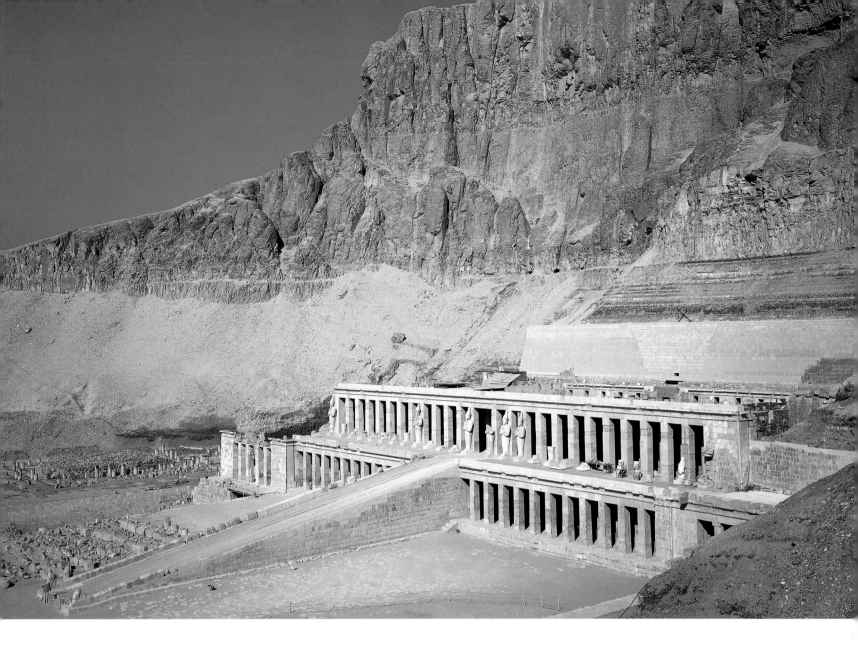

needed. Every year the river would flood, which was good for annual planting but not for trees. Here again irrigation solved the problem of preserving trees. Gardens existed around the Nile at the time of the Old Kingdom (founded about 3050 BC) and, like any desert plot, they must have been walled to keep out drifting sand. A small model of just such a garden was found in an Egyptian tomb of about 2000 BC. It has a fish pond and an avenue of sycamore figs, and the pillars at the rear are colourfully painted and carved in typical ancient Egyptian style.

About five hundred years later Queen Hatshepsut tried to transplant frankincense and myrrh trees, but without success, while in the twentieth century archaeologists found at her palace of Deir-el-Bahari root systems of an avenue of tamarisks and sycamore figs.

Hatshepsut, Queen of Egypt, was one of the first plant collectors. About 1500 BC she tried but failed to grow myrrh and frankincense trees at her palace at Deir-el-Bahari.

Many of these ancient gardens included water or a fish pond, both for coolness and to produce fish for the cooking pot. A wall painting from the Egyptian city of Thebes shows plump fish and ducks swimming companionably together, while date palms and other, leafier, trees line the water's edge.

In early China walled gardens developed in a similar manner. The semi-mythical emperors Jie Gui (c. 1700 BC) and Zhou ruled 1075–1046 BC), the last ruler of the Shang dynasty, created vast walled hunting parks for themselves. Zhou not only conducted orgies among the trees and plants but also bankrupted the imperial treasury in the process of making his garden. In the fourth century BC the philosopher Mencius suggested that luxurious gardens were a sign of barbarity in a tyrant who would demolish villages, deprive peasants of their land and generally act in a high-handed way, all to have a fancy garden. The mandarins and wealthy merchants were also gardening fanatics who tried to create the illusion of empty nature even in the smallest area.

Subsequent Chinese emperors took no notice of Mencius. About 221 BC the first real (rather than mythical) emperor of China, Qin Shi Huang Di (259–210 BC), built his palace on a huge mound, and his Upper Grove Garden, which could be viewed from the palace windows, was partly planted and partly a hunting park. One hundred years later the park was made even bigger when 260 square kilometres (100 square miles) were enclosed. Like the Roman emperors with their 'bread and circuses', the Chinese rulers made sure they had the commoners on their side. In 103 BC the imperial historian wrote that the people were invited into the park – no less than a Chinese Colosseum – to watch contests that included chariot racing, archery and wrestling. At other times exotic animals living in the park were massacred for sport.

The second ruler of China's Sui dynasty, Sui Yangdi, who ruled from AD 604 to 618, had a garden that was surrounded by a wall 120 kilometres (75 miles) long. Inside were golden monkeys, trees stolen from neighbours and 'water palaces': lined artificial pools where dragon-headed barges filled with concubines (who doubled as an orchestra) drifted along the water among artificial lotus flowers. It is no wonder that this caught the eye of the Japanese envoy to the emperor. It is thought to have been the inspiration for the seventh-century imperial parks

in Japan, though gradually these became less expensive, less magnificent and rather more pleasant.

The people of the first true civilization of Europe, ancient Greece, had little time for gardening, though representations of such plants as acanthus, honeysuckle and figs feature in their architecture. However, while groves, waterfalls and landscapes were more to Greek taste, Homer mentions at least two gardens: Alcinous had a walled garden of fruit trees, and Ulysses's father, Laertes, had a characteristic garden of water, shade and fruit trees.

Writings, myths, carved tablets and tomb paintings have yielded evidence of the appearance of historical walled gardens, though these accounts are certainly idealized. In the case of the Roman Empire, however, we are able to study the gardens themselves. Those at Pompeii, near Naples, were buried in AD 79 by the massive eruption of Vesuvius (pp. 178–81). The Vetti family's garden, which was created around AD 60–70, emerged from the volcanic ash nearly intact. Though to the Romans Pompeii was an unimportant and rather dull provincial town, this walled garden gives an insight into those created by people other than emperors and aristocrats. It is clearly a precursor of the monastic cloister, having simple carved pillars all around the enclosing walls, which are painted with stylized murals. The unroofed centre combines pools and fountains (characteristic of any walled garden in a hot country) with statues on columns decorated with foliage. Scientific investigation shows that there would have been trees and pot plants including olives, figs, bay, pomegranates and quince. Lemons and oranges were probably grown then, as now.

On the other side of the world, the people of pre-Columbian South America behaved in a remarkably similar way. Around the time of the birth of Christ, the Mayans made huge pleasure parks, and fifteen hundred years later, at the time of the Conquest, the

Below Nebuchadnezzar II built the Hanging Gardens of Babylon for his wife, Amyitis, who missed the lush meadows of her Median homeland. A screw system irrigated the brick-built terraces. This representation was engraved by Johann Adam Delsenbach (1687–1765) in 1721.

Below, right The irrigated gardens of Nineveh were built by Sennacherib to encourage palms and vines. In this stone carving his grandson, Ashurbanipal, lounges in a shady pavilion.

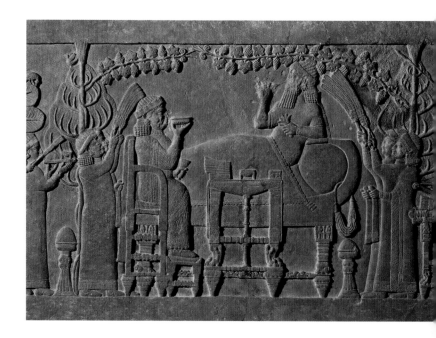

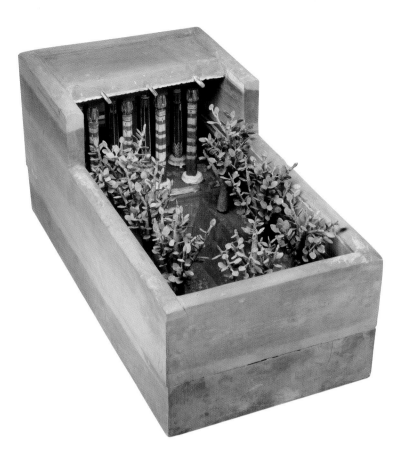

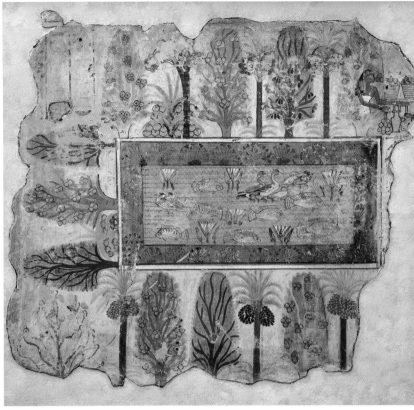

Aztecs had walled gardens that included shrines, temples and stages for theatrical performances. The houses in their cities had brilliantly coloured roof gardens filled with flowers, while their rulers kept menageries and aviaries on land around their palaces. Montezuma erected a 9.7-kilometre (6-mile) fence to enclose a park containing a lake and tropical plantings of trees (transported with their roots wrapped in bundles, just as the early English landscape gardeners would do three hundred years later).

The medieval walled garden in Europe, the *hortus conclusus*, was as much an idealized Garden of Eden as were those of the ancient world. It sprang from the Christian idea of the 'locked garden', where the Annunciation took place. Indeed, nearly all pictures of Mary receiving the Angel are set in a small garden pavilion. Penelope Hobhouse believes that the medieval mind in Europe could not conceive of gardens in any other way than surrounded by walls: 'Any notion of finding comfort and beauty in a rural setting, any appreciation of natural scenery ... had vanished; in the material and social conditions prevalent in the early years of the Middle Ages it was an idea the contemporary mind found impossible to grasp.'

The period AD 500–1000, which followed the fall of the Roman Empire, has been called the Dark Ages, yet there is evidence that gardening continued in the Classical mode. Surviving accounts of a garden founded by an Irish monk about AD 820 at St Gall in Switzerland describe a herb garden and a 'paradise' where flowers for the altar grew. Eleanour Sinclair Rohde, in

The Story of the Garden (1932), called the garden 'remarkably interesting for it shows that the monasteries maintained the traditional layout of the Roman villa rusticus [sic]'.

By the later Middle Ages writers were once again describing gardens. The Italian Petrus Crescentius, writing in the thirteenth century about a garden suitable for the regal and rich, says: 'Let it be a place where the pleasant winds blow and where there are fountains of water [I]t should be enclosed with lofty walls. Let there be in some part a wood of divers trees where wild beasts may find a refuge. In another part let there be a costly pavilion where the king and his queen or the lord or lady may dwell, when they wish to escape from wearisome occupations and where they may solace themselves.' He describes shade and fish pools, nightingales singing and rooms made of trees: in short, exactly the gardens of the ancients.

King James I of Scotland, who was imprisoned at Windsor between 1413 and 1424, described in verse the castle's garden, with its green arbours, hidden walks and birdsong:

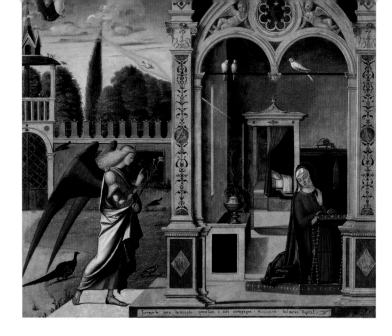

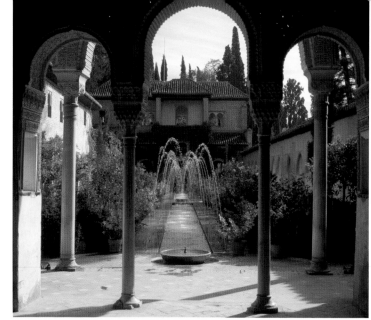

Above Paintings from the Italian Renaissance teach us a lot about the ordinary domestic life of the times. Carpaccio's *Annunciation* depicts a colonnaded pavilion, a shady area in a fashionable walled garden.

Above, right The Generalife Palace in Granada was built by the Moors during their occupation of Spain. As desert people they valued every quality of shade and water: the sounds, the ripples, the coolness and the drama.

> On the small greene twistes sat
> The little sweet nightingale, and sung
> So loud and clear, the hymnis consecrat
> Of lovis use, now soft, now loud, among,
> That all the gardens and the wallis rung
> Right of their song.

This is the high period of the romantic walled garden, the 'flowery mead' of lawns sprinkled with wild flowers, of herberies and arbours entwined with roses, of the Virgin sitting among irises and lilies with a unicorn bowing before her.

When the European walled garden and its plants had almost vanished, after the fall of the Roman Empire, the only civilized gardens in the continent were those created in Spain by the Moors. These were in the style of the gardens of Babylon and Nineveh, of Mughal India and Arab North Africa. Though the ideal was a green, secret, formal garden with cooling fountains and ponds, hidden within walls, the Islamic style was dictated by a firm tradition that can still be seen both in the gardens of Moorish Spain and in the carpets made by Persian weavers. A typical Eastern garden (for this style travelled from India west of the Himalayas to the western edge of Europe and Africa) was made of four squares divided by streams or ponds. This, the *chahar bagh*, meaning 'four gardens', had existed for centuries in Persia before the idea was taken to India by the Emperor Babur

in the mid-sixteenth century. Summer houses and pavilions were set against the surrounding walls of the *chahar bagh*. Among the devotees of the form was Tamerlane (1336–1405), the Mongol conqueror of Persia.

China, across the mountains, created its own form of garden, which began with schemes to encourage the Immortals – semi-divine beings who could bestow eternal youth – to visit. The Immortals liked islands in lakes with hills in the landscape, and this is what the rich Chinese tried to copy in their gardens. The Immortals also liked unusual rocks and boulders, and from this comes the Chinese love of special stones, a characteristic that was taken up by the Japanese. The tradition in China was slow to change: it was not until the eighteenth century that an emperor, Kang Xi, enclosed his summer retreat with a wall. The 19-kilometre (12-mile) boundary enclosed a park full of Père David deer and including a lake with islands.

Why, at the start of the fifteenth century, did the Renaissance happen in Italy, in gardens just as in architecture and art? Was it that religion had eased its grip or that people were tired of looking inwards? Certainly it was not that peace had suddenly broken out among the warring Italian city-states. In any event Italy, followed slowly during the century by the rest of Europe, broke loose from the medieval, enclosed way of thinking and began to take a wider view. This did not mean that garden walls suddenly fell to reveal the landscape all around – that would not happen until the eighteenth century – but now the walls of such private havens were breached at strategic places, and the design deliberately encouraged the eye to rove outside their limits. That this happened in the soft Florentine hills, with their terraces of olives and grapes and avenues of cypress trees, made it easier for the designers to include glimpses of the beautiful countryside outside the walls. This, of course, was something that Chinese gardeners knew all about.

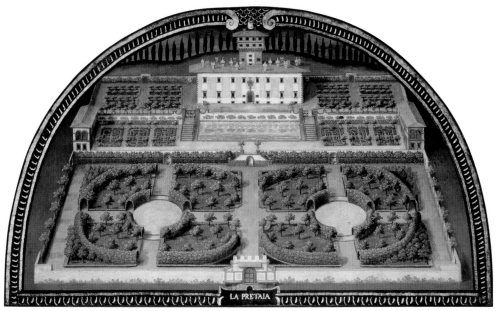

Villa Petraia, a Medici garden near Florence, is captured in a lunette by Giusto Utens. The formal layout (and the bird's-eye view) became fashionable in seventeenth-century Europe.

What has been called the most exciting and innovative period of European gardening coincides with the survival of these creations in reality rather than as drawings and words. Even so, the ties with an imagined paradise persisted: the gardens at Villa Barbarigo, for example, were a deliberate allegory of the Garden of Eden. Pratolino, designed by Bernardo Buontalenti for the Medici family in 1569, may have vanished (tragically, as recently as the nineteenth century) but its layout is immortalized, as are many other Tuscan gardens, in the lunettes painted by the sixteenth-century artist Giusto Utens, now in a museum in Florence. Within its long walls it combines formal greens and complex waterworks with 'wild' woods and mountains.

The Villa Petraia, seen in another lunette, was also a Medici garden, but rather less exuberant. The surrounding walls are pierced by gates, and it is terraced, like the surrounding countryside. The gardens of Villa Gamberaia, also outside Florence, have been restored, but here one can see the Renaissance genius at work in the judicious gaps in the enclosing walls that give glimpses of olive groves and of Florence itself in the distance (pp. 42–45).

Between 1537 and 1547 Sebastiano Serlio published five volumes of Renaissance architectural theory that were soon translated into French. Though the impetus of this new garden style (which would continue in fashion until it was swept away by the English landscaped parks of the eighteenth century) was Italian, its influence quickly spread to France, which was ready for magnificence. The fashion was helped first by the wife of King Henri II of France, Catherine de' Medici, who knew her family's villas and gardens well. Her gardens at Fontainebleau were designed by the Italian Francesco Primaticcio (1504/05–1570) with private walled gardens, parterres, statues and a moat. St-Germain-en-Laye, another royal garden in the Italian style, was built in 1593. Entirely enclosed by walls, it was also a series of walled, terraced rooms, each with its own pattern and style.

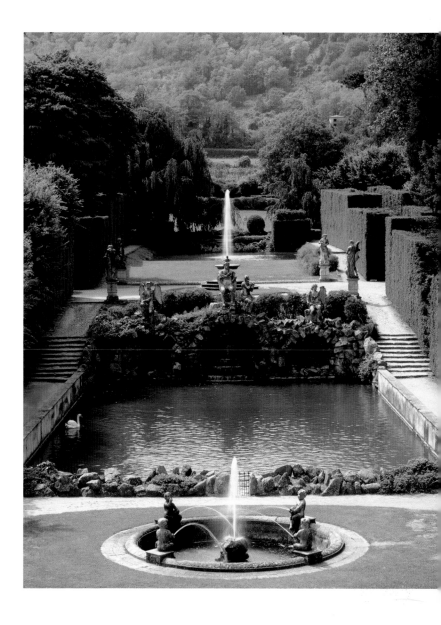

Italian walled gardens are very theatrical. The elaborate gates, statues and fountains at Villa Barbarigo, near Vicenza, were designed to contrast with the dramatic mountain scenery beyond.

15

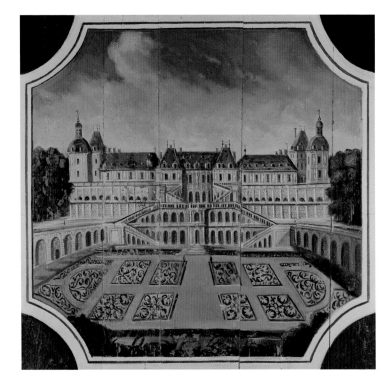

The royal garden at St-Germain-en-Laye was inspired by the Medici gardens of Tuscany through the French queen, Catherine de' Medici.

There was also Versailles. Designed by André Le Nôtre (1613–1700) for Louis XIV of France, it is Europe's grandest walled garden, containing a series of huge courtyards, ponds, parterres and palaces. It is divided by a central avenue that breaks into the walls, affording a vista that extends from the obelisks of the main entrance to the ordered forests beyond the garden and the gentle hills in the distance.

What could anyone do after such a grand project? The answer is that Northern Europe did not try very hard. Yet the Italian influence was felt from Sweden to The Netherlands, and from Austria to Britain, helped greatly by the concept of the Grand Tour. Young 'Milordi', especially from Britain, took months to travel to Italy to see the sights, and Renaissance gardens were very much on their itineraries.

The Dutch were ahead of the British in adopting the Italian Mannerist walled garden. One reason was that The Netherlands was very rich in the late seventeenth century, and, like Britain, took in Protestants who fled France after the revocation of the Edict of Nantes in 1685. Perhaps because the Dutch were less vain than Louis XIV, the 'Sun King', and perhaps because the countryside was domesticated and flat, their gardens are less theatrical. The most famous, at Het Loo, created between 1686 and 1692 and now restored, was made for William of Orange and his wife, Mary Stuart, by Daniel Marot (1661–1752). Harking back still to the Islamic four-garden layout, it was divided into rooms, and there were fountains, ponds and waterfalls (see pp. 174–77).

Naturally the Dutch style – a muted version of the Italian style and translated via the French – arrived in Britain with William and Mary. The Privy Garden of Hampton Court Palace, near London, also now restored (pp. 166–69), originated with Cardinal Wolsey and Henry VIII in the sixteenth century, but Charles II and William and Mary employed George London (1681–1714) to change it to a garden in the French and Dutch manner. The gardens at Wilton House in Wiltshire, designed by the Frenchman Isaac de Caus (1590–1648) between 1631 and 1635, are the most Italian in style, and the bird's-eye view of their formal *allées* and parterres could have come from the pen of Utens. The whole, as was usual, is an immaculate rectangle surrounded by a wall. The wall is broken twice, by an entrance at one end and an ornate pavilion at the other, but De Caus has allowed the River Nader, at the centre of the garden, to meander in its own path – something of which the formal Italians would not have approved.

Then everything changed. The fashion for formal walled gardens – for rooms, for symmetry, for vistas and decorative walls – became outdated. The new passion, particularly in England, was for landscapes, and it appears to have been inspired by the ancient Chinese gardens that rare visitors to that country had seen and enjoyed. The Chinese idea was to encapsulate nature within the walls of a very unnatural garden, originally, it is thought, because emperors, mandarins and other grandees wanted to attract the Immortals to their favoured habitat (see p. 14). The Immortals loved mists and jagged mountains, twisted pines and pools of water, and this is what the Chinese nobility set about making. Even in a few hectares, a whole landscape could be imitated. This would be far from symmetrical: it twisted and turned, pavilions and belvederes were dotted along its winding paths, and 'scholar' stones were placed at regular intervals to imitate mountains.

However, it is hard to believe that the English landscape park as created by Lancelot 'Capability' Brown (1716–1783) and others could have been inspired by such an alien style. The English landscape garden evokes the English countryside in idealized form, along with the painted landscapes of Nicolas Poussin (1594–1665) and Claude Lorrain (1600–1682). The formal walled garden was swept away so completely that hardly any survive. One of the few is at Melbourne Hall in Derbyshire, the garden of which retains a formal symmetry emphasized by lakes, statues and terraces. Its survival is probably on account of its status as a second home; it was never used by its owners as a fashion statement.

It is tragic that so many seventeenth- and early eighteenth-century formal gardens have vanished. At the time, formality was

so unfashionable that the traditional vegetable and picking gardens that remained walled were placed at the back of the great house so that their stern rectangles would not interfere with informal 'nature'. The walled garden became of secondary importance, worked only by gardeners propagating vegetables and flowers for the house. Indeed, the owners of some great houses, such as Calke Abbey in Derbyshire, so disliked the idea of gardeners blotting the landscape that tunnels were made through which they could reach the vegetable gardens, leaving the parkland unsullied.

This attitude persisted until almost the end of the twentieth century, though the walled garden as provider continued to exist, reaching its heyday in Edwardian times. With the advent of sophisticated heating and watering systems during the Industrial Revolution, the walled garden spawned numerous special houses: for growing grapes, pineapples, mushrooms and hothouse flowers (especially orchids), and for forcing fruit and vegetables. Often there was a large engine house powering all the steam boilers, along with gardeners' bothies and areas for propagating and potting. The recently restored gardens at Audley End demonstrate what a powerhouse the walled garden became (pp. 170–73).

It all disappeared with World War I, when the slaughter of young men throughout Europe ended cheap labour and the walled garden began its long decline. Even today, derelict greenhouses and forcing sheds can be seen, left tragically unloved. The garden designer Stephen Woodhams evoked the sense of despair that this sight provokes in his gold-medal-winning garden at the Chelsea Flower Show in 1994. To create Mr Maidment's Garden he took the remains of a derelict greenhouse and 'designed' the dereliction in which it existed. It was a rallying call to all estate owners, gardeners and garden designers to save what was about to be lost.

Today there are signs that this call has worked. The National Trust, which at one time used its numerous walled gardens as places to site car parks (and to keep the ugly ticket machines out of sight of the grand houses), has now rediscovered the pleasures of the walled garden. English Heritage's work on the walled garden at Audley End (pp. 160–63) and the restoration projects at Alnwick Castle and Scampston Hall (pp. 150–53) also demonstrate the renaissance of the form.

More interestingly, walled gardens have begun to be created again, a fine example being the new garden at Broughton Grange planted out by Tom Stuart-Smith, its walls designed by the architect Ptolemy Dean (pp. 78–81). Walled gardens are appearing on the rooftops of high-rise buildings throughout the world, and a strong Modernist influence is also evident in many new ground-level walled gardens. This movement is led by Christopher Bradley-Hole, whose prize-winning gardens at the Chelsea Flower Show – notably his Hortus Conclusus (2004) – have convinced much of the conservative gardening public and press of the value of simplicity (pp. 158–61). Designers from both North and South America are experimenting with lines, colours and water in walled gardens that in some cases contain not a single plant. Chinese garden design is being revived after the anti-elitist years of the Cultural Revolution. The walled garden has triumphantly re-emerged after the long predominance of the landscape garden.

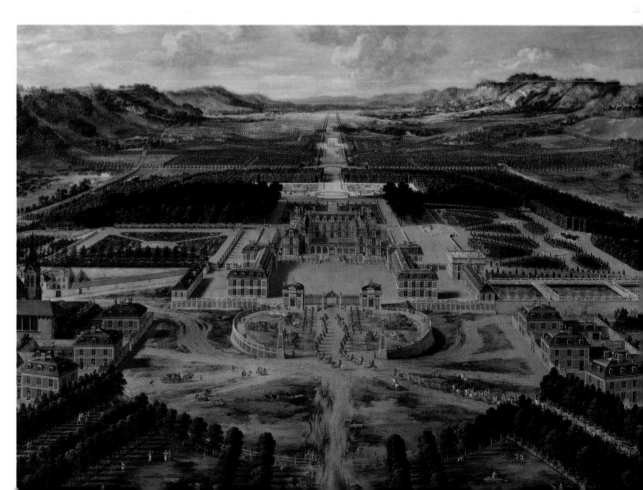

Versailles, designed in the seventeenth century for Louis XIV, is by far the grandest walled garden in Europe.

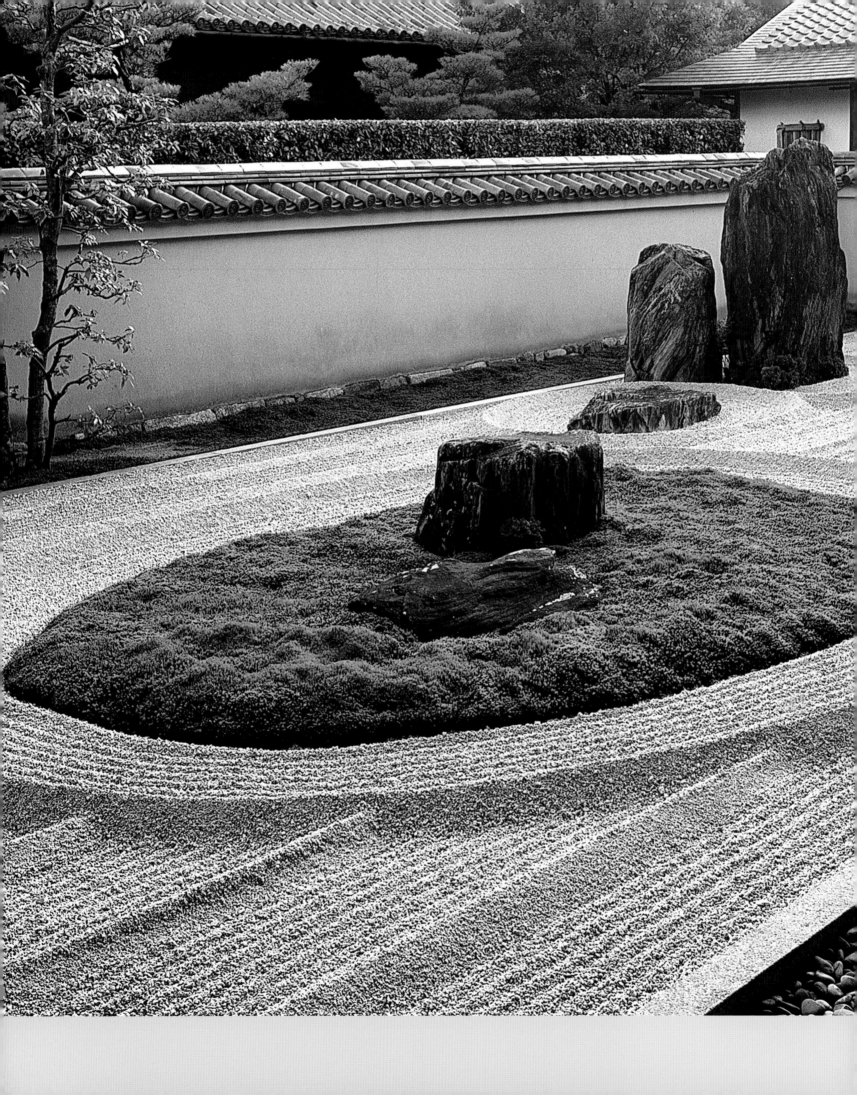

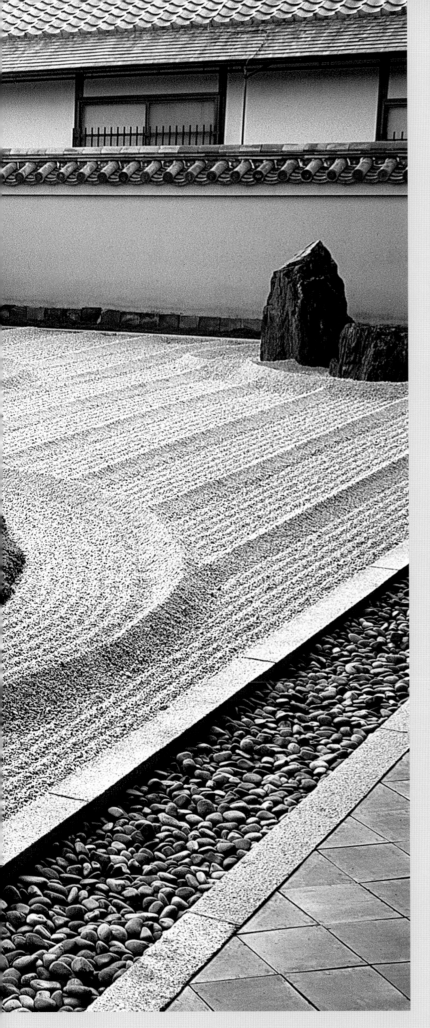

THE ORIENTAL WALLED GARDEN

Gardens are attempts to create paradise: something we would love to have but cannot. However, the creators of the Oriental gardens, from China and Japan through India to the Middle East, made heroic attempts to devise idyllic surroundings and shut out everything they found oppressive about everyday life.

For this reason almost all Oriental gardens, even huge hunting parks, were walled, not only in an attempt to keep out drifting sand and create calm, shady places, but also to keep the world at bay. In China (and in Japan, where Chinese gardens were widely copied) the walls hid the ant-like activity of teeming populations outside and created, however small, an ideal landscape: calm, serene and empty, a microcosm of unspoilt nature.

Reginald Farrer, a plant-hunter who travelled throughout China and Tibet, wrote in *On the Eaves of the World* (1917) of the delicious haunt of the Lin Tung baths: 'Here, nestling under the slope and piled upon its flank, is a brood of elegant little old Chinese pavilions, stair above stair flight of them, with elaborate latticed windows and the upcurling roofs of convention. In and out among them meander lakes and pools of soft warm sulphur water, steaming gently up into the calm air of the sundown. Sheets of golden jasmine shine reflected in the water, and lilac, rose and peony are terraced up in borders here and there beneath the buildings [In] this haunt of ancient peace you choose your pavilion and its accompanying bath and are happy in an exquisite seclusion of repose'

Those few gardens in China that have survived the onslaughts of time and the Red Guards testify to this beauty: pavilions open to the winds look out over 'scholar' stones and lily ponds; the whole garden was, however, used by only the rich.

Large areas of raked gravel, seen here at Ryogen-in, are typical of Japanese walled gardens. Plants are reduced to a backdrop for the raked pattern and 'scholar' stones.

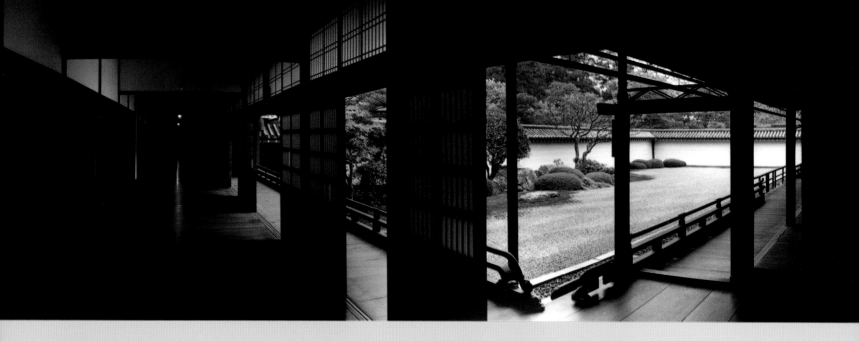

The Japanese garden, with its raked gravel, bonsai trees and characterful stones, was inspired by the Chinese, and the two were remarkably similar. The Chinese invented the bonsai and collected (as they still do) contorted boulders and twisted pines. As soon as they discovered Chinese gardens, the Japanese emperors set about making their own. About AD 1000 an imperial park with islands, lakes and pavilions was made for Emperor Ichijo, and was used for parties, boating and hunting. Another emperor covered the bottom of his lake, which had five linked islands, with pebbles. His garden also had a 'waterfall' that may never have had any water. Dry waterfalls, with rocks in a cascade, then became fashionable in walled gardens that were as small as a tennis court. This was, in fact, a Japanese invention, as was the concept of raked gravel and stones as metaphors for lakes and mountains respectively, but in both countries these havens were surrounded with walls made of stone, brick and tile, ornate wood latticework or complex patterned weavings of bamboo.

In the blazing heat of India and Persia the ideal was shade and cool. The creators of these gardens tried their best to pretend that there was no desert, no blinding sun and no chaos outside the walls. Their design was always formal, as an antidote to disorder, and water was the major feature, plants being used to create verdant shade and the impression of a temperate climate. The Indians and Persians enforced formality within their walled gardens, and have done so since the pre-Islamic Sassanian dynasty, which ended in AD 641. Norah Titley and Frances Wood describe the invariable pattern in *Oriental Gardens* (1991): 'Whether on a grand scale or in the simplest garden, the layout usually consists of a central pool with a fountain and four channels at right angles to each other enclosing flower beds, while shrubs, shady trees and fruit trees line the paths to provide the essential shade. This scheme, known as the *chahar bagh* (literally, four gardens), has been used in large or small gardens in Iran for centuries and was introduced to India by the first Mughal emperor, Babur, after 1526. Gardens retained the original plan under successive Mughal emperors but with increasing emphasis on the use of water … . [The] *chahar bagh* was the ideal garden, the earthly paradise, providing coolness and shade to offset the heat of an Iranian summer.'

The Persian garden was so successful that the Mongols appropriated it. Tamerlane had several walled gardens in Samarkand: there was a garden of plane trees, a paradise garden and a northern garden. These, too, had shady pavilions where small streams ran across the floors to cool the atmosphere, and where parties and concerts were held.

There is a curious postscript to the *chahar bagh* in the huge walled garden that was designed about 1930 by Sir Edwin Lutyens for the British Viceroy in Delhi, and that now belongs to the President of India (pp. 26–29). The designer David Hicks, in *My Kind of Garden* (1999), calls it the greatest garden of the century: 'It captures all that is most wonderful of the great Mughal gardens of India and infuses them with that comfortable air of Surrey tea parties that was so much part of Lutyens's youth and the Raj itself.'

With the effective end of Communism in China and the passing of the Raj in India, surviving great walled gardens in these two traditions are being restored and 'new' versions made. It is not too fanciful to say that the Mughal garden inspired the formal gardens of Europe, and that the naturalistic walled gardens of China and Japan were the precursors of the English landscape garden of the eighteenth century.

At Nanzen-ji the garden was for the abbot's exclusive use, and only he and the gardeners were allowed to enter. The interior of the monastery is subordinated to the garden in the overall plan.

The four-section Persian garden, or *chahar bagh*, spread to India with the first Mughal emperor, Babur, sometime after 1526. Canalized rills of cooling water quartered the garden. In the Indian garden, as depicted in this diptych of Babur's garden, walls both afforded protection from extreme heat and enclosed what was regarded as an earthly paradise.

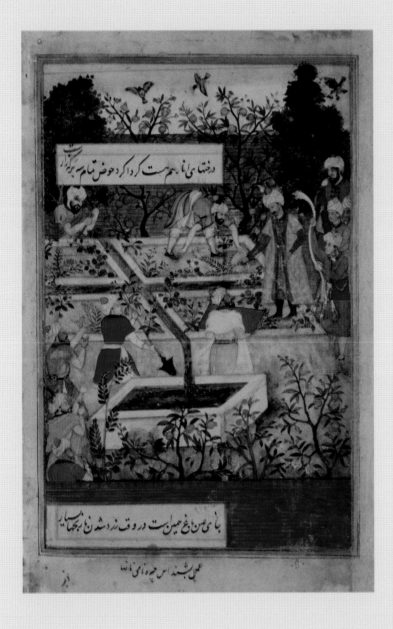

Amber Palace
Rajasthan, India

Amber, one of the most visited buildings in India, is a fortified citadel just north of Jaipur, and between 1037 and 1728 was the seat of the Kuchwaha Rajputs. Within the huge city walls, which run for several kilometres, is the Rajputs' palace, walled in turn and reputedly built on the site of a tenth-century Hindu temple. (The palace has no connection with the fossilized resin amber.) Within its walls are rooms with the most exquisite architectural decoration, in which tracery, inlay, texture and pattern vie with one another. At the centre is the walled courtyard, a living example of the ancient Persian and Indian *chahar bagh*.

Amber Palace's courtyard, quartered by canals in rills, conforms to the four-garden pattern that is the meaning of the term *chahar bagh*. Like many 'gardens' in this climate, it has few flowers, but instead formal lawns and neat trees.

What is extraordinary about this courtyard is its walls, which are lined with buildings two, three or four storeys high. Some have open loggias supported by columns, within which lie shady walks. It is like an Indian version of the centre of a small Italian town, such as Siena or Lucca,

The Persian term *chahar bagh* means 'four gardens',
a format seen in the courtyard of Amber Palace.
Rills, fountains and pools are essential features
of traditional Indian gardens such as this.

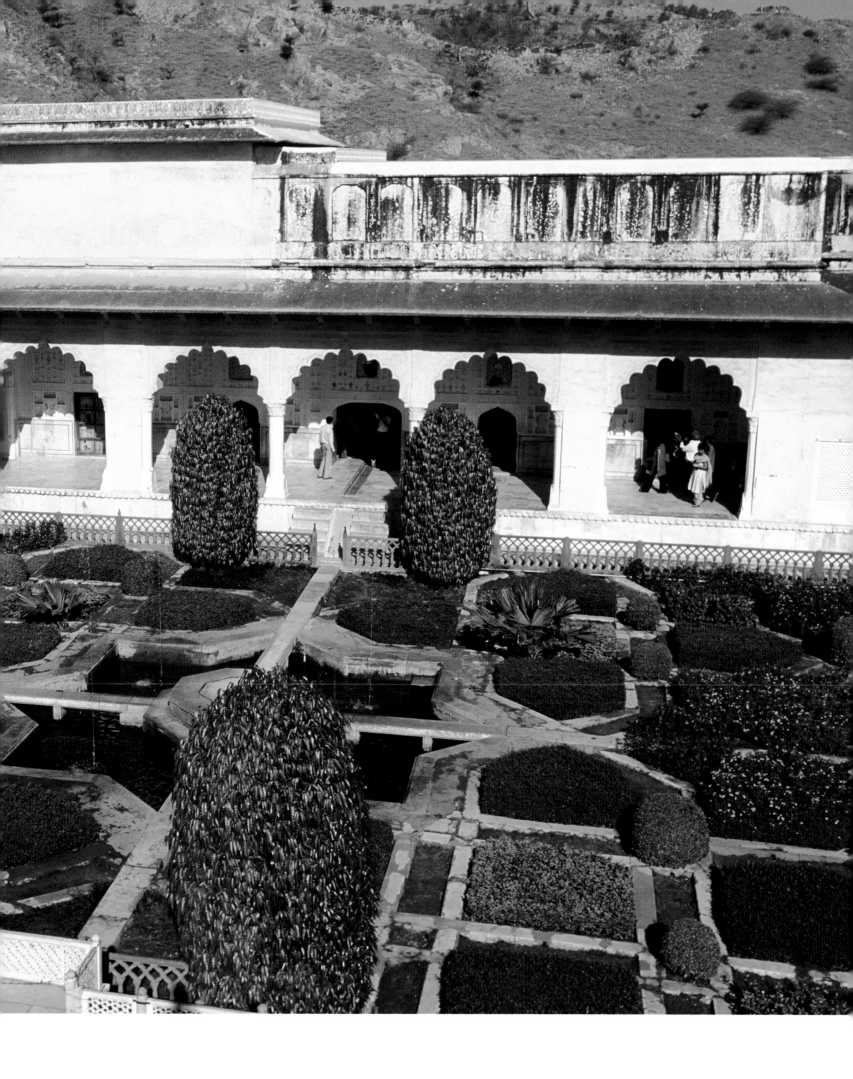

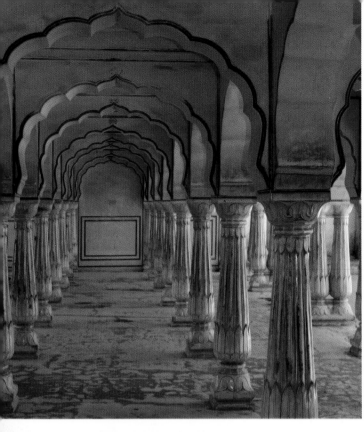

Left Everything within the walled garden is decorative and intended to enhance the pleasure of entertaining. The elegant black edges of the segmented arches emphasize their fluid shapes.

Below The surrounding walls double as buildings with outside staircases that serve upper storeys containing habitable rooms. A similar arrangement occurs in medieval Italian cities, such as Siena and Lucca.

Opposite Within the city of Amber are further walled enclosures, havens of serenity protected from the heat (and, in earlier times, warring enemies). These roofed colonnades, with their handsome detailing, invite a stroll in the shade.

where busy activity surrounds the cool waters and rills.

The walls are beautifully carved and patterned, as are the rooms behind them. The arches and columns are also decorated, and outside staircases lead to upper floors. Within these walls there is a great sense of security, which must have been welcome during the violence Amber Palace witnessed. A distant huge range of mountains creates a dramatic and dangerous backdrop to the whole.

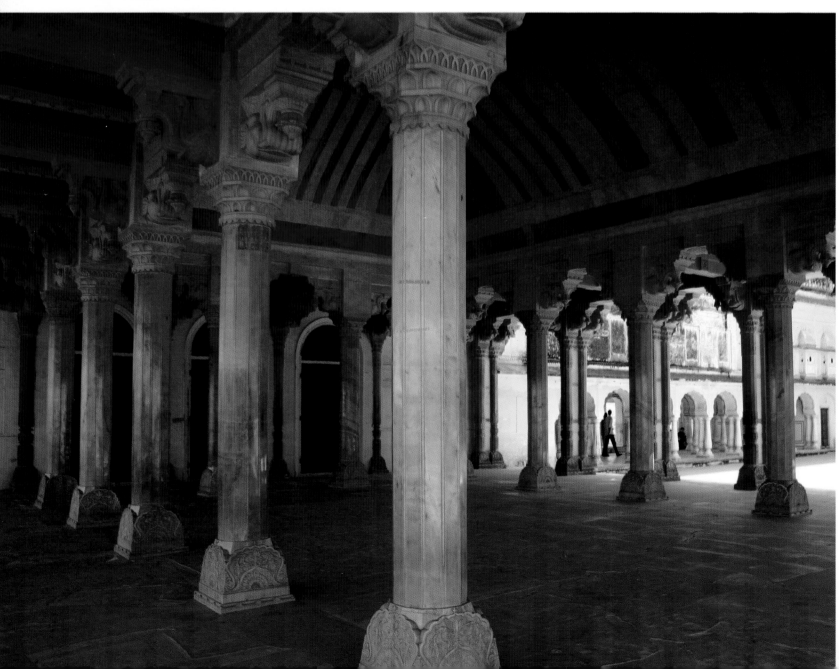

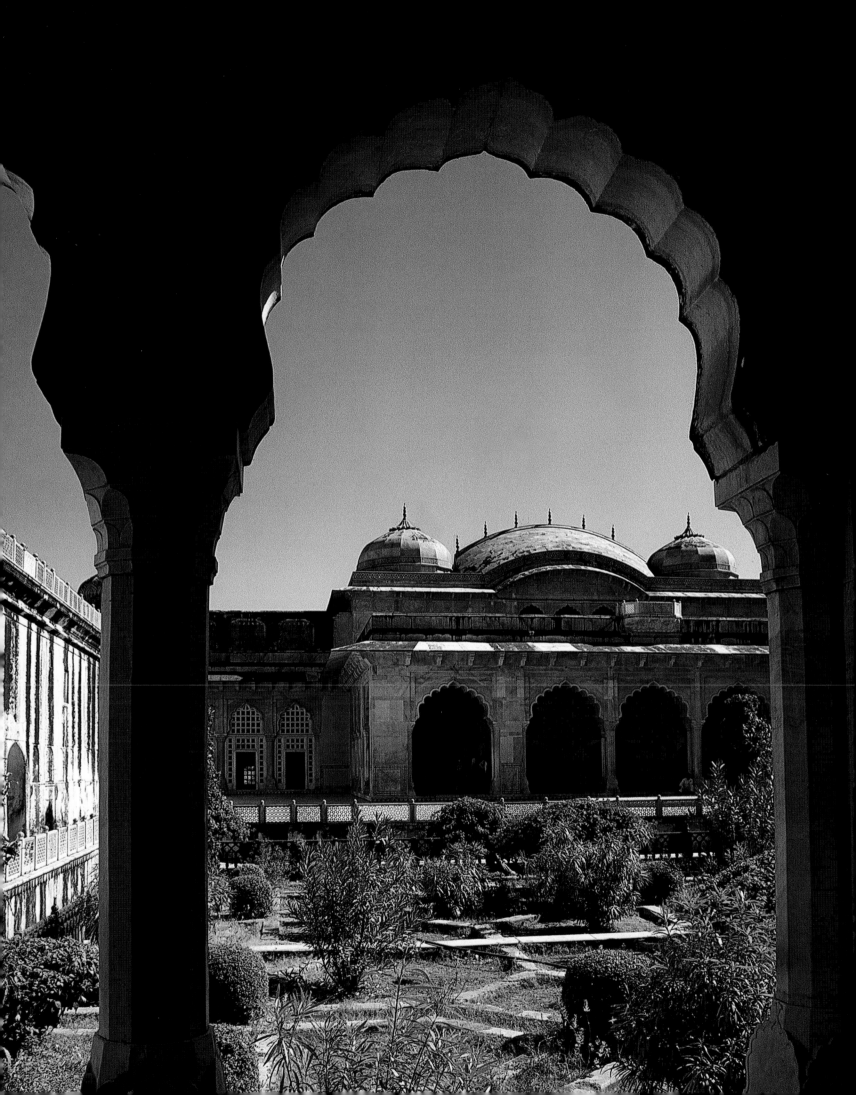

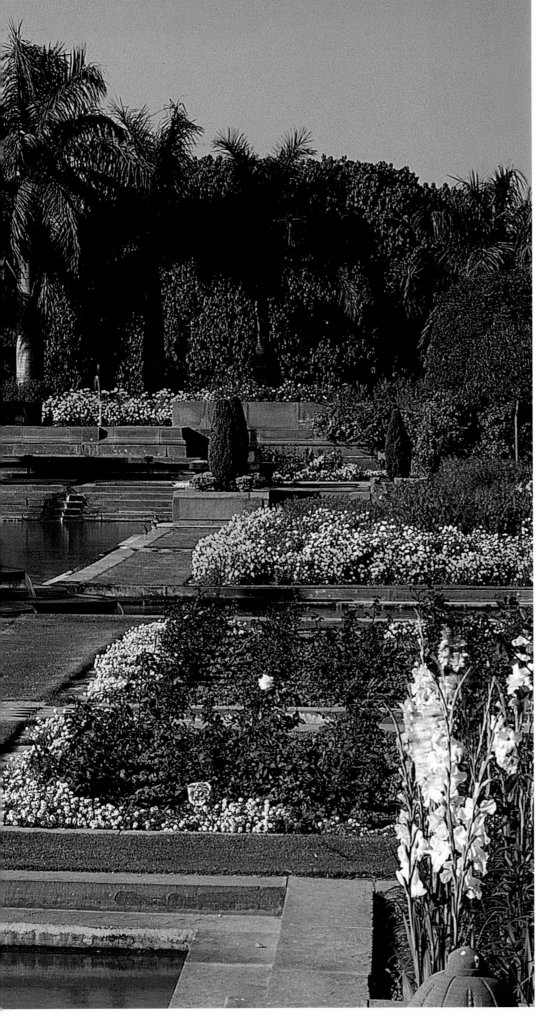

Mughal Gardens
New Delhi, India

At one time the Mughal Gardens
surrounded the vice-regal palace in Delhi,
seat of the ruler of India in colonial times.
Now Rashtrapati Bhavan, as the palace
is called, is India's presidential residence.
The gardens are the work of Sir Edwin
Lutyens (1869–1944) at the height of his
powers, but were created without his
famous collaborator Gertrude Jekyll, with
whom he had already made seventy
gardens. His achievement with the Mughal
Gardens is astonishing, especially when
one considers the Indian climate, and the
project (including the palace) occupied
Lutyens from 1912 until 1930.

These gardens are at once intensely
Indian and typically English, containing
elements of the gardens Lutyens designed
in his native country. The enormous area
is surrounded by walls of red sandstone
carved in huge blocks and arranged to show
the various colours of the stone. In nearly
eighty years they have weathered little.

Within the walls there is an immensely
complex layout of textured stone paths
intersecting with still canals that surround
formal, grass-edged flower beds. The paths
are made in herringbone patterns or
diapers, or of plain flags like a pavement.

The Mughal Gardens, within which sits Delhi's former
vice-regal palace (now the residence of the Indian
president), were designed by the British architect
Sir Edwin Lutyens at the zenith of his career.

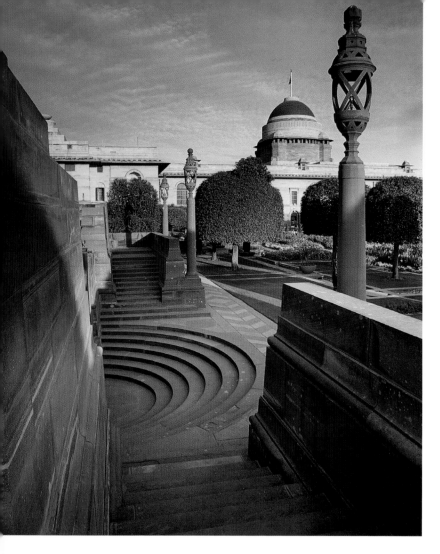

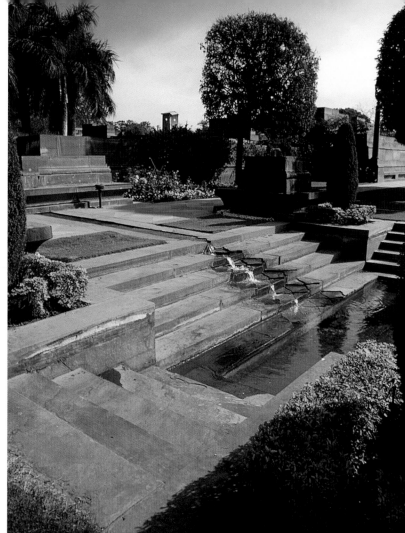

The beds are planted with blocks of brilliantly coloured flowers so that, seen from the windows of the palace, the gardens are laid out like a painting by Piet Mondrian. Some of the beds are terraced and edged with sandstone; others are level with the lawns.

Around the lawns there are lollipop-shaped trees, obelisks and columns, all immaculately cut to shape with more blocks of low plants (most of them white) at their bases. Their placing seems almost random, though some are in avenues and at vista points.

The main feature of the gardens is the canals, still and brilliant blue under the hot skies. These vary in width and are crossed at intervals by bridges that are on the same level as the paths, so that from above the canals appear to be cut off. Elsewhere there are broad steps leading down to the water and small stepping-stone bridges. Red sandstone is also used for a pergola and columns with lacy Indian-lantern capitals. A tennis court is screened by a wall.

At intervals on the wider canals there are astonishing fountains designed by Lutyens in sandstone the colour of the darkest-red brick. These are shaped like lily pads: the central fountain splashes on to a group of four pads, which is surrounded by four more beneath and a further eight at the bottom. In this hot, dry climate the water splashes from the top of the fountain and passes through carved runnels until it falls back into the canal, hardly disturbing the surface.

Beyond the walls, the countryside stretches into the distance: a complete contrast with the high-maintenance garden, which is cared for by a highly dedicated team of gardeners.

Above, left Lutyens varied the levels of the gardens, not only with steps and flat bridges but also with obelisks and stone columns in the Indian manner, and with lollipop-shaped topiaried trees.

Above The formal gardens within their surrounding walls use the deep-red local sandstone. Lutyens specified that the stone should be carved in huge blocks, each one smoothly finished.

Opposite, top Variety in the pathways is provided by plain flagstones and herringbone patterns. The many fountains spring from red-sandstone bases carved to suggest giant lily pads.

Opposite, bottom Although the designer was British, the influence most evident in the Mughal Gardens is Indian (in turn derived from the Persian). The formality of the layout is relieved by channels of cooling, glittering water.

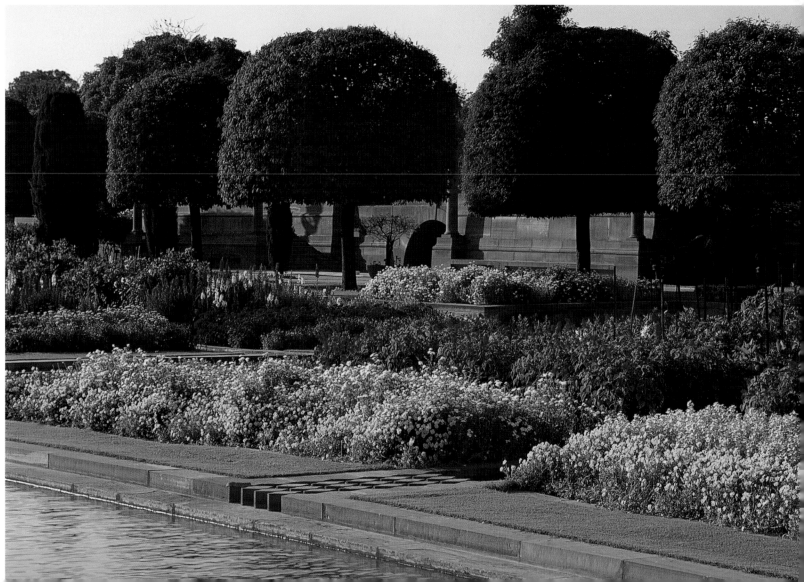

Ryoan-ji
Kyoto, Japan

If you think of minimalism as a twentieth-century style, you are five hundred years too late. Nothing could be more austere than the fifteenth-century garden of Ryoan-ji in Kyoto, Japan. This walled space, about the size of a tennis court, is plantless apart from moss.

The garden, considered to be the sparest of all in the Zen Buddhist style, consists of fifteen rocks arranged in five groups, of five, two, three, two and three. These are surrounded by a flat area of gravel, which can be raked into various patterns, including raised circles and striations (as shown here), and simpler straight rows leading up to the rocks.

The most influential of all Zen gardens, Ryoan-ji was probably created after the temple to which it is attached was burnt down in 1488. When the temple (which had been rebuilt) was destroyed again in 1780, the garden was saved and left untouched until it was rediscovered in the 1930s. It was probably designed by an anonymous artist–monk to create a small area of calm. The symbolism of the rocks is not understood, though it has been variously suggested that they could represent islands afloat in a sea of gravel, the tops of mountains, or tiger cubs

At Ryoan-ji an expanse of raked gravel is enclosed by diamond-shaped and rectangular pale flagstones, which also act as borders for darker, randomly placed stones.

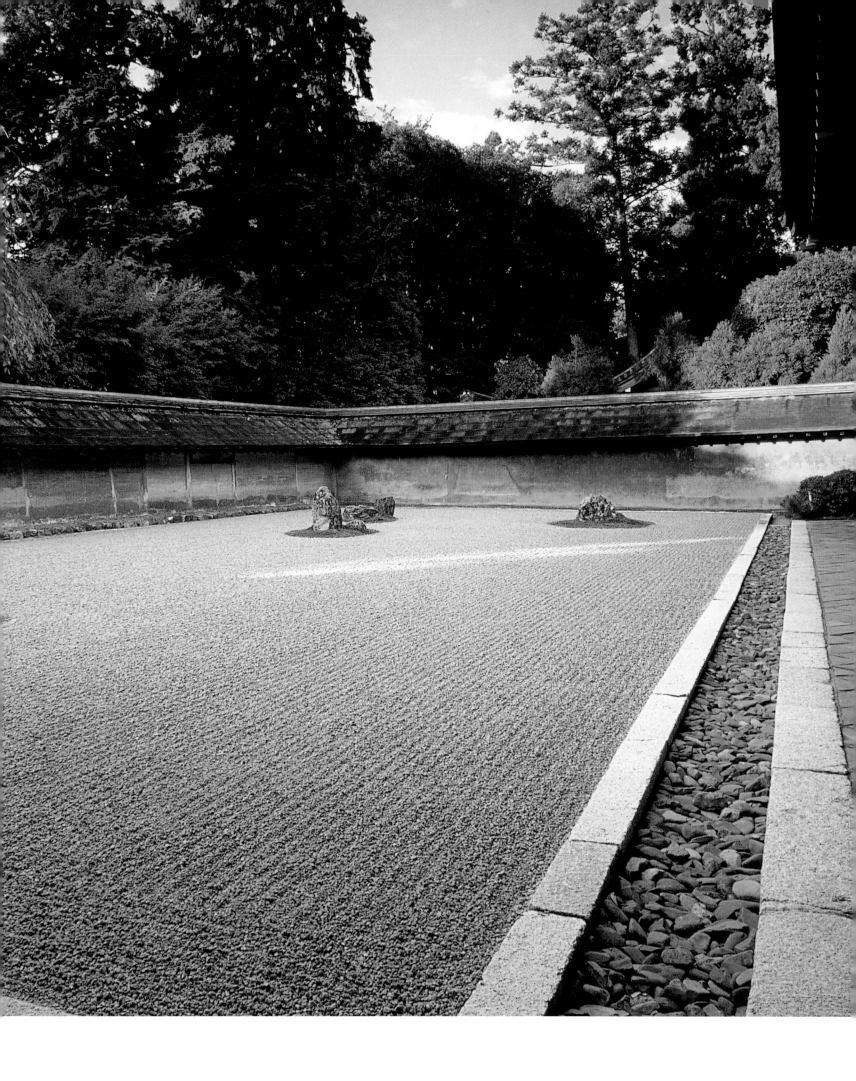

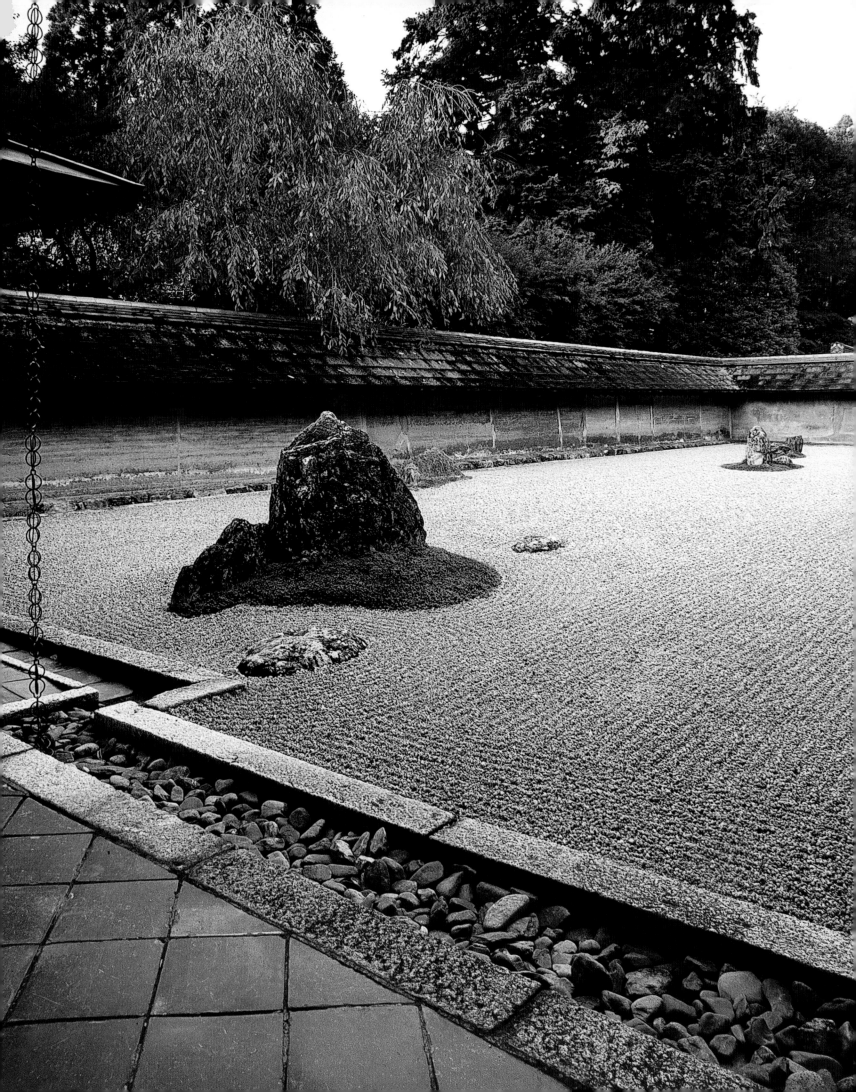

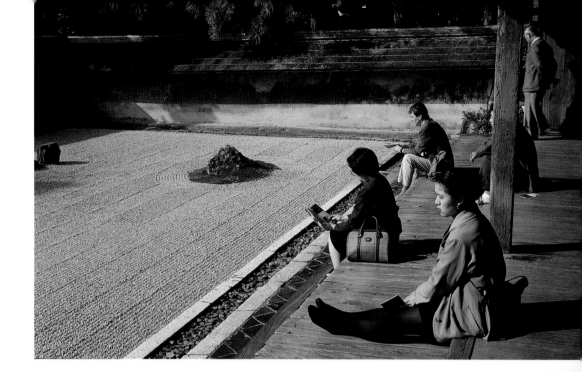

Opposite Ryoan-ji illustrates perfectly the ancient roots of what is now described as minimalism. In a country rich in Zen Buddhist gardens of dignified simplicity, this fifteenth-century creation is perhaps the most austere.

swimming with their mother. Ryoan-ji means 'Dragon Peace Temple'.

Like all Zen gardens, this one is intended to be seen from only one point, the temple's veranda. It is entirely surrounded by a border of diamond-shaped and rectangular flagstones and a channel of dark pebbles and paler stones, then by a dark-tiled wall, beyond which rise tall trees. No one, except the lay brother who rakes the gravel and removes dead leaves and other litter, ever sets foot in this garden.

The intention of this and other *kare sansui* ('dry landscape') gardens is to help the monks meditate. The first such garden was probably that at the thirteenth-century temple of Saihoji, near Kyoto, and was a 'strolling' garden used for contemplation. Later examples, of which Ryoan-ji is the best known, were always walled and placed outside the abbot's living quarters.

Kare sansui gardens were an important influence on most Japanese garden design, and in the eighteenth century books were published, complete with woodblock prints, describing how to rake the gravel around the rocks and how to create a suitably rustic fence or grassy slope. Their influence continues to this day, both in Japan and in the West, with the result that many garden designers and artists, including David Hockney, have visited and been inspired by them.

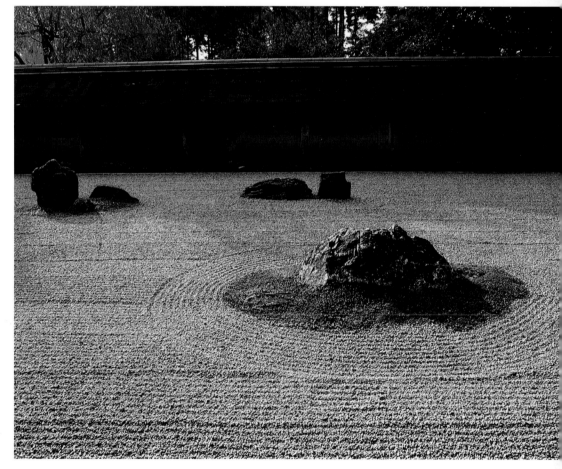

The garden was designed to help Ryoan-ji's monks to meditate. Modern-day visitors follow in their footsteps in this place of quiet contemplation at the heart of the 'Dragon Peace Temple'.

In a walled space not much larger than a tennis court, plants are kept to an absolute minimum: a group of trees and controlled moss that surrounds the stones.

33

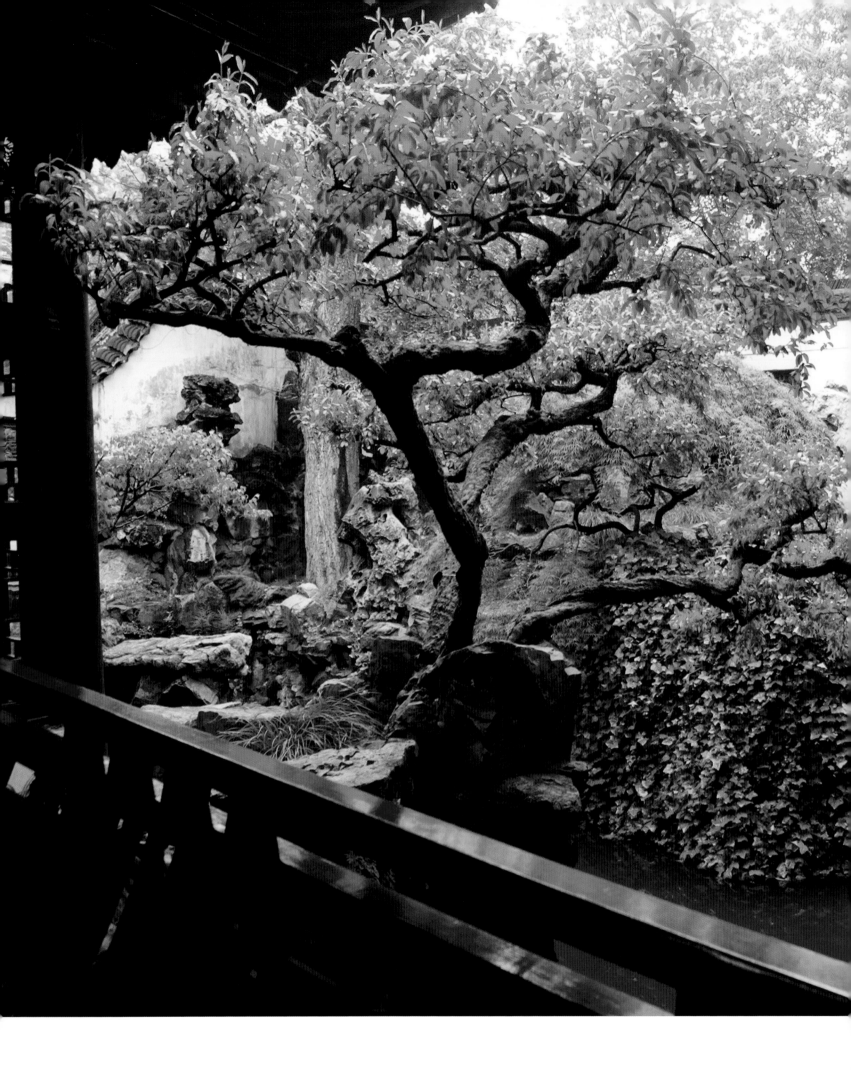

Yuyuan
Shanghai, China

The garden of Yuyuan is an oasis in the heart of Shanghai, a city so vibrant that four thousand high-rise buildings are currently under construction there. This complex garden, entirely hidden behind walls, is comparatively recent for a Chinese garden: it was created over twenty years during the Ming dynasty in the mid-sixteenth century. Its designer, owner and builder was Pan Yunduan, who made it in homage to and as a present for his parents, spending all his savings in the process.

It is extraordinary to find this garden in such a city. Leaving the skyscrapers behind, you approach it along a street of curly-roofed shops and across a zigzag bridge with no fewer than nine kinks, to deter evil spirits. Then, as you walk through a gate in the walls, you enter a different era.

This garden did not survive for four hundred years unscathed, and though several restorations were started, they did not last. In the mid-nineteenth century Yuyuan was the headquarters of the Small Swords Society, dedicated to the overthrow of the Qing dynasty and the restoration of the Ming. A century later much of the land was again weed-ridden or built upon,

Yuyuan was designed and built about 1550 by Pan Yunduan, who dedicated it to his parents. The project bankrupted him but, one hopes, pleased them.

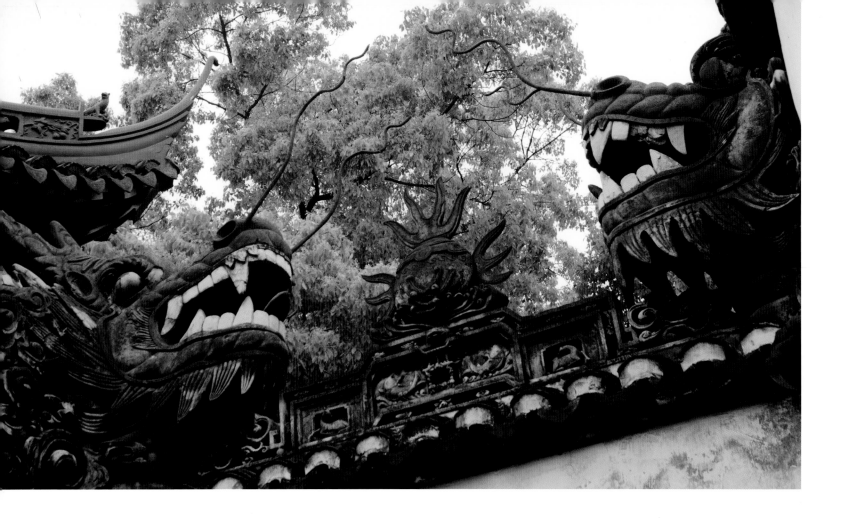

its original buildings derelict. In 1956 the city authorities decided to restore it and reconstruct the lost buildings. Six years later Yuyuan was opened to the public for the first time. It was declared a national monument in 1982, having survived the rule of Mao Zhedong, when many ancient sites were destroyed.

Inside the walls is a garden of 2 hectares (5 acres), itself divided by further walls into six parts. These include the Grand Rockery – the most elaborate and ancient in south-east China – the Ten Thousand Flower Pavilion, the Hall of Heralding Spring, the Hall of Jade Magnificence and the Lotus Pool. To build the Grand Rockery 2000 tonnes of stone were imported into the city. This feature stands 12.8 metres (42 feet) high and includes cliffs, gorges, winding caves and dangerous peaks, all designed to give the feeling of mountain country. Another impressive sight is the Dragon Wall, a white structure surmounted by an undulating dragon, its scales represented by tiles.

Scattered across the site are forty buildings, from small belvederes to sizeable halls, one filled with Ming furniture. Each contains a single room. Because the climate is subtropical, the windows are open but filled with elegant traceries, and the walls are pierced with stone-mullioned windows to offer tempting glimpses of more gardens beyond. It was here that the owner and his parents lived, meandering from one building to another along winding paths, over bridges gently sloping across still pools overlooked by benches for watching the fish, and through inviting doorways, some in the traditional moon shape.

Throughout the gardens the planting includes immaculately tended bamboos, ancient pine and maple trees, and box bushes carefully manicured into cloud shapes. Flowers – among them azaleas – are rare.

To say that the plan is complex is an understatement. It is a maze: buildings with upswept roofs surmounted by carvings of birds and beasts block the view at every turn, and small paths patterned with neatly placed pebbles wind between buildings and bridges.

Above The Dragon Wall, one of the walls that surround the gardens, is dominated by ferocious white-toothed dragons, their scaly skin represented by ornamental tiles on the vertical coping.

Opposite, top left Near Yuyuan, modern Shanghai suddenly gives way to streets of old wooden houses with carved balconies and upturned roofs, a fitting approach to these venerable gardens of the Ming dynasty.

Opposite, top right The upturned roofs on the forty buildings that stand in the gardens were thought to prevent dragons and evil spirits from sliding down the ornamental tiles.

Opposite, bottom Scattered about the maze-like gardens, the buildings were used by members of the owner's household and are essentially a series of rooms separated by walks, streams and flowering shrubs.

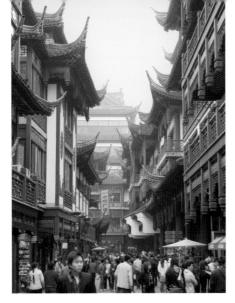

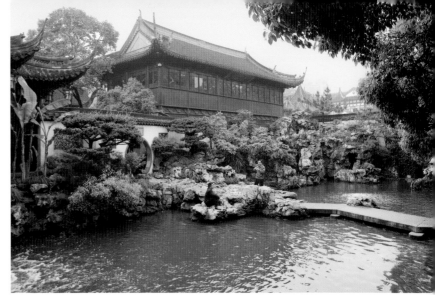

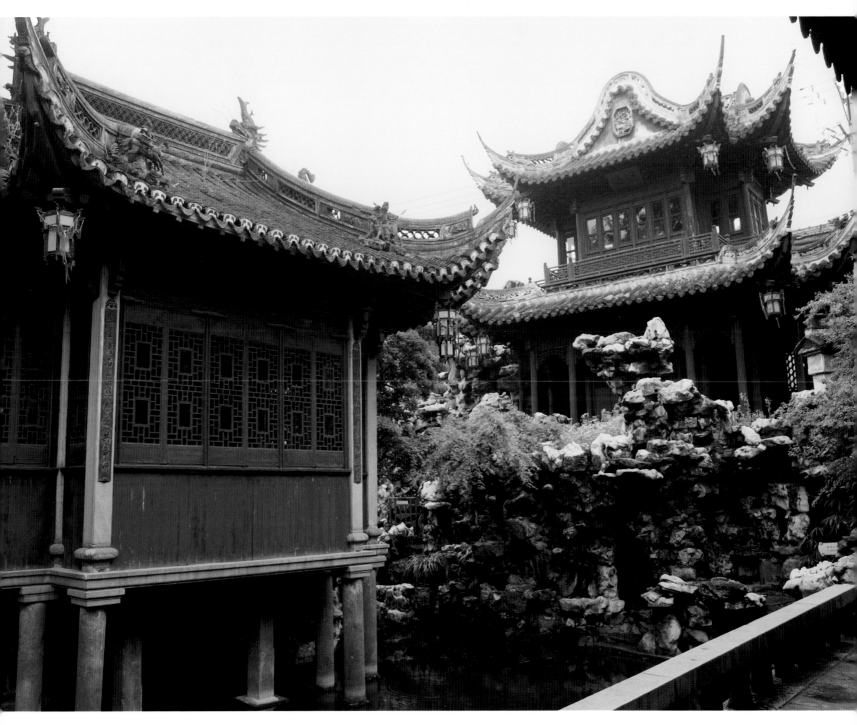

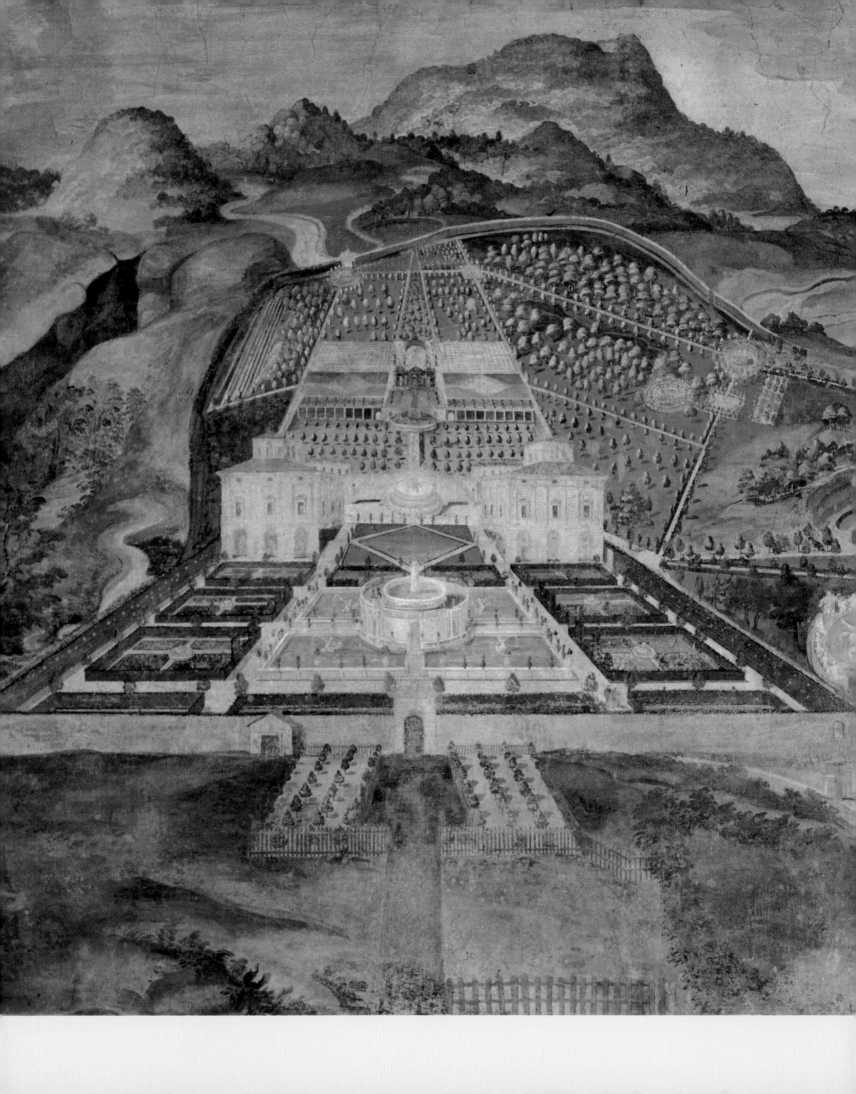

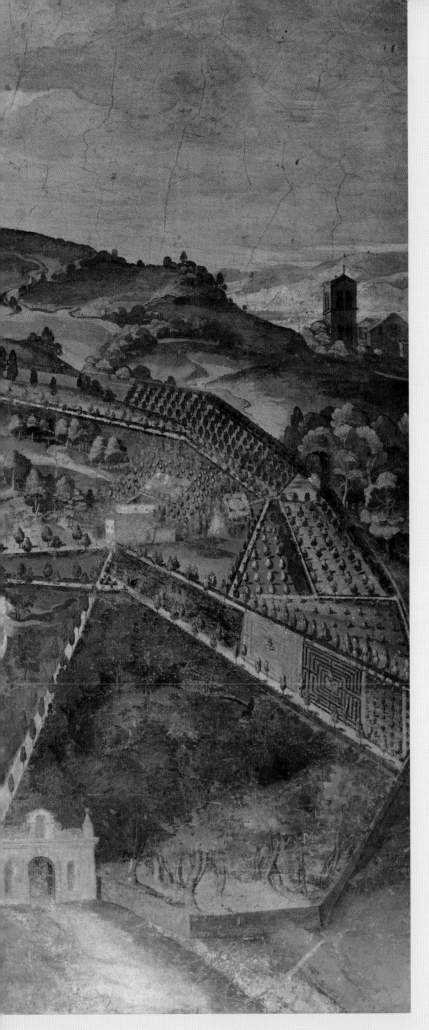

THE FORMAL WALLED GARDEN

The formal walled garden seen in so many seventeenth-century bird's-eye-view prints, with its rooms and vistas, avenues and topiary, is a direct descendant of the gardens of Roman villas. These were in turn inspired by those of Persia, which was conquered by Rome. Pompeii provides evidence of the Romans' use of the walled and peristyle garden for the small town house, but the Italian designers of Renaissance gardens did not know this, for the preserved town was not discovered until the eighteenth century.

What the Renaissance designers could do was visit and measure the derelict gardens of the Roman Empire and learn from their layouts and proportions. In *The Story of Gardening* (2002), Penelope Hobhouse suggests that these gardens, 'based on Roman precepts, are among the greatest in the world. Their influence on developing garden styles throughout the centuries is impossible to measure or over-rate … the Italian garden with its Roman overtones, as an architectural concept, dominates the whole future development of European and American garden styles; its rules provide the "grammar" of all good Western garden design.'

Compare the following formal walled gardens, geographically distant from one another, and this theory is borne out. A fresco of Villa Lante della Rovere, near Rome, painted in 1574, shows such a garden at the front of the villa, its inner walls covered with climbers and flowering roses, its centre a huge fountain with encircling pond, and its beds laid out with formal topiary and carpet bedding. The gardens of Het Loo in The Netherlands, completed in 1692 and restored to splendour in the 1980s, are very similar (pp. 174–77).

At its peak in the sixteenth and seventeenth centuries, the European formal garden was set out in all its complexity in many bird's-eye-view depictions. This fresco shows Villa Lante della Rovere, outside Rome, in 1574.

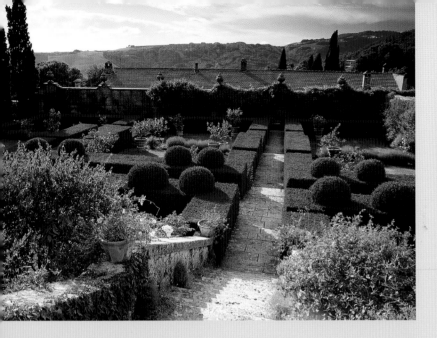

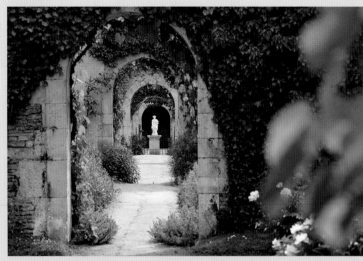

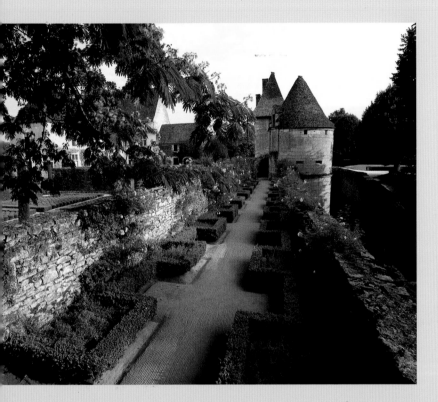

Top left The formal garden encircled by walls – seen here at Villa La Foce in Tuscany, Italy – is in its layout and proportions a direct descendant of Roman gardens.

Top right After starting life in Italy the stern formality of the walled garden spread into France (as here, in the Château Canon, Gironde) and throughout Europe. It reached its peak in the seventeenth century.

Above The Château de Losse in Dordogne Périgord, France, another defensible castle, has formal beds surrounded by box topiary in an endlessly repeated pattern, drawing the eye towards the turrets. Walls that deterred the enemy in times of conflict became a frame for formal planting when peace returned.

Then consider the engravings made in the seventeenth century by Johannes Kip of the great English country houses' contemporary formal gardens, most of which were subsequently destroyed to make way for 'natural' landscapes. These gardens are virtually indistinguishable from that of Villa Lante. Il Brolino, in California, created in 1922 by the designers Florence Yoch and Lucille Council for the timber heiress Mary Stewart, was directly inspired by Villa Medici in Rome. Filoli, also in California, was inspired by the owners' visits to Europe, and especially by the colours of the stained glass in Chartres Cathedral. Inside its walls are layer upon layer of formal hedges, the straight lines softened by topiary balls and brilliantly coloured roses and bedding.

At Kykuit, New York, pediments, fountains and topiary are grouped around an Italian belvedere. The planting is severe, but the impression is lightened by the use of twentieth-century sculpture with Classical figures, among them pieces by Aristide Maillol, Pablo Picasso, Henry Moore and Isamu Noguchi. The same Modernist inspiration combined with Classical proportions can be seen at Val Verde in California. The designer was Lockwood de Forest, working in the 1920s. In this garden the solid walls are replaced by massed tall columns, close together, giving the same feeling of enclosure. These are reflected in a series of pools, all rectangular but different in size. The planting includes box topiary, olive trees and agaves.

The French have always preferred formal gardens in the Italian manner. The Château de Brécy, in Normandy, still has the remains of a Baroque garden designed by Jules Hardouin-Mansart (1646–1708), the architect of Versailles and designer of the mansard window. This garden includes parterres and terraces, topiary obelisks and symmetrical staircases. The enclosing walls are only waist-height and are made of heavy balustrades, but a pair of giant wrought-iron gates five times the height of the

walls creates a magnificent entrance. Planting in many beds consists of swathes of fluid box in gravel, similar to that at Het Loo, while a rare flash of colour other than green is provided by the soft blue of Versailles tubs, regimented on yet more gravel.

The English version of such a garden can be seen at Melbourne Hall, Derbyshire. It survives in its seventeenth-century form, and consists of the same terracing, long vista – in this case stopped by an airy iron 'bird-cage' belvedere – pools and fountains. A separate walled garden has been added to enforce the symmetry of the main area at the front, though, curiously, the house does not sit symmetrically in its formal setting.

Among formal gardens, those of Quinta da Bacalhoa, at Setúbal in Portugal, are especially interesting in that they are more heavily influenced by the Persian ideal than by the Roman and Renaissance versions that came later. Portugal was occupied by the Moors for several hundred years, and the Portuguese love of cooling water rills and decorative tiles can be traced back directly to ancient Persia. The gardens were designed in the mid-sixteenth century, supposedly in the Italian manner, but the scrollwork parterres are in the style of Versailles and Het Loo, and the high walls are dotted with pepper-pot roofs that resemble the dovecotes of the Dordogne. The house itself is ornamented with colourful geometric tiles surrounding every

window, and an arched loggia on an upper floor could be in Italy or, indeed, Persia.

The formal walled garden, its colour often restricted to green and its materials to those used for the walls and buildings, translates well to small spaces, for such gardens are often reduced to a series of small 'rooms'. Indeed, the Italian ideal was to have – even in a small space – fountains and ponds, grottoes, a terrace for orange and lemon trees (with an orangery and *limonaia* for them in winter), and a small, dark, informal area of woodland, usually containing evergreen ilex, box, olive and bay. At Quinta da Bacalhoa there is an orchard at a lower level than the parterre and fountain; at Val Verde groves of oak woods form a backdrop to the stone-coloured pillars; and at Il Brolino the woodland is backed by the formidable Santa Ynez Mountains. The visitor therefore realizes that beyond the serenity and orderly calm of the formal walled garden lies a natural wilderness.

The backdrop does not need to be natural: it can consist of anything that suggests untamed growth. A good example is a roof garden by Abbie Zabar in New York. If massed topiary, hard stone and clumps of evergreens count as formality, this tiny space overlooking Central Park and the high-rise buildings beyond certainly qualifies. The calm of verdant symmetry can work as well in the pressurized city as in the untamed countryside.

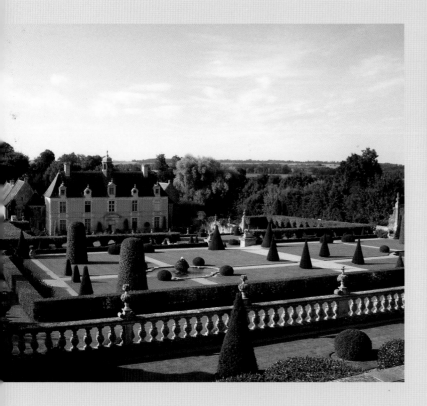

The architect of the palace of Versailles, Jules Hardouin-Mansart, designed the still-existing seventeenth-century formal gardens at the Château de Brécy in Normandy.

The formal gardens of Melbourne Hall in Derbyshire are a rare survival. The house was a second home in the eighteenth century and escaped the fashion for landscaping.

Villa Gamberaia
Tuscany, Italy

The gardens of Villa Gamberaia are among the most famous in Italy, partly because they are but a short distance from Florence (with its thousands of visitors, among them painters, writers, historians and designers), and partly because they contain everything typical of an Italian garden. The gardens are a mixture of the old and the recent: they were created by the Florentine noble Marchese Capponi in the early eighteenth century and by 1744 most of the features were already there. In 1954 Marcello Marchi bought and restored the property, which had been devastated during World War II.

At the centre, among the small areas devoted to holm-oak woods, a terrace for lemon trees in pots, and a water parterre, is an elongated 225-metre (738-foot) bowling green, which terminates at one end in a curved Nymphaeum and a grotto with a figure of a god – Pan or Dionysus, no one is quite sure – flanked by lions and backed by tall, dark cypresses. At the other end stands a walled balustrade that tempts every visitor, for it offers an impressive view of Florence below. This is effectively a walled garden, despite its unusual shape: at one side is a series of

The overall plan of Villa Gamberaia exploits axes and formal ponds to draw the eye to a single point: the stupendous view of Florence beyond and below the gardens' green perimeter.

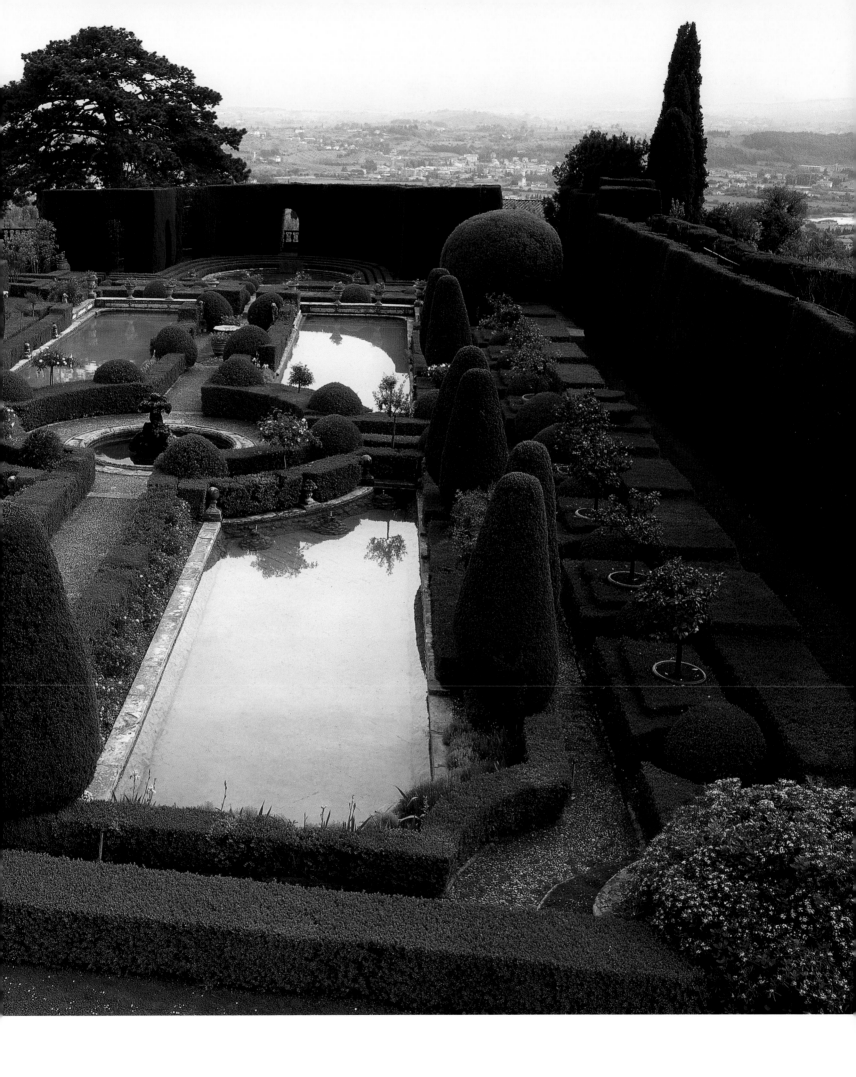

Left Central to the gardens at Gamberaia is the bowling green, 225 metres (738 feet) long. Virtually unplanted except for a fine lawn, and lined by a retaining wall, it extends to an open area that looks out over Florence.

Below At the start of the bowling green a complicated grotto made of tufa (solidified lava) disguises a change in level, the dark trees behind being on much higher ground. The villa and its outbuildings form the left-hand side of the green at this point.

Opposite The Gabinetto di Roccaglia is a sunken area of great formality. Its walls are decorated with tufa and stones in patterns, and there are urns and statues.

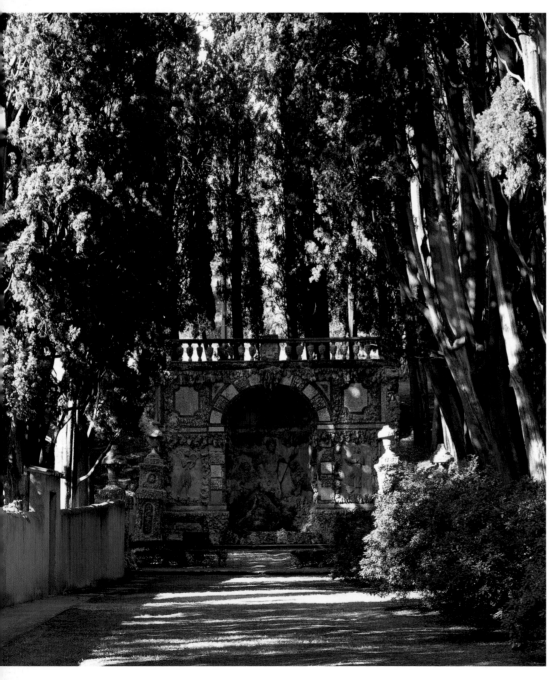

buildings culminating in the villa itself; at the other is a high, cream-coloured retaining wall. These cut off the area from the rest of the garden, as does the lack of planting (the bowling green is nothing but a long lawn).

Gamberaia has a second walled garden, smaller than the green one and more conventional. This, with the villa itself, makes the other axis of the plan, only half the length of the bowling green. The Gabinetto di Roccaglia (known in English as the Open-air Drawing-room, though *roccaglia* refers to the patterned stones that decorate the walls) is directly below the elevated lemon terrace – with its own *limonaia* in which the plants are overwintered in their pots – and is therefore sunken. Sets of symmetrical stone steps lead down into its grassed area: one from the lemon terrace and the other from the Selvatico, the little holm-oak wood. At the end of the sunken garden is a curved fountain area, and the walls are richly decorated, with statues in niches and on top of the walls. All this amounts to quite a grand little drawing-room.

Edith Wharton, in *Italian Villas and their Gardens* (1904), enthused over Villa Gamberaia's 1-hectare (2¼-acre) garden, which 'combines in an astonishingly small space, yet without the least sense of over-crowding, almost every typical excellence of the old Italian garden'. In 1925 the garden designer Geoffrey Jellicoe went further, saying that the 'concept of a domestic landscape is by general consent the most thoughtful the western world has known'. But I like best the comment made by Harold Acton in 1971: 'It leaves an enduring impression of serenity, dignity and cheerful repose.'

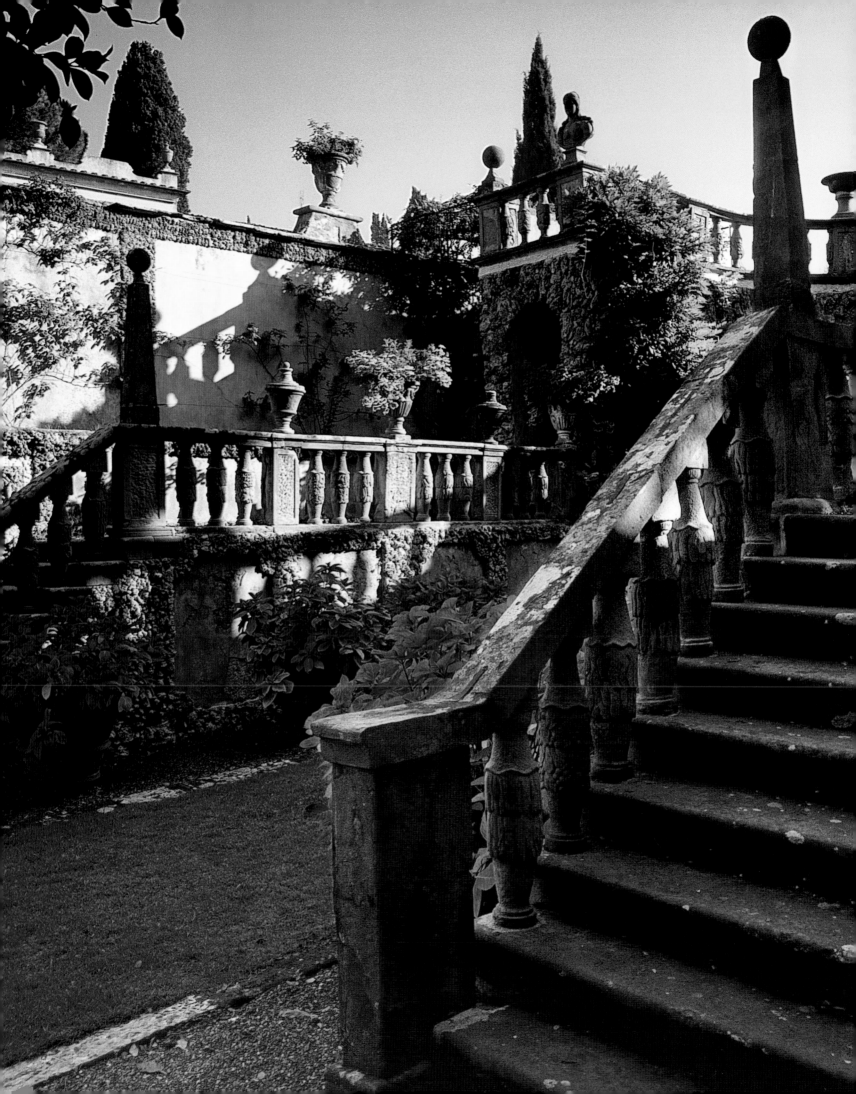

Iford Manor
Wiltshire, England

Iford Manor in Wiltshire is the creation of
Sir Harold Peto (1854–1933), who bought
the house in 1899 and worked on the
garden until his death. Peto was an
architect and in 1876 formed a practice
with Ernest George that, by the following
decade, was one of the most fashionable
in London (the young Edwin Lutyens was
a pupil). But Peto grew tired of the city
and probably with architecture too, for
when the partnership was dissolved in
1892 he agreed with George that he would
not practise architecture anywhere in
Britain for the next fifteen years.

Iford has been described by Jane
Balfour of the Hampshire Gardens Trust
as the 'most delightful Italian-style garden
in Britain', but Peto also designed other
gardens in the West Country and the
deeply romantic but still Italianate garden
of Ilnacullin, on the island of Garanish in
Bantry Bay, Ireland. Garden writer George
Plumptre believes that Peto's work was a
reaction against the opulent gardens he had
grown up with: he lived in Somerleyton Hall
in Suffolk, where the gardens were designed
by William Andrews Nesfield (1793–1881)
and Joseph Paxton (1803–1865).

As well as being an avid collector, Peto
was a keen traveller, especially in Italy, and

At Iford Manor, Harold Peto took great care to work out
the levels so that the gardens would descend in a series
of walled terraces rather than more natural slopes.

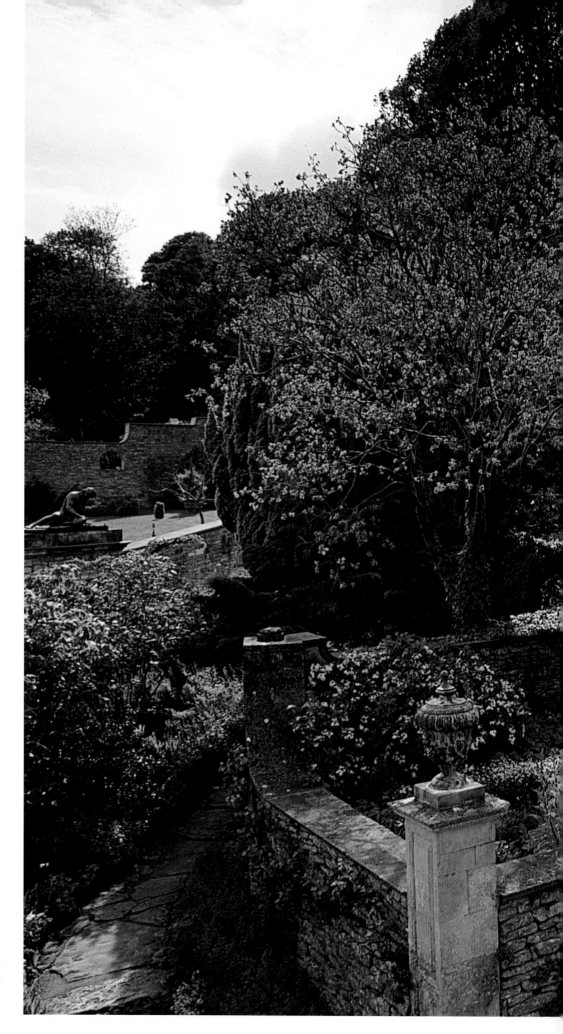

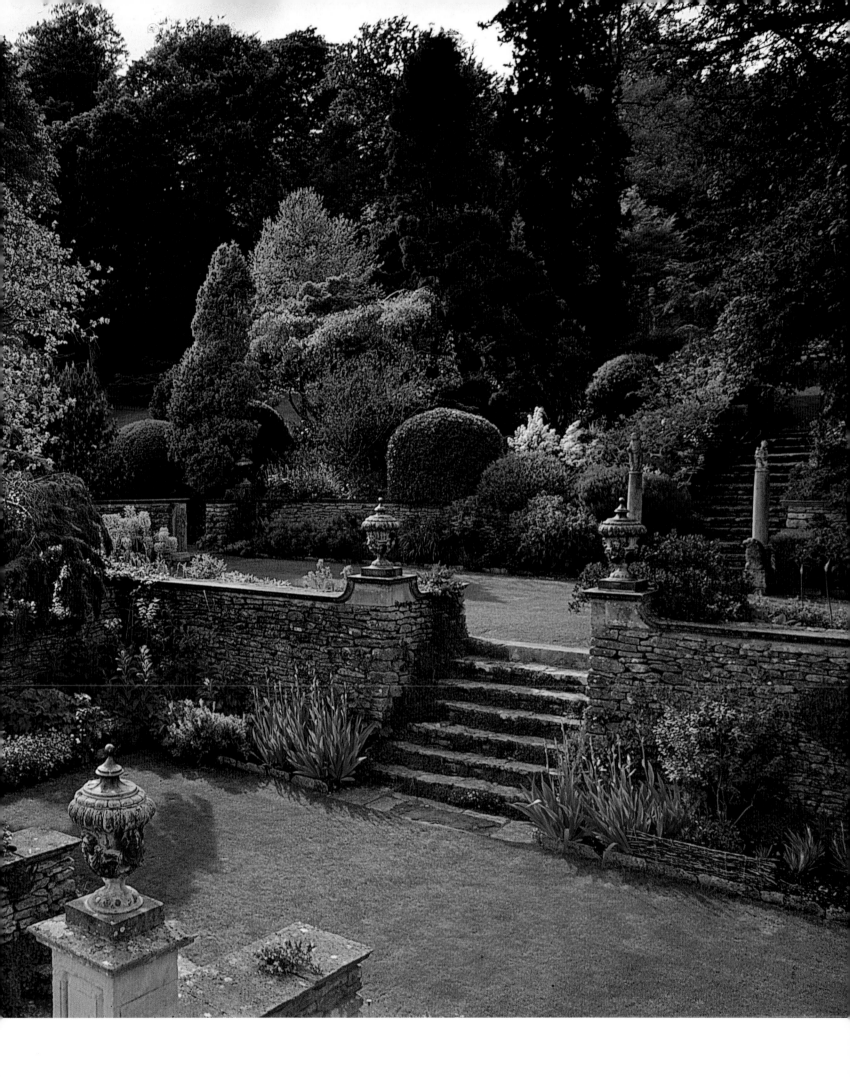

the garden at Iford is punctuated with Classical statues and objects found during his travels in Italy, France and Spain. The garden, covering just 1 hectare (2½ acres), is on a steep slope running down to the River Frome. It was in a bad state, and Peto cut down twelve hundred trees before creating his own series of terraces, each with a *patrio*, or pavilion. On the terraces he put his huge collection of Classical and Renaissance statues, wellheads and reliefs.

The planting was equally Classical, with Italian cypresses, phillyrea, yew, juniper and acanthus, though plants were not of prime importance, as Peto explained: 'The entirely subordinate place in the scheme that flowers occupy gives a breadth and quietude to the whole which is sympathetic, the picture being painted with hedges, canals and water tanks, broad walks with seats and statues … . If more of our English gardens could have an increase of this influence it would be well … .'

The Great Terrace is an enclosed 'walled' garden with a series of closely set stone columns. At one end there is a semicircular stone seat that adds to the cathedral-like effect of the columns, and before this is a Byzantine wellhead of AD 500. The religious atmosphere is enhanced with smaller enclosures that resemble side chapels, one with emblems of the aristocratic Italian Chigi family in topiary. In 1914 Peto constructed the walled cloister in the Romanesque style. It was made of the local Westwood stone, but antique fragments were included: a pair of wrought-iron gates from Verona dating from 1350, and a green-marble column from Diocletian's Roman baths. In the courtyard, surrounded by Pavonazzo marble columns from France, is a wellhead from an Italian convent.

Peto's close friend Avray Tipping described the garden as a haunt of ancient peace, and even Gertrude Jekyll, his near contemporary but his opposite stylistically, was a great admirer.

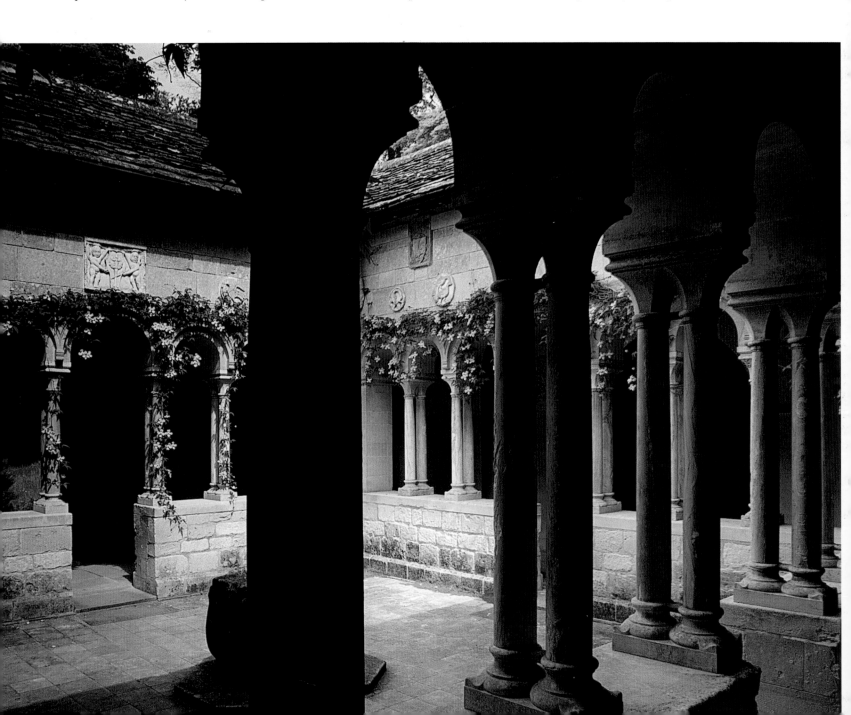

Opposite To create an authentic Italian atmosphere in the gardens at Iford, Peto installed many Classical and Renaissance statues and other artefacts, for which as an architect he had a refined eye. In the thirty-four years he lived in the house he travelled all over Italy, France and Spain and sent home whole colonnades, single columns, wellheads and reliefs.

Right The planting is severe in the formal Italian style and relies on a preponderance of geometrical topiary, as in the chequerboard area. Dark box contrasts with the soft colour of the surrounding walls.

Below With good reason Peto's creation at Iford Manor has been likened to a haunt of ancient peace and lauded as 'the most delightful Italian-style garden in Britain'.

Norfolk, England

This property in Norfolk provides a fine
history lesson on the walled garden, for
though the house itself is Elizabethan, the
park around it was created by Humphry
Repton (1752–1818), whose attitude to
walled gardens was much the same as that
of other landscape gardeners of the time:
he despised them but agreed that they
were a necessary part of the estate. In the
early 1990s the walled garden came under
the eye of the garden designer and Repton
scholar George Carter, who is known for
his formal, theatrical schemes (including
that of my own garden at Columbine
Hall; see pp. 102–105).

'When Repton was called in', Carter
explains, 'the house had a hole down the
middle and the Repton family – probably
John Adey Repton, Humphry's son – did
the repairs. The park was done in 1810
and included a proper oval walled garden.
Repton was quite keen on the servicing
of a house and garden and its technical
back-up. He was concerned about where
to site things; the walled garden should
not be seen but should be placed near
the stables as a good source of manure,
and this has been done [here]. The walled
garden is a technical adjunct to the house.'

Inside the walled garden the designer George
Carter has underpinned the riotous charms of
old rose varieties and other climbers with a firm
set of formal bones.

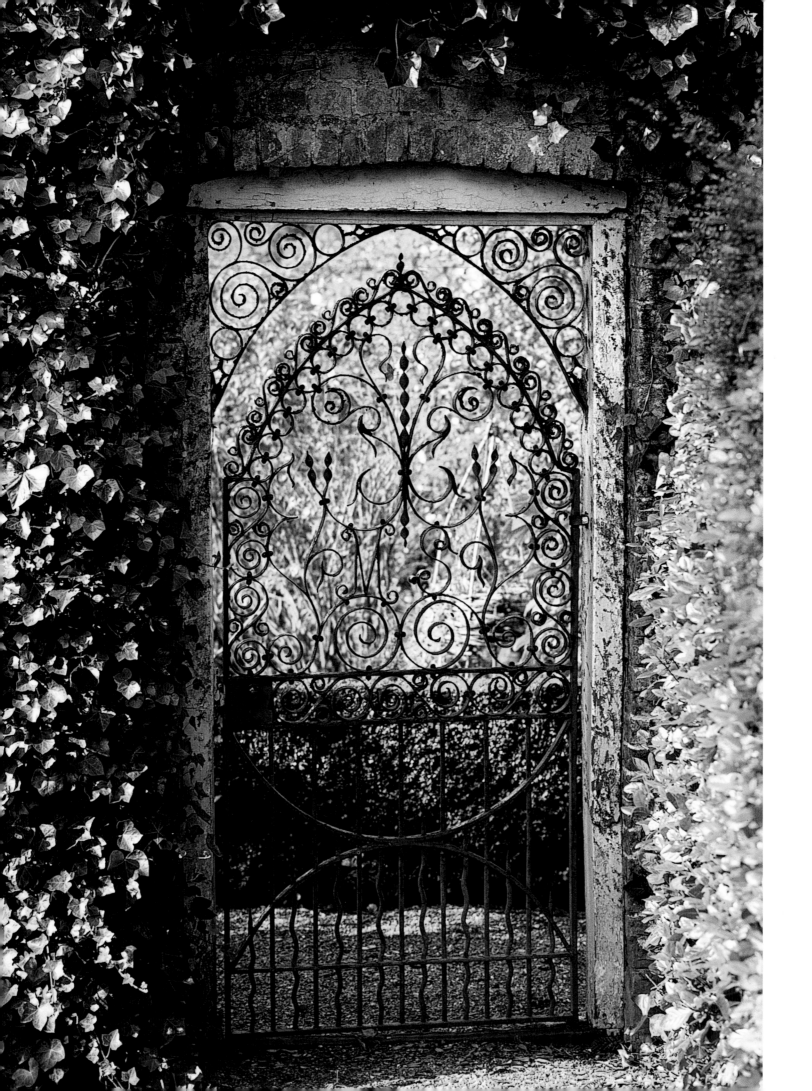

In fact, the oval walled garden here was treated as we would treat a compost heap today: essential to the garden but best kept in the background.

When Carter's clients bought the house, the walled garden was in a poor state. 'They had a huge range of derelict glasshouses, which they couldn't afford to restore, so their answer was to turn all but one – which is an outdoor dining room – into a picturesque ruin. These are planted with roses and clematis in a deliberately blowsy manner, which I think looks good with a romantic Elizabethan house.'

The walled garden is entered through a Gothick iron gate, and manages – despite the ruins – to be formal. A vista from the glasshouse orangery is stopped by a small building that Carter describes as 'a sentry box hut': too small to serve any purpose but catch the eye. Despite their height, the walls allow views across the landscaped park, which forms a complete contrast with the designs within. The walls, however, still do their job of hiding whatever is currently unpalatable in a garden: Carter has managed to insert a secret tennis court. An area for vegetables retains the original nineteenth-century pool that was intended to be used for watering them. The old nut walk had to be abandoned, according to Carter, as it had got out of control, but he planted formal hornbeam hedges when he designed the garden, and these are now fully mature.

Carter likes to design with monochromes, and grey plants are a frequent choice. Thus the ancient mounds of tall *Senecio greyii* have been clouded into an extraordinary grey hedge, and this colour theme is continued with areas of lavender and terraced santolina that look like grey steps.

Opposite Formal walled gardens are allowed a touch of frivolity in their gates. This fine example draws visitors towards the hidden area with tempting, controlled views.

Top When George Carter was appointed in the early 1990s, Humphry Repton's 180-year-old walled garden was derelict. Greenhouses that could not be restored were left as picturesque ruins.

Above Within the oval walled garden is hidden a tennis court. A pleached hornbeam hedge, fully mature after being planted in the early 1990s, distracts the eye from the court.

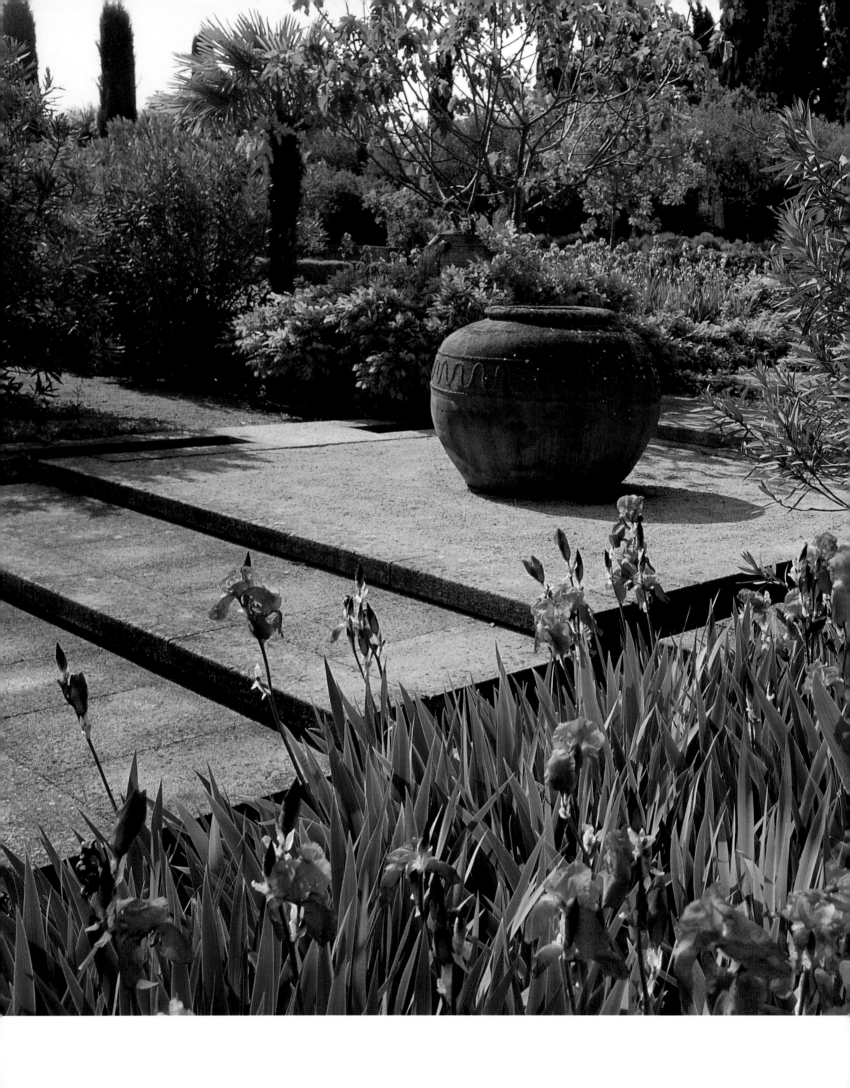

Maussanne-les-Alpilles
Provence, France

One reason for the English love affair with Provence and Italy is the chance to create a Mediterranean garden. Colours, shapes, design and planting can be far more exuberant in the strong southern light, and there is also the possibility of planting olive groves, fig and walnut trees, and topiaried rows of brilliant-blue lavender that echoes the colour of the sky. Southern gardens, however, have to be created with the climate in mind: blazing-hot, drought-ridden summers with the occasional flash flood are followed by winters that can, if rarely, produce frosts and snow. Such gardens need to protect the plants – and the owners – from the sun, giving a sense of the relaxed ease of a get-away-from-it-all haven.

The garden designs of Sir Terence Conran, the winner of several gold medals at the Chelsea Flower Show, display a definite attraction to the formality of French design, and an enjoyment of such features as statues, pools, stone walls and water spouts. His work at Habitat, The Conran Shop and his restaurants makes it clear that he puts the beauty of his surroundings and the importance of good food high on his list of priorities. Where better to practise this philosophy than in

Walking up Conran's flight of stairs at Maussanne, said the artist David Hockney, made him feel like the Emperor Nero. It is at once stately and shallow. Purple irises fill the beds on either side of the steps.

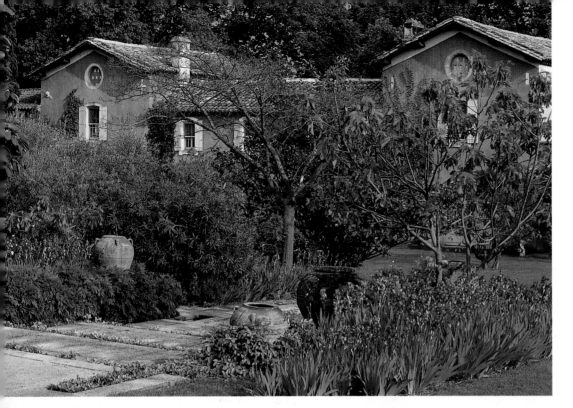

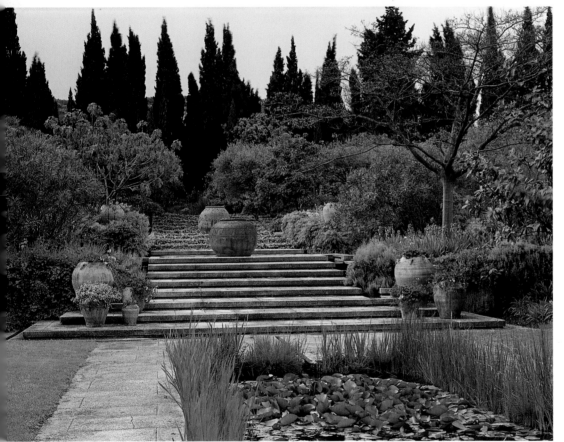

The *mas* (farmhouse) at Maussanne is painted a vibrant orange, a colour that, along with the soft blue of the windows, provides a perfect backdrop for the massed purple irises and large terracotta pots.

Like many Mediterranean gardens, this one lies on a sloping site. Central to the design is a generous set of steps, edged with trees, shrubs and pots, that leads gently down to a formal rectangular pool.

As befits the work of a fine designer such as Conran, these gardens are full of complex but effective touches. One example is a rill that is channelled alongside stone steps and punctuated by waterfalls as it descends the slope.

Provence, where the light is brilliant, the landscape has inspired great artists, and ancient forts and farmhouses, ruins and Roman remains are part of the vernacular?

Conran's *mas* (farmhouse) is typical of the region, and he has chosen to paint it in brilliant, earthy orange and complementary blue. Despite this, the light ensures that the house does not dominate the garden but provides a backdrop as natural as the colourful surrounding hills. One wall of the house creates a boundary for the main, walled garden. It is a single-storey element with a traditionally tiled lean-to arbour that is supported on solid columns draped with bright-green wisteria. From here the walled area stretches formally up to a swimming pool, which is hidden neatly at a higher level, beyond the horizon, rather than sunk below the sight line. But the pool is by no means treated surreptitiously: a broad series of stairs leads up towards it. These are made of pale flags alternating with softer levels of crushed stone, and on them sits a series of large textured and battered oil jars. On either side of the steps are small rills, descending through stone canals in line with the terraced steps. David Hockney, who has stayed there as a guest, said that walking up the stairs made him feel like Nero.

On the level of the arbour there is a neat rectangular pond edged with flagstones and surrounded by two smallish green lawns (not easy to maintain in this climate). The planting leans towards English insouciance: local wild irises spike upwards beside wisteria rambling over pots, roses tumble by walls and fig trees dot the area. There is the obligatory area of lavender. The whole is charming and languid and – the mark of a good designer – rather than looking planned appears just to have happened. The pool, when you reach it up the steps, makes no apologies for its bright-blue depths (ponds are often fitted with black liners to dull the colour), and is surrounded by ancient olive trees and yet more lavender.

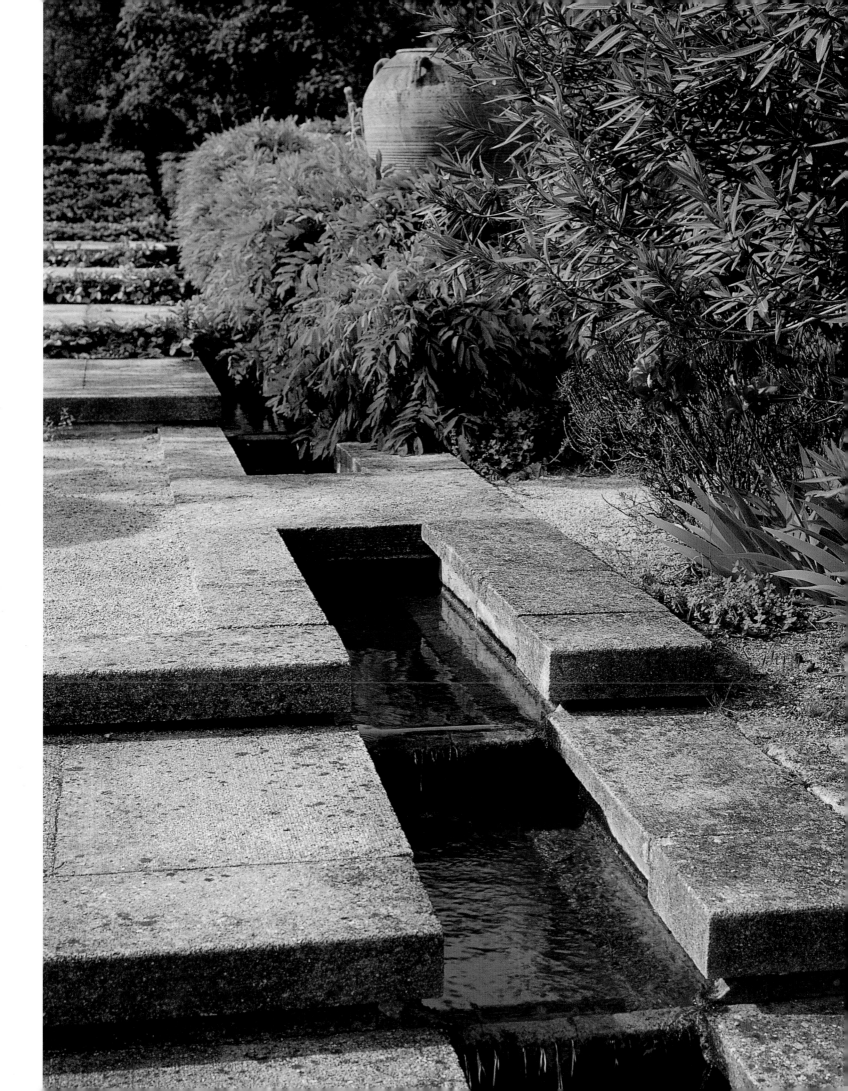

Vizcaya
Florida, USA

Just as Northern Europeans, particularly the British, roved around the Mediterranean in the eighteenth and nineteenth centuries, scavenging like Goths and Vandals, so did the Americans in the twentieth century. 'Raiding parties' picked up Venetian wellheads, Roman (or other) statues, Greek bas-reliefs and any old ironwork from castles in Spain and Portugal; they then turned for home, followed by cargo boats containing the booty. Such depredations would today be considered unacceptable, but they produced some wonderful houses and gardens: Hever Castle in Kent, Kedleston Hall in Derbyshire and Iford Manor in Wiltshire (pp. 46–49) are all British examples of the lust for Classical details. And in the United States there are the astonishing gardens of Vizcaya in Florida.

This 4-hectare (10-acre) plot on Biscayne Bay was the obsession of James Deering (1859–1925), who made his money from agricultural equipment through the International Harvester Company. In fact, Vizcaya was merely his winter home, from 1916 (when building work was finished) until his death. His intention was to make it resemble as closely as possible

At Vizcaya the long-established practice of enclosing a central pond with stone borders and flower beds is inverted. Here the centre of interest is an island-like lawn surrounded by a sinuous rill.

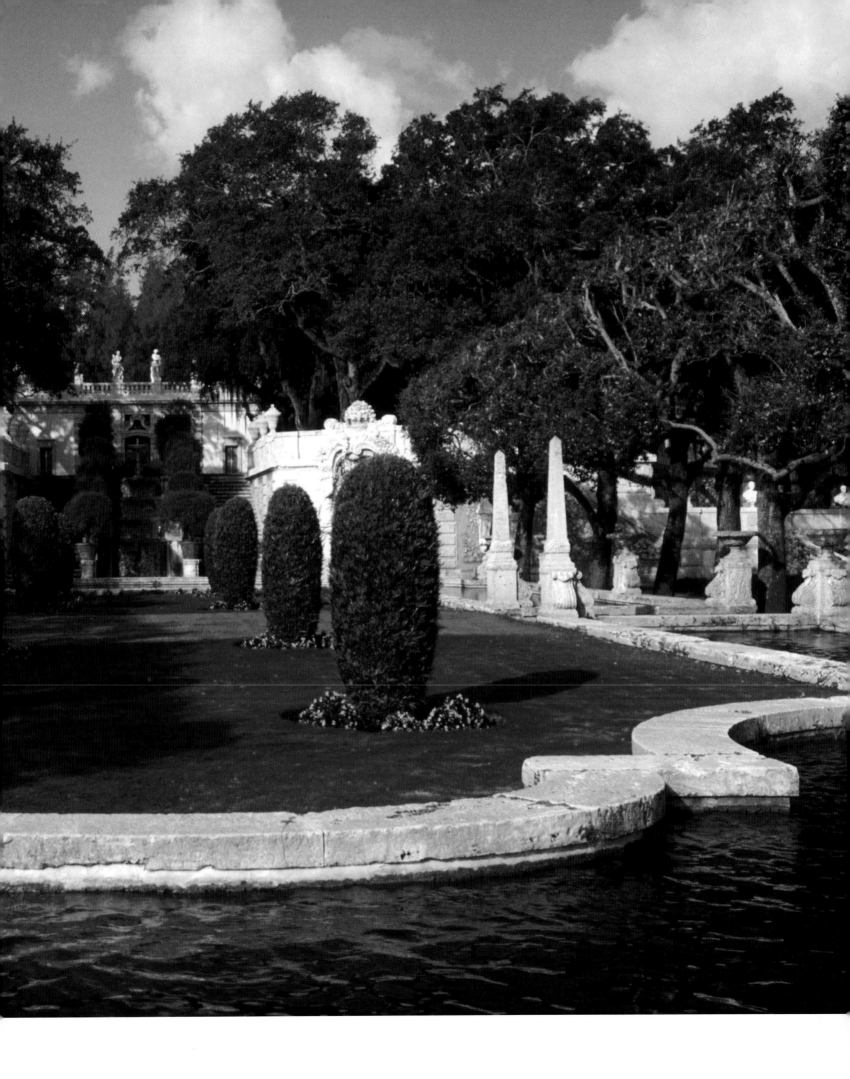

Left Harold Peto was not the only gardener to scavenge in southern Europe for ancient architectural treasures: James Deering's garden at Vizcaya has an impressive array, including this bench topped by a shell.

Below This mythical mask acquired on Deering's travels is made mostly of plain stone, with tufa (solidified lava) providing the beard, hair and eyebrows. Tufa is much used in Italian formal gardens.

Opposite In collecting centuries-old colonnades, seats, statues and other items, Deering aimed to replicate as closely as was possible in Florida the style of an Italian Renaissance villa. Some would say that his enthusiasm and means led him to exceed this ambition.

a four-hundred-year-old Italian estate and villa. To this end he spent seven years travelling around France, Spain and Italy looking for Renaissance architectural salvage. He was helped in the building by the New York artist Paul Chalfin, who travelled with him. Other designers included Burrell Hoffmann and Diego Suarez. Deering also employed up to one thousand workmen to complete the estate, to which everything had to be brought by water as there were no roads.

Vizcaya is overdone, but wonderful. Where an Italian villa might have a couple of fine statues, Vizcaya has dozens. It has ranks of ancient obelisks and urns on top of Baroque grottoes; it has spouts and fountains and pools; it has wide staircases decorated with coral stone from the Florida Keys, and massive walls with stone quoins. It is like a surreal version of Villa Gamberaia (pp. 42–45). And, at a certain point, it leaves Tuscany behind and becomes Venice as the waters of the bay lap against stone quays with Venetian-style striped poles for any passing gondola (and expected guests). It also has a ship-shaped stone breakwater that refers to Villa Lante, though Vizcaya's is much larger.

The centre of the garden is an enclosed green parterre with podocarpus topiary. In an inversion of the usual central pool, water forms the edge of the central space, contained by stone walls just high enough to make a barrier, edged with heavy, dark trees. At one end a grand staircase with central spouting fountains leads up to a *casino*, or dining pavilion. The base of the stairs is flanked by elaborate grottoes.

It is easy to make fun of Deering's folly, but it is a fine folly, especially as his intention was to save the local native forest. However, more seriously, he chose to build in a hurricane zone. The year after his death the gardens were destroyed (they were restored by Chalfin in 1933), and another hurricane struck in 1935. Deering's heirs had had enough, and sold the house and gardens to Miami-Dade County for $1 million. The new owner has the considerable task of upkeep, but Vizcaya has a reasonably secure future, hurricanes permitting.

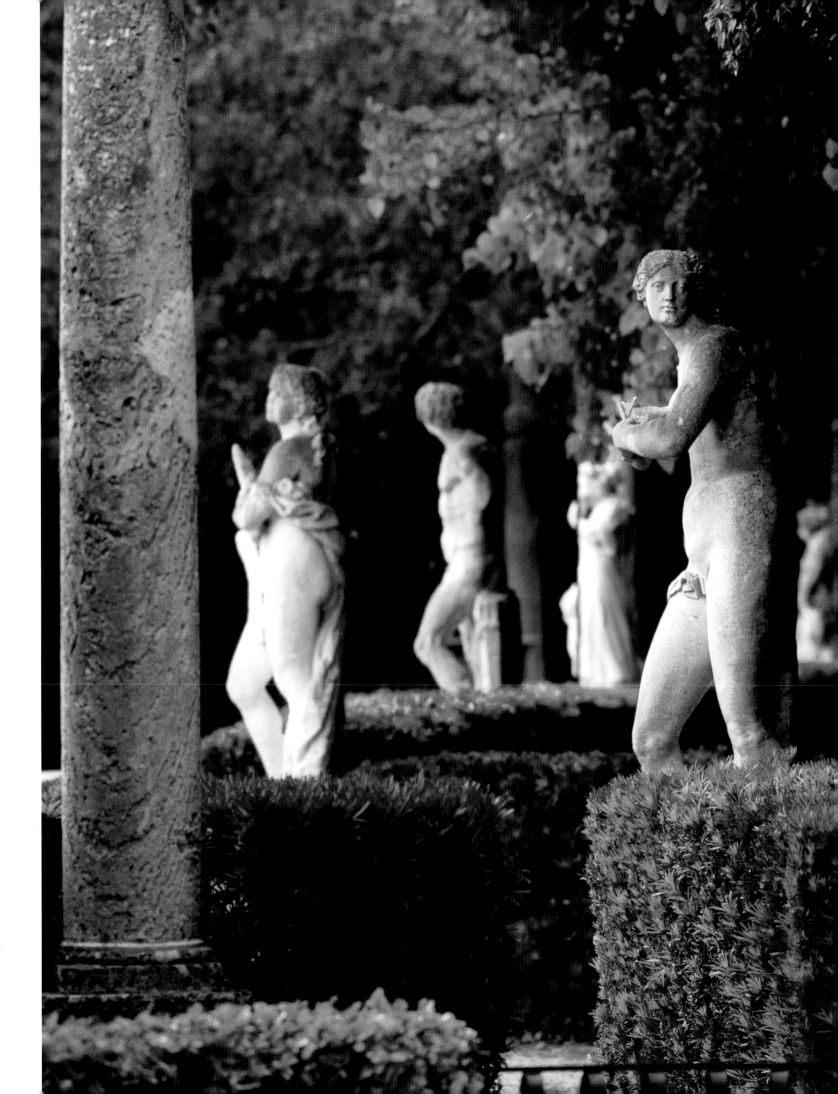

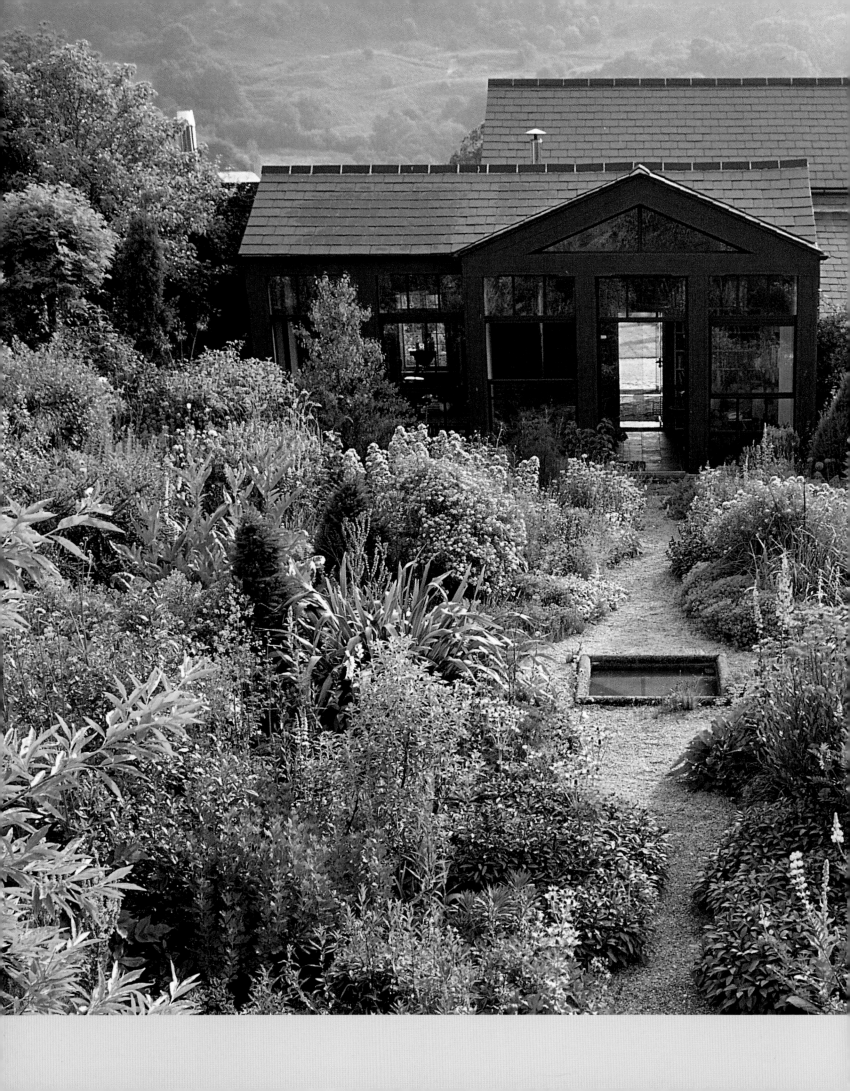

THE WALLED FLOWER GARDEN

That essential feature of the English country-house garden, the herbaceous border, is comparatively new, having been invented in the nineteenth century by a clergyman, amateur gardener and journalist named James Shirley Hibberd (1825–1890). Therefore the walled flower garden as a haven of colourful flowers of many varieties is also a newcomer on the scene. Walled gardens were not created for this kind of display, but those that existed before the mid-nineteenth century have adapted themselves wonderfully to it; the very fact that the walls create a warmer microclimate and protect the beds against flying weed seeds makes the introduction of flowers worthwhile.

Walled flower gardens are at their best when contrasted with the more natural landscaped garden outside the walls. Visitors can stroll through parkland dotted with deer or cattle, admire sinuous rivers carefully bridged, and glory in the open vistas of the countryside before immersing themselves in a controlled haven that is far from natural. Though the best herbaceous borders cunningly pretend to be low-maintenance, the reality is that they are very high-maintenance indeed, needing either a team of hired gardeners or, more likely, one dedicated amateur, probably female. For the walled garden as herbaceous border is the domain of the plantswoman, allowing the plant collector unbridled access to deep, rich soil within an area protected from high winds, sharp frosts, marauding sheep and children playing ball games.

Within the walled garden, too, the gardener can indulge in flowery fantasies: if the soil is alkaline, dedicated fans of such acid-loving plants as Himalayan poppies and azaleas can replace

The insertion of a tumbling flower garden within austere walls is a typically English style, combining formality with charming indiscipline. This is Penelope Hobhouse's design at the Coach House, at Bettiscombe in Dorset.

In Henk Gerritsen's design for Waltham Place, Berkshire, formal elements are undermined by the playful and exuberant use of flowers.

One of the most beautiful walled flower gardens in the world must be that of Mottisfont Abbey in Hampshire, a National Trust property. The abbey was built in the twelfth century but became a private house after the Dissolution of the Monasteries under Henry VIII. Its walled garden, surrounded by high, soft-red-brick walls, houses the British national collection of old-fashioned roses, amassed by Graham Stuart Thomas (1909–2003) in the 1970s. While these cover the walls and billow out over the flower beds beneath, the borders are filled with plants that complement the June lushness. Grey lamb's lugs (*Stachys byzantina*), old-fashioned pinks and lavenders give good contrast in form and texture, as do the bed edgings of miniature box and the formal topiary around a central fountain. Though white garden furniture is generally to be deplored, here the formal wood-and-iron benches are painted white to good effect, providing focal points in a garden dedicated to over-abundance.

Another abbey, Notre Dame in Normandy, has ancient stone walls with borders planted in the French manner: there are no soft English pinks and lilacs here, but a cutting garden of brilliant-yellow rudbeckia interspersed with orange and sulphur dahlias and clashing lilac Michaelmas daisies. It is brutal but effective.

In the wonderfully relaxed and English garden designed by Mr and Mrs Henry Harris – a walled garden that one writer describes as being firmly in the Cotswolds though geographically in Philadelphia – the borders are planted with splendid profusion. To prevent the tiniest space being left bare, the high stone walls are draped with tumbling old-fashioned roses, mostly in pale yellows, pinks and whites to complement the plants beneath. These include geraniums, poppies ranging from salmon pink to crimson, and delphiniums and irises, which provide pale-blue notes. Like Gertrude Jekyll – who must surely have been an inspiration for this garden – Mrs Harris is a painter, and her choice of colours, textures and forms is perfect. This walled flower garden, from its central lawn to its crowded borders, is just the way it should be.

Walled gardens need not be hermetically sealed from the outside world with towering walls and solid doors; the walls can be pierced to frame a view, be punctuated by a sudden gap of a metre or two, or even be metaphorical. One such device, used by Sir Edwin Lutyens and Gertrude Jekyll at Hestercombe in Somerset, is a series of hefty stone columns, covered with climbing roses, creating both a screen and a sense of height typical of the walled garden. In this case, underplanting was characteristic of the English herbaceous border, even if pride of place was given to lavender, a shrub.

The same trick has been used by the designer Deborah Nevins in the Peter May garden, in Connecticut. While some parts of this garden are properly walled, the stunning view over

whole areas of soil to suit their passions; those who salivate over cacti and other succulents can plant a desert garden; or, with a careful choice of hardy plants that look exotic, one can mimic the tropics. Lovers of the modern craze for swathes of waving grasses can create a whole prairie within the walls.

But the true herbaceous border is king here, especially as the walls solve the problem of what to do behind it. The plants are graded by height, from miniature creepers to tall 'guardsmen' at the back, and so the wall is a natural foil; in most other situations these borders need hedges or, worse still, the guardsmen have to be planted in the centre and the creepers on all four edges.

the hills has been emphasized and incorporated by a series of tall, square columns highly reminiscent of Lutyens's. In this case the columns are in pairs, with pergola beams above for large hanging baskets, and the raised area above the flower garden contains a flagged terrace for entertaining. The sunken flower garden has extremely wide beds, more than double the width of the lawn. The colouring is soft: pale-blue delphiniums (with a colour and spikiness so useful to the herbaceous gardener), white daisies and areas of citrus yellow. Even the tops of the stone walls are used for planting.

Not all walled flower gardens follow the herbaceous route: the cloister of the abbey of St Pierre in France, still in the Bene-dictine order, has taken the walled flower garden back to the earlier, formal notion of colourful bedding. Within the arched walls of the working cloister, scrolls of immaculately trimmed box are filled with bedding flowers of bright scarlet and soft mauve, all within an ordered square of pale-grey gravel.

The era of Victorian bedding at its most confident is recalled by the walled garden of the Biltmore estate in North Carolina, where 1.6 hectares (4 acres) are densely planted with blocks of bright colour. Scarlet salvias and ranks of mixed pink, yellow, orange and scarlet dahlias are restrained with edgings of white flowers and – a Modernist touch – blocks of waving green grasses. High-maintenance, pretty unfashionable – and stunning.

Gertrude Jekyll was one of the earliest garden designers to create blowsy, colourful planting within severe walls. Seen here is her design for Hestercombe in Somerset, where the architect was her long-time associate Sir Edwin Lutyens.

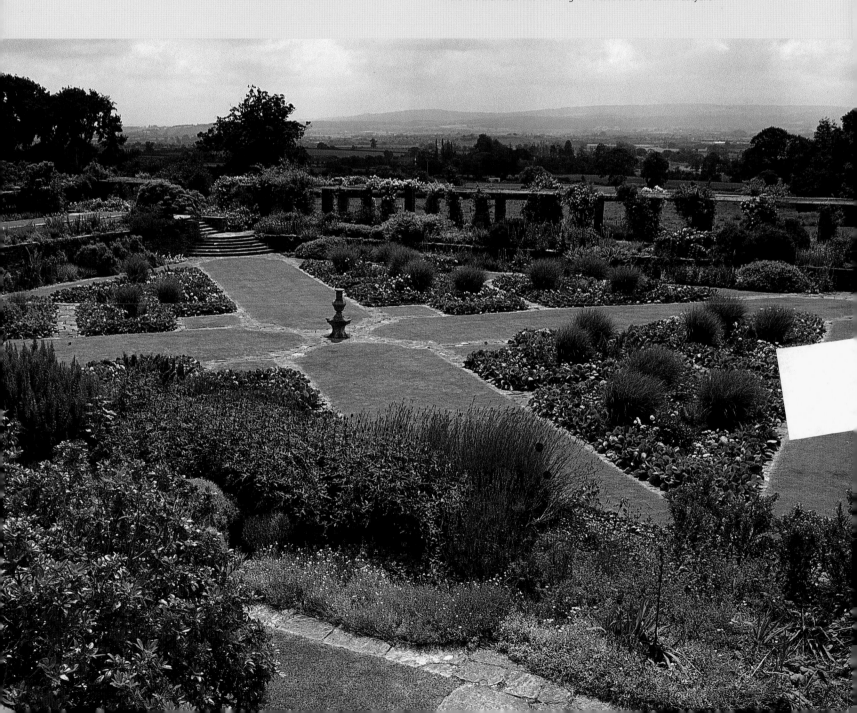

THE WALLED
FLOWER GARDEN

Rousham
Oxfordshire, England

The garden at Rousham is a miraculous survival. It was created in the 1730s by the architect and landscape designer William Kent (1685–1748). The owners then and now, the Cottrell-Dormer family, have seen no point in altering it, so it remains as it was nearly three hundred years ago. Within the bounds of what is a very early example of the English landscape garden, however, is another wonderful relic: the Pigeon House garden, which dates from a century earlier.

When the landscape craze swept England, the complex formal gardens that had been so fashionable in the seventeenth century were almost all destroyed. The walls, the walks, the parterres and the knot gardens were demolished in favour of sweeping vistas or, in Rousham's case, carefully planned eye-catchers, statues and water features, including the River Cherwell. If the landscape craze was controlled, at least one walled garden (for kitchen produce and cut flowers) survived. And this is what happened at Rousham.

The Pigeon House garden derives its name from a fine circular dovecote dating from the early seventeenth century and

Outside Rousham's walls lies a very formal, very unfloral garden laid out by William Kent almost three centuries ago. Within, colourful beds and climbers provide a complete change of style and pace.

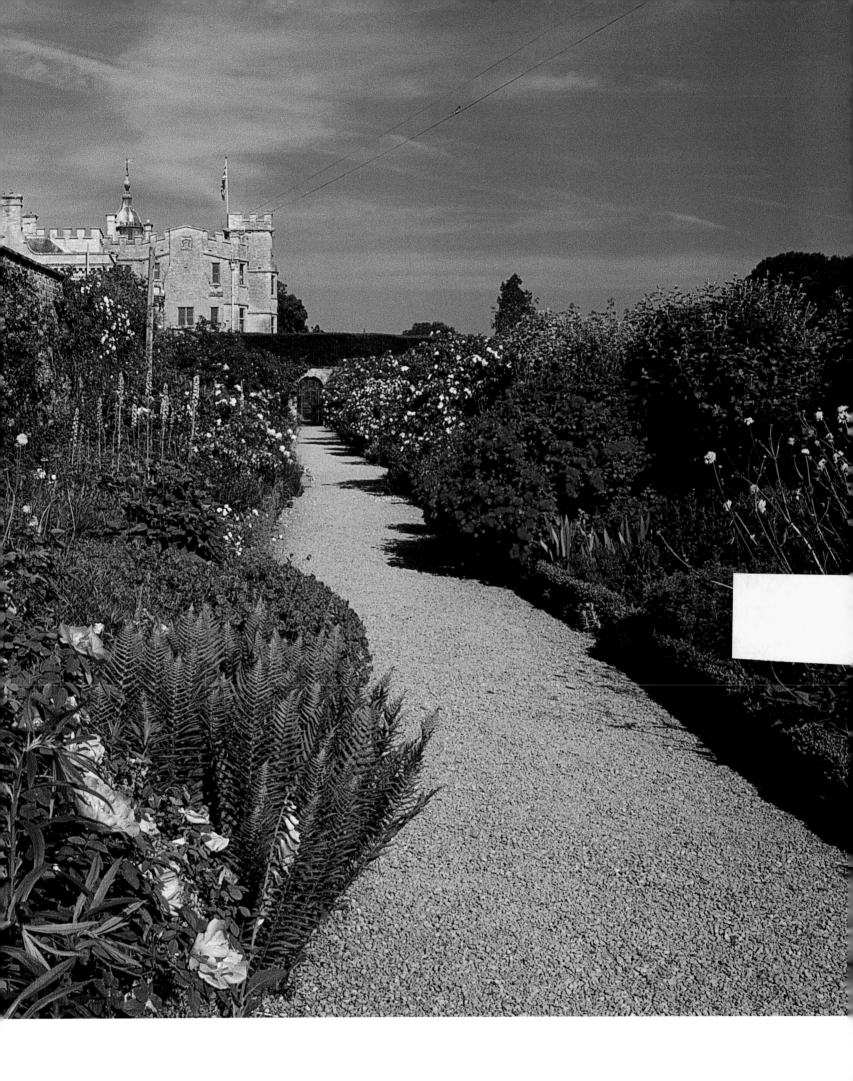

Left A plain doorway is intended to increase the surprise within. Most good walled gardens are tantalizingly hidden from outside view.

Above The walled garden, seen here looking towards the Pigeon House, succeeds in accommodating two distinctive styles. One area is exuberantly floral, while this one is fiercely formal – and perfect in winter.

sited within the walled garden (slightly surprisingly, perhaps, given the damage that pigeons can do to vegetables). The garden is surrounded by high walls in the delicate, apricot-coloured local stone, and a beautiful eighteenth-century wrought-iron gate stands at its entrance. This gate, David Hicks suggests in *Cotswold Gardens* (1995), should be copied by modern wrought-iron workers, and then 'I would perhaps become a convert to the material'. It is arched to fit the wall opening and is made of the slenderest ironwork imaginable. The plain lower half gives way to increasingly frivolous Rococo swirls as it rises. Not only a thing of

beauty, the gate also gives a tantalizing glimpse of the garden beyond.

This garden does exactly what a walled garden should: it provides a complete contrast with the style and atmosphere of the terrain outside it. The main garden is, as Hicks describes it, 'simplicity of design as an end in itself … . The different greens against the cool stone structures give form and line. This is no flower-dominated garden with burgeoning borders.' In the walled garden, though, the owners have forgotten their restraint, and in one section, in front of the high walls, have created herbaceous borders brilliant with reds and mauves. Fruit trees are espaliered

against the walls, their pale blossom an ideal contrast with the stone behind. Beside the circular dovecote with its pointed roof, however, the more formal style of the seventeenth century remains, perhaps all that is left of the gardens of Rousham before Kent began his work.

There is a pattern of box-edged beds, and diapers with central box balls are surrounded in turn with rectangular box beds. The spaces between are filled with colourful planting used en masse – both restraint and profusion within one walled garden – and the advantage is that although the herbaceous plants will die back, the box patterns are effective all year round.

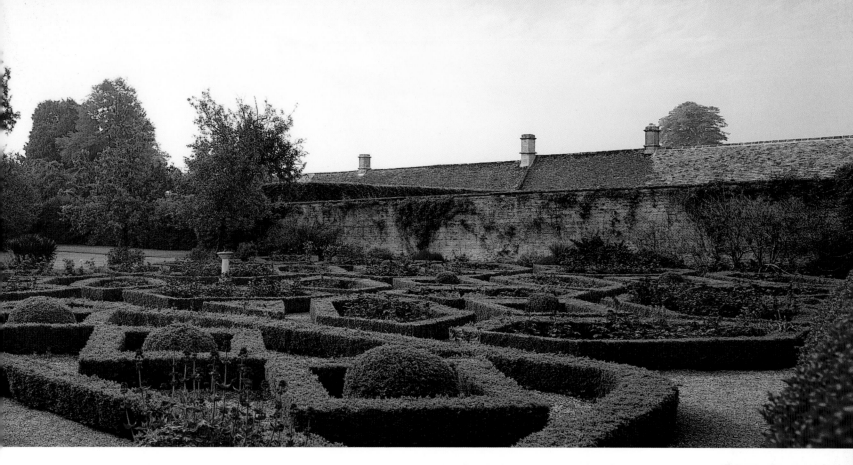

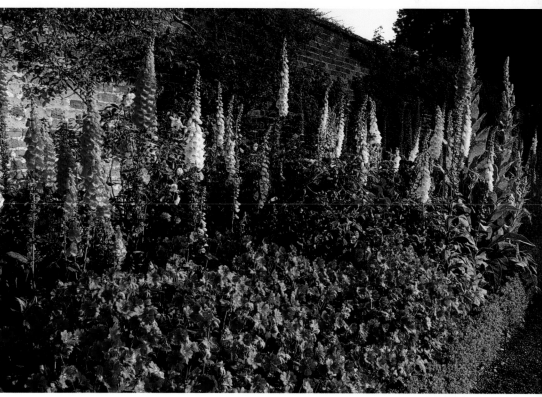

A carved stone plaque on the Pigeon House proves that this building was here long before William Kent came on the scene in the 1730s.

The interior of the walled garden is not just floral but also hugely colourful and abundant. A classic English herbaceous border runs the full length of the wall.

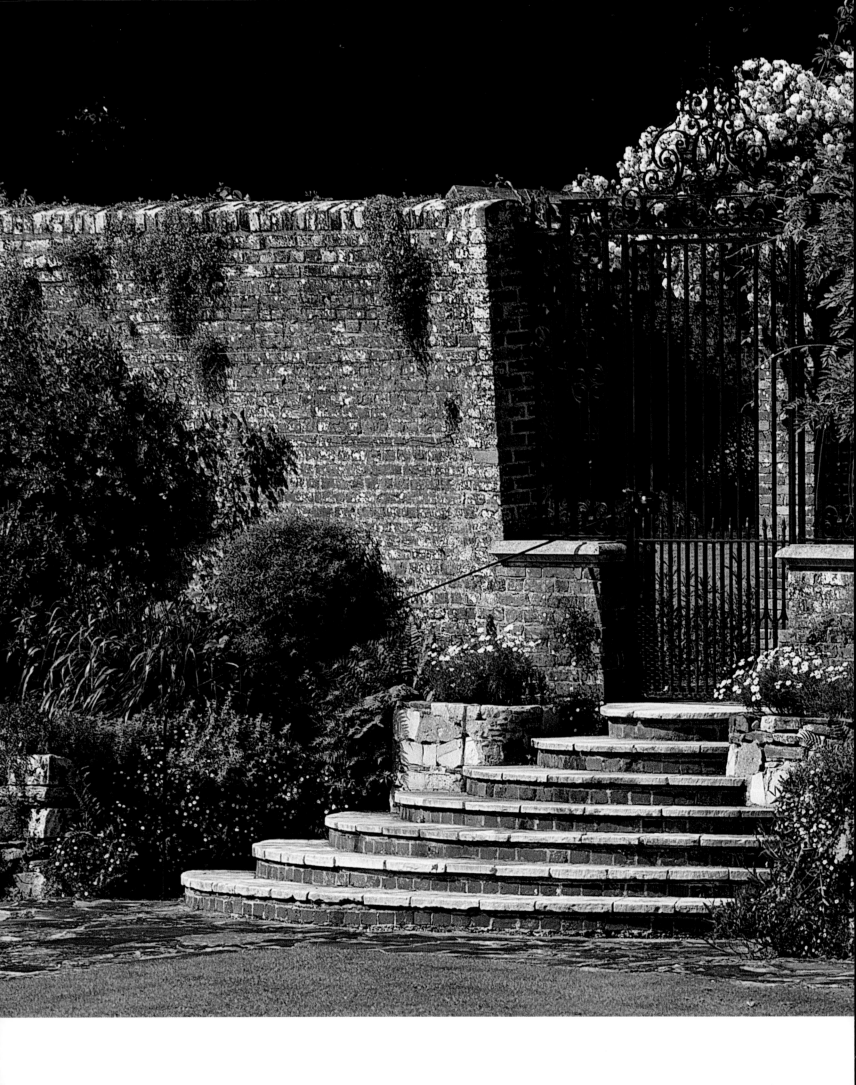

Great Maytham Hall
Kent, England

Great Maytham's walled garden must be one of the most famous in the world, yet it is one of which few people have ever heard. The walled garden – set apart from the large house, which was designed by Sir Edwin Lutyens between 1910 and 1912 – was used as inspiration by Frances Hodgson Burnett (1849–1924) for her book *The Secret Garden* (1911). Born in Manchester, Burnett emigrated to Tennessee in 1865; she returned to England and lived at Great Maytham during the first years of the twentieth century. With her book she created the perfect story for little girls. Mary Lennox, the heroine, lives with her parents in India and is both spoilt and in ill health. An outbreak of cholera persuades her parents to send her back to England, to Misselthwaite Manor, the home of her rich Uncle Dickon.

Dickon, who is rather a colourful character, talks to animals and grows all kinds of plants. But the secret garden that Mary Lennox finds with the help of a friendly robin is untouched, hidden in unruly swathes of ivy. Then Mary 'was standing *inside* the secret garden. … "How still it is!" … "How still!" … "No wonder it is still … I am the first person who has spoken in here in ten years"',

The entrance to Great Maytham's walled garden is typical of Lutyens. Rounded steps diminish in size as they approach the gate, creating a false perspective.

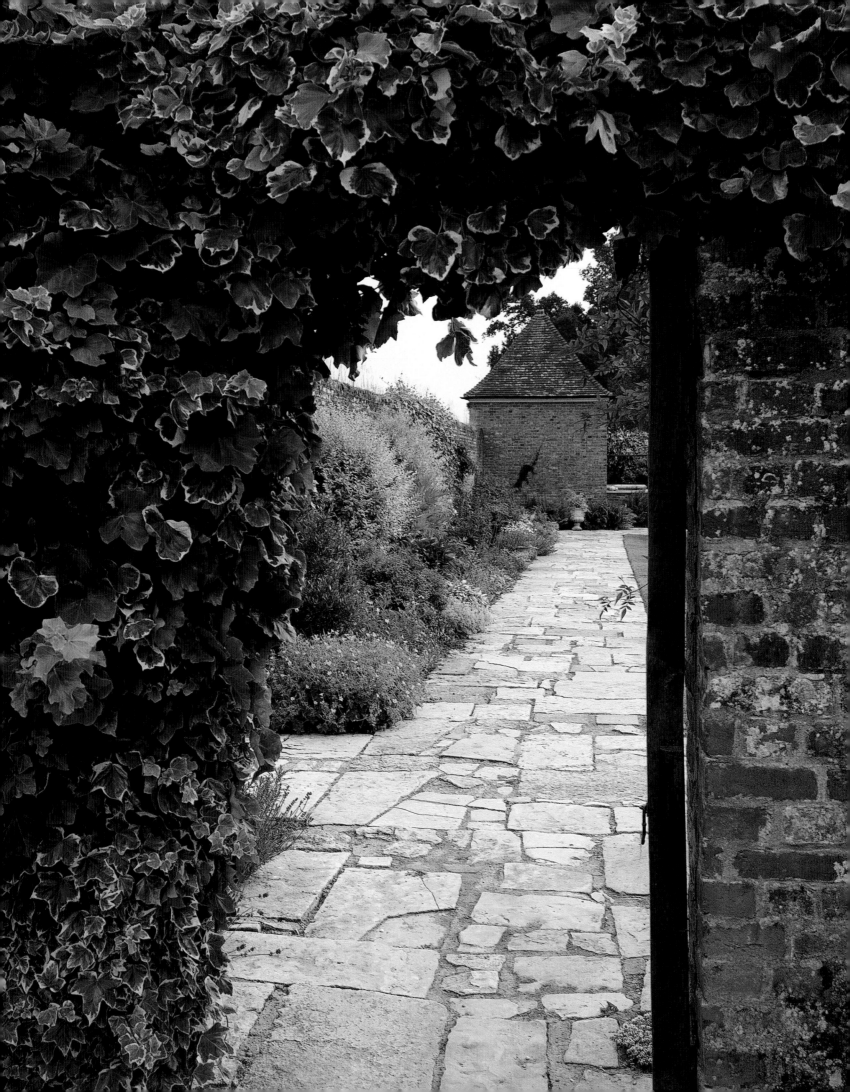

cries the enchanted child, who has found – as all children long to find – a secret domain. 'It was the sweetest, most mysterious-looking place anyone could imagine. The high walls which shut it in were covered with the leafless stems of climbing roses, which were so thick that they were matted together.'

Mary, who discovers the secret garden in winter – very different from India – visits regularly to see the emergence of the first snowdrops. She begins to set it to

rights, digging and weeding to counter the dereliction. She disappears into the garden for long spells, so that 'when its old walls shut her in, no one knew where she was'. It was, she decided, 'some fairy place'.

Great Maytham is an institution now, but can be visited. Its 4 hectares (10 acres) of garden and parkland are in the formal manner of the early twentieth century, certainly designed by Lutyens and probably by his colleague Gertrude Jekyll too. The secret garden has long

since ceased to be either secret or derelict. Frances Hodgson Burnett's tale continues to enthral children, as do derelict walled gardens everywhere. Those I have visited have the same enclosed privacy, secret air and sense of waiting. But while a restored walled garden, the bricks repointed and beds redug, is a fine sight, perhaps a few ancient ones should be left as they are. Every secret garden that is presently derelict should have its Mary Lennox.

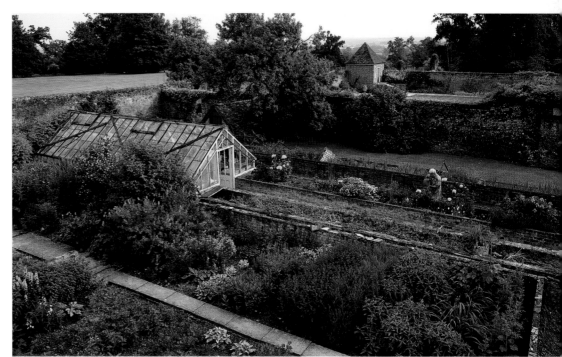

Opposite Its association with Frances Hodgson Burnett's classic children's book *The Secret Garden* has made this the most famous walled garden in the world, but nowadays, tended lovingly, it looks very different from the overgrown hideaway that entranced the story's young heroine, Mary Lennox.

Above This doorway recalls the story of *The Secret Garden*, in which a helpful robin shows Mary a concealed entrance to a realm of delight.

Right, top and bottom The house that Lutyens designed at Great Maytham attracts visitors from all over the world, and its walled garden is now a working one. Like many English walled gardens, it mingles ornamental, unruly flowers and climbers with straight rows of vegetables destined for the kitchen.

THE WALLED
FLOWER GARDEN

Läckö Slott
Lake Vänern, Sweden

Gardening for pleasure must be firmly embedded in the human spirit, considering the efforts expended to create gardens. The ancient Egyptians made oases in the desert to provide relief from the scorching winds, drifting sands and blazing sun. In the far north, Scandinavians battle with frost and snow, biting winds and a very short growing season to create the brief illusion of a summer's day.

At Läckö Slott in Sweden, the conditions could hardly be worse. The enormous seventeenth-century castle is a beautiful, white-painted Baroque palace created by Count Magnus Gabriel de la Gardie between 1655 and 1688. It has large pepper-pot turrets around the remains of earlier buildings that date from the thirteenth century. There are four storeys, of which Count Magnus added the fourth and his father the third.

This enormous white edifice with slate roofs stands on the edge of Lake Vänern, one of the largest landlocked lakes in Europe, a stretch of water so huge that it seems as though one can see the earth's curvature from the centre. If any garden is to survive in this place of extreme weather, it must be walled, and

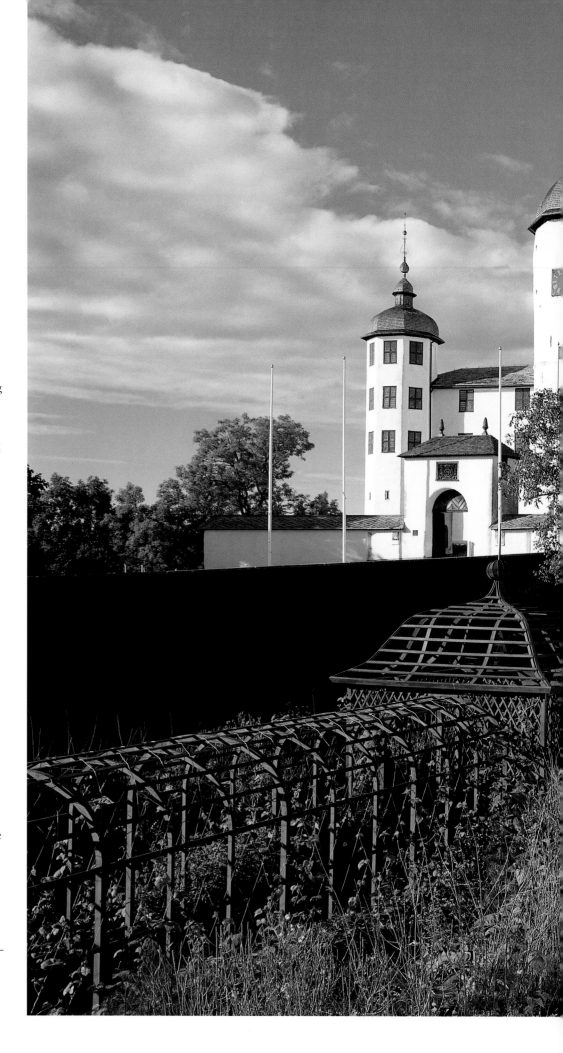

The white Baroque structure of Läckö Slott looks out over Sweden's vast Lake Vänern. Its semi-formal walled garden was created by British garden designer Simon Irvine, and is still nurtured by him.

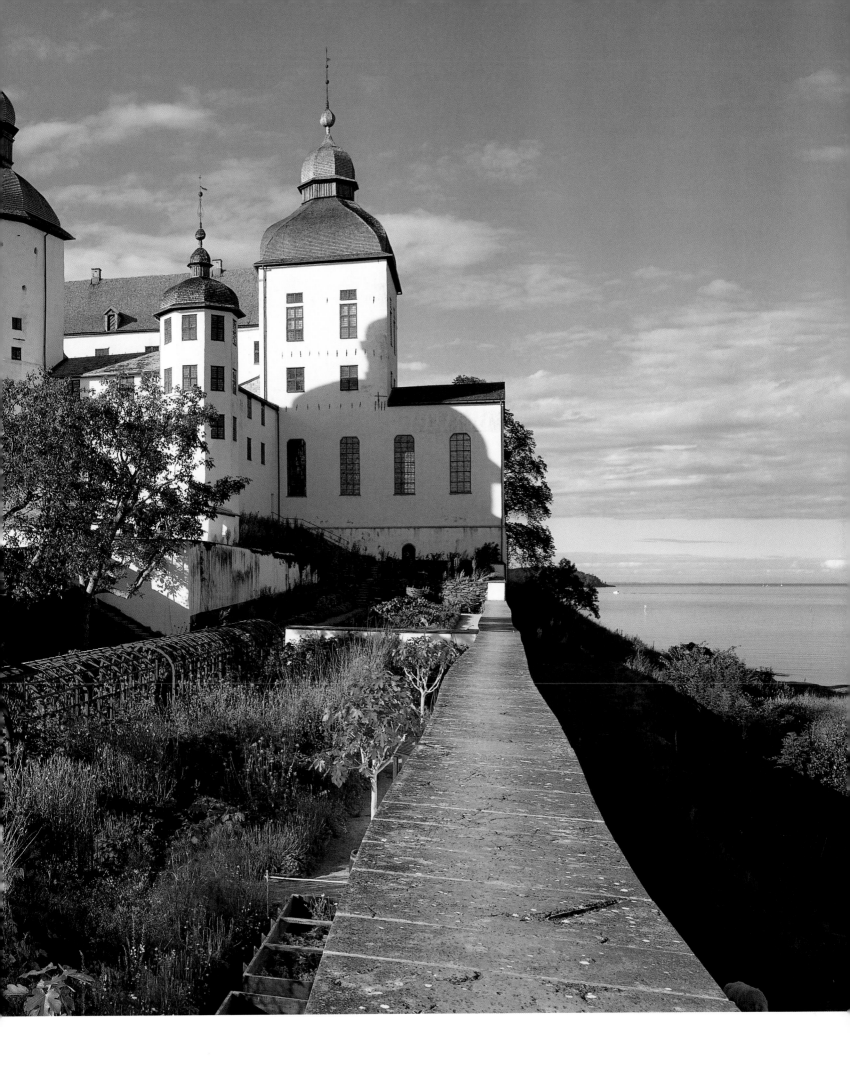

the compact (though not small) walled garden is bounded on the lake side by walls of panelled wood, set horizontally. The other sides are formed by the walls of the castle and its outbuildings.

The garden is semi-formal, with gravelled paths running down beside the beds next to the walls, while in the centre is a long pergola built of wood with a central belvedere. The belvedere's ogee roof, topped with an orb, echoes in miniature those of the castle's turrets.

Läckö Slott's garden is now in the care of the British garden designer Simon Irvine, who has made his home in Sweden. He understands the local climate and replants the garden, almost from scratch, every year. Irvine uses a mixture of annuals, perennials treated as annuals, vegetables and the occasional shrub. Each year the theme is different: when I visited, the garden was planted for scents, though it was also wonderfully colourful. The trellises of the loggia were planted with the runner bean *Phaseolus coccineus* 'White Emergo', and other vegetables, such as artichokes and broccoli, appeared among sweet peas, large cotton thistles, cornflowers and bergamot. Large areas of white nicotiana added their heavy scent and, along with planted iron obelisks, sunflowers gave extra height.

There was absolutely no feeling that the garden was immature. Indeed, this northern garden was lush and overflowing with foliage and flowers, planting that was typically British within the formal framework of the paths and loggia. Simon Irvine has brought to Läckö Slott's walled garden an informality that is perfectly in

keeping with the French-inspired surroundings so typical of Sweden.

My visit was in late August, when the growing season was almost over. As the season does not begin there until May (if then), it is amazing that the plants ever reach maturity, but the long hours of daylight make up for the summer's short duration. In June the sun rarely sets, giving the plants a chance to catch up.

Opposite, top Irvine renews the garden at Läckö every year, and most of the plants are annuals. Each year he chooses a theme, such as colour, scent or vegetables. Annuals are used to take advantage of the extremely short season, which runs from May until September, during which month frosts are possible. The long hours of daylight in summer yield phenomenal growth.

Opposite, bottom This walled garden produces a microclimate that is necessary for its survival. It faces the expanse of Lake Vänern, which is really a landlocked sea with its own temperamental weather.

Like many of the houses in this land of forests, the walled garden at Läckö has wooden walls. Irvine uses these to help tall plants and climbers resist the harsh winds that are common in the area.

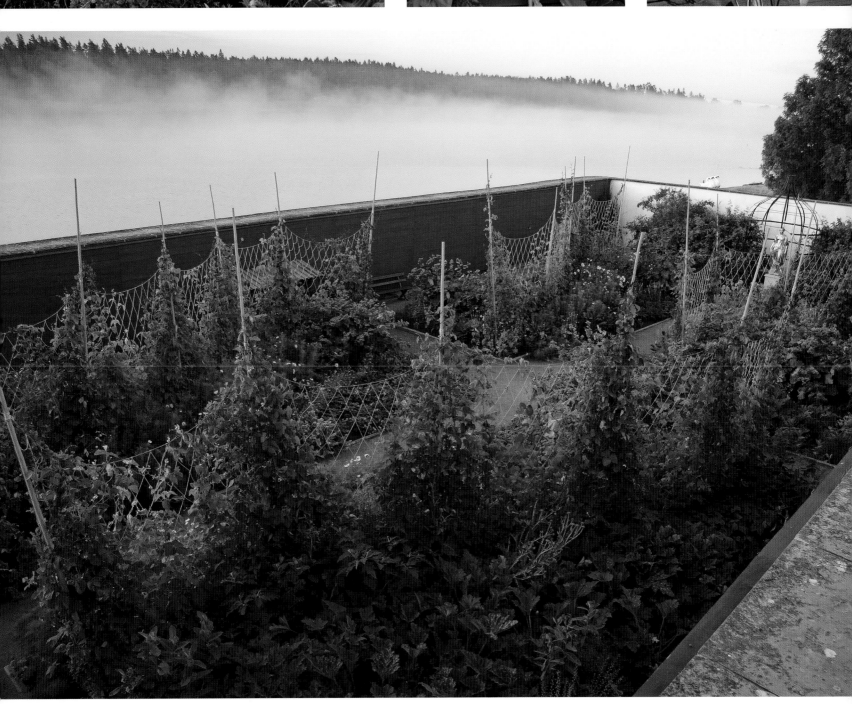

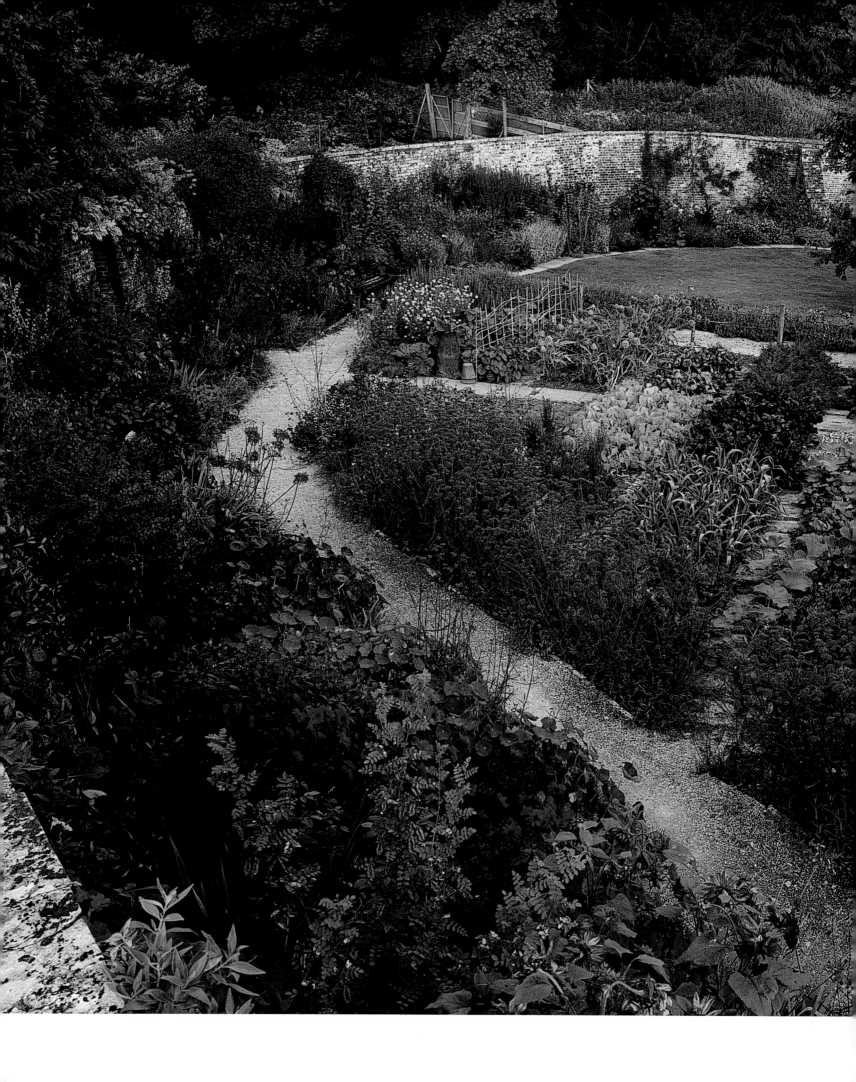

THE WALLED
FLOWER GARDEN

Hadspen
Somerset, England

The grounds of Hadspen in Somerset
contain two walled gardens: a rectangular
kitchen garden with a central lily pond,
and an extraordinary semicircular area
bounded by a brick wall. As the former
occupants, Nori and Sandra Pope, explain
in *Colour by Design* (1991), the second is
a feat of engineering: 'Sited on a south-
facing slope, the wall curves down the
slope to allow for air drainage and thus
creates a microclimate within it, while the
strength of its shape ensures its stability –
and it was all devised by a local builder
several hundred years ago.'

On this unparalleled site the Popes,
both from Vancouver Island in Canada,
created a garden that manages the
difficult feat of being both traditional
in outlook and utterly modern in effect.
This is a walled flower garden for the
twenty-first century (though, sadly, the
Popes have now left and the garden is
being redesigned).

The design is based on colour: not
the Gertrude Jekyll style of mixing and
complementing, but using blocks of
each colour of the rainbow, one merging
seamlessly into the next. 'A passion for
colour at its finest, combined with

The walled gardens at Hadspen were justly famous
for their floral planting. The great curved wall with
its warm-toned bricks provided the inspiration for
the colour schemes.

excitement about the effect it has on perception and emotion, have become the basis for our design at Hadspen', say the Popes. Their book considers the colour of plants with the same clear eye. The stalks of ruby chard are compared with the emerald striations of malachite; nectaroscordum flower heads with mother-of-pearl; and *Cerinthe major* 'Purpurascens' with bluesy jazz.

However, in order to control what would otherwise be a riot of colour, too much for the human eye, the Popes put the blue notes into the walled kitchen garden, leaving the D-shaped curved wall for the yellows, oranges, reds, plums and near-black plants. This wall is 750 metres (2460 feet) long, reaching from the hottest and driest area to shady damp spots. The Popes explain: 'The functional layout of

the walls has had little to do with any aesthetic contrivance; there is no diminishing perspective, no alignment, whether of doorways or of water-filled reflective rills. But all pictures have a frame and ours is provided by the many hues of the crumbling brick walls – pale buff terracotta in some areas to over-fired, almost iridescent plum in others … . [In] 1987, the plum-toned bricks … told us where to begin. We knew where the plum border would start.'

To be dictated by the colour of the walls themselves is not a bad idea for a walled garden; and plum is a very juicy colour for the plantsman. This area includes poppies, roses and pinks, along with the dark-red leaves of 'Bull's Blood' beetroot and 'Dark Opal' basil. Pink roses, such as *Rosa* 'Felicia' and

R. 'Zéphirine Drouhin', clamber up the walls, with geraniums, phlox and aquilegia in front of them.

Peach also has its own roses, for example 'Alchemist', complemented by hollyhocks, poppies and lupins, breaking up the area before orange is introduced. This strident colour is anathema to many gardeners, but the Popes take the opposite view: it is a shade 'with which to celebrate and exult'. *Rosa* 'Westerland', dahlias, crown imperial lilies and Welsh poppies feature in these beds before giving way to yellow, generally of the lemon shades rather than the less pleasant, egg-coloured flowers. Euphorbias, achilleas, tulips and more crown imperials are used here. This is a walled garden to inspire the plantsman to greater things.

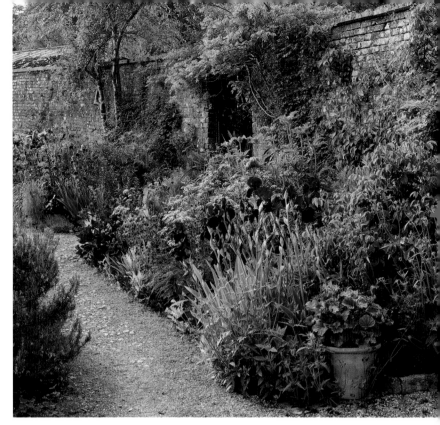

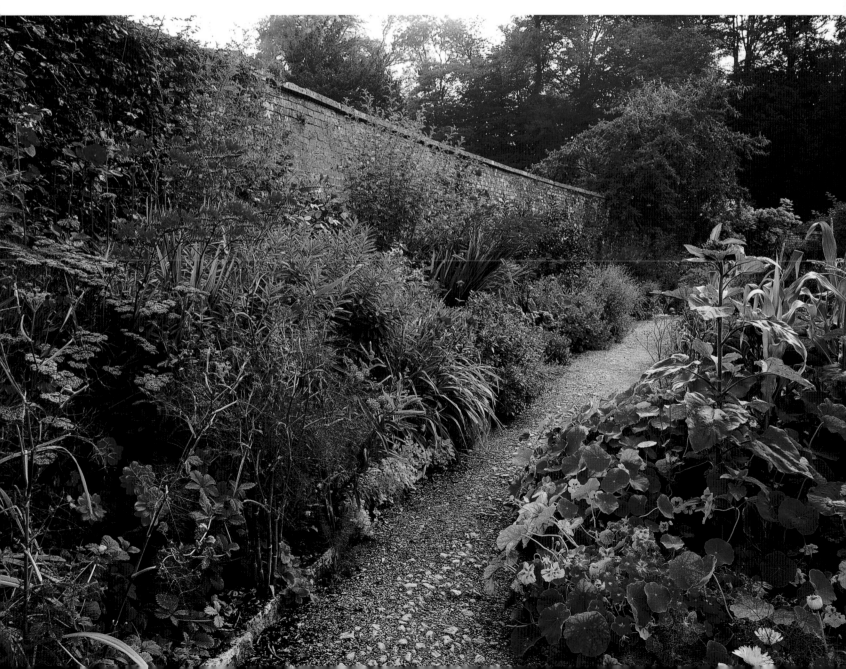

Broughton Grange
Oxfordshire, England

The walled garden at Broughton Grange is a rare animal: it is a completely new version, designed and created in 2001. Even the walls are new, designed by the Neo-classical architect Ptolemy Dean and made of a mixture of Hornton stone and red brick in alternating heavy stripes. They were made by expert craftsmen using traditional methods, money being no object in this multi-million-pound project.

A notable feature is that this walled garden is entirely separate from the house and gardens to which it belongs. The owners cannot see their project from the house, but instead must cross the driveway and enter through a forbidding oak door. Inside, the main surprise – apart from the lavish planting – is that this apparently impenetrable enclosure is actually walled on only two sides, those nearest the house. The terraced garden falls downhill from the walls towards the magnificent rolling countryside.

The design and planting were done by Tom Stuart-Smith, winner of numerous gold medals for his show gardens at the Chelsea Flower Show. 'The garden is unusual in that it is completely disconnected from the house and relates

The walled garden at Broughton Grange was designed and planted by Tom Stuart-Smith. This exuberant display was completed only in 2001.

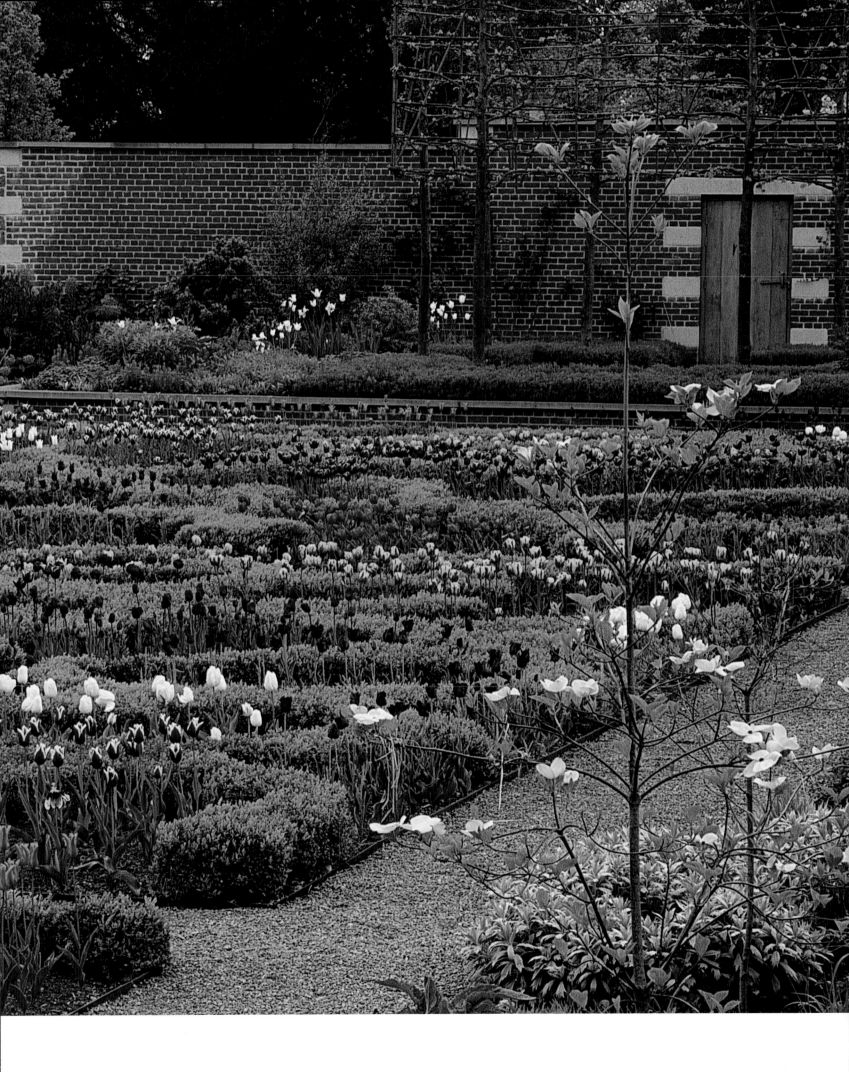

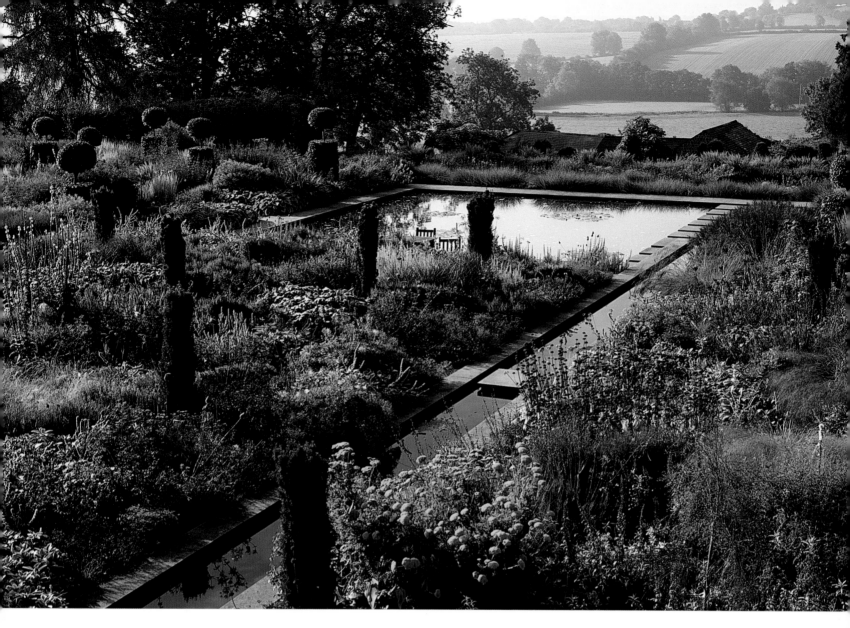
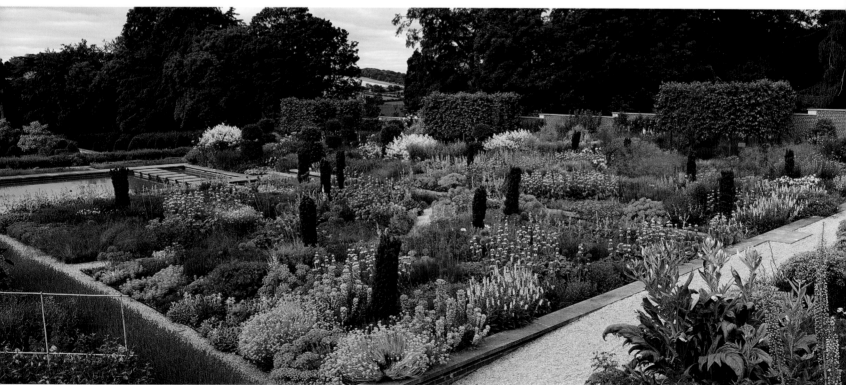

Opposite, top Broughton Grange appears to be a walled garden, but it is in fact closed on only two sides. The rolling Oxfordshire countryside is brought into play at one end.

Opposite, bottom The planting, which is in large, flat beds, may appear uncontrolled to the untutored eye, but the sizeable area it covers is given formality by a series of paths, rills, ponds and waterfalls.

As is traditional, the walled garden is entirely separate from the house. The layout also follows custom in that the large, ornamental, lean-to greenhouses are sited against the containing wall.

to the landscape rather than the architecture. It's a pure pleasure garden, a separate place to go', he says. At Broughton, as at Chelsea, his style skilfully mixes the classical with modern swathes of perennials and grass plantings. However, the structure of this garden is strong enough to make it as elegant in winter, when the planting is minimal, as in summer.

The top terrace, at the entrance, has a fine greenhouse against its wall with a vista of the countryside in the distance, but you are encouraged to turn right immediately once through the gate, where a series of formal lawns leads enticingly down to a yew avenue. The slope of the land has been skilfully exploited, not only with the planting, which changes with each terrace, but also in the use of water. A series of flat rills bordered by York stone progresses in a string of controlled waterfalls. At the garden's centre sits a large rectangular pool surrounded by a flagged terrace, and at the bottom of the garden is a rectangular swimming pool disguised from above by an area of formal evergreen topiary.

Higher up, and in complete contrast, is a loosely planted abstract parterre. The key plants, in complex arrangements, include evergreen spires of veronicastrum, miscanthus clumps along with panicum (a tuft-forming annual grass), *Persicaria polymorpha* plumes, the tall native verbascum, and another native, *Dianthus carthusianorum*. It can be seen from this that Stuart-Smith is an admirer of Piet Oudolf's work, but this garden is very different from Oudolf's at Scampston Hall in North Yorkshire (pp. 150–53). Broughton is a massive walled garden for the new century, totalling 420 square metres (4520 square feet). It combines all the features of the eighteenth- and nineteenth-century gardens – a greenhouse, high walls, formal paths and ponds, along with flowers and topiary – but at the same time manages to be completely modern in feeling. This garden, I believe, sets a pattern for the future.

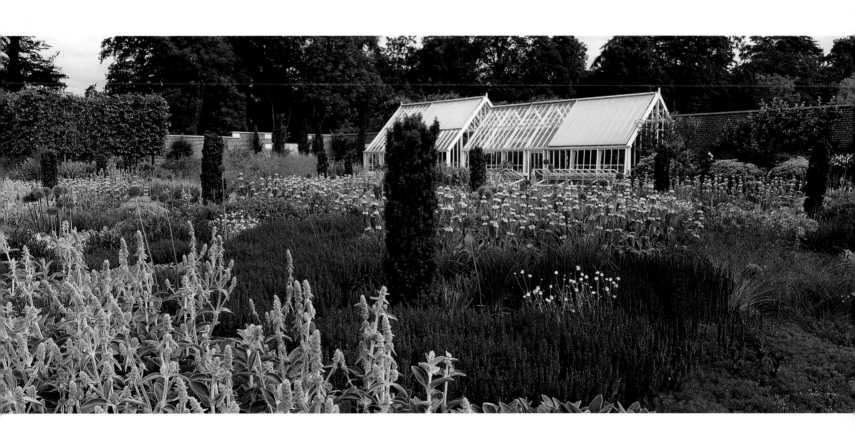

THE WALLED VEGETABLE GARDEN

As a great lover of food I find vegetable gardens magically appetizing. The serenity of the ordered rows of fruit and vegetables, the daily check to find what is at its peak and ready to eat, the sensation not only of absolute freshness but also of the earth – my plot of earth – working, as it should, to provide food for us, our friends and our dog: this is what I mean by magic. Our own walled vegetable garden was created from nothing in the late 1990s (see pp. 102–105).

I am delighted to see that this sense of peace and proprietorship is also felt by others. Lord Carrington (former Foreign Secretary, an ex-soldier and a fine gardener) said that he loved his walled vegetable garden because of its regimented discipline, a feeling all vegetable growers have. The French writer Colette remembered her childhood vegetable garden, its walls topped by flat tiles, where neighbours were always friendly and the children never fought. Probably because the French take their vegetables seriously and have a disciplined attitude to gardening, France's walled vegetable gardens are a permanent inspiration to gardeners in the rest of the world.

I love, for example, Limésy, a garden in Normandy designed by Pascal Cribier, where the vegetables, herbs and flowers are laid out in 2-metre (6½-foot) squares, each square having only a single plant, fiercely controlled. These might include chives, coloured lettuces, cabbages and potatoes, along with zinnias, irises and scarlet-flowered salvia. A variation on this, described by the writer Michèle Lamontagne, is to divide each square into two triangles and plant these with separate vegetables, while at Vézelay the chef Marc Meneau has used square beds in two rows with the squares opposite one another holding exactly the same plants. These ideas

At Vézelay, Yonne, France, vegetables are planted as though they were flowers. Tall herbs are set against architectural artichokes and steely cabbages.

turn the vegetable garden from a mere source of produce into as formal a plot as anything seen at Versailles. The epitome of this French style is the garden of the Château de Villandry (pp. 94–97).

Since the late 1990s, most gardeners have begun to appreciate the intrinsic beauty of vegetables, which are increasingly being planted in borders alongside flowers. The walled vegetable garden can be diffused in this way, but my own preference is to grow flowers in the vegetable garden in the same way as the vegetables: in rows or as borders. The exception is climbing roses, which contrast blowsiness and scent with the discipline. Otherwise I like to use annuals for formality: lots of differently coloured nasturtiums (with edible flowers and leaves) border the lines of cabbages; my chives flower in a beautiful row of dark-lilac pompoms; and I grow sweet peas for their scent.

Artichokes are a perennial delight, with their grey, deeply cut leaves visible all year. In his own garden David Hicks put artichokes in plastic pots and sank them into blocks of topiary hawthorn, where the contrast in colour and leaf style is empha-

sized. Sir Terence Conran, in a garden for the Chelsea Flower Show, planted great squares of chives, black Tuscan cabbage (*cavolo nero*, another showy edible) and red chard, the leaf stems of which are more brilliant than a dahlia's petals.

The French again lead the field in creating beautiful vegetables, with seed catalogues of more than ninety different beans (red-podded, red- and white-flowered, and purple-leaved and podded), squashes and pumpkins both edible and ornamental, lettuces of red stripes and brown with floppy leaves, along with red-veined sorrel and red-leaved dandelion. Philippe Ferret showed the readers of the magazine *L'Ami des Jardins* how these plants can be used decoratively in walled gardens. Climbing beans were made into tall obelisk shapes, dark-red lettuces contrasted with yellow marigolds, and the canes used to support beans, tomatoes and other climbing vegetables were painted in colours to complement the plants.

Walled vegetable gardens created in the sixteenth and seventeenth centuries might be anything from 0.4 hectare (1 acre) to

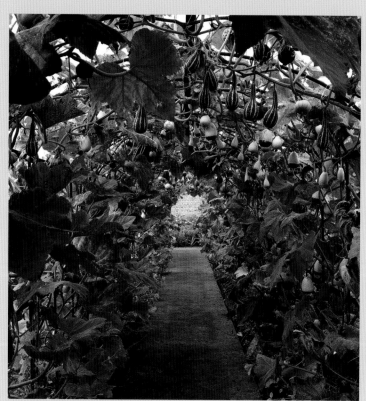

Above A permanent iron structure introduces height at Helmingham Hall in Suffolk. The gourd tunnel is planted with ornamental gourds that hang below the frame while their stems climb it.

Left The trick with vegetable gardens is to give them both height and structure. At Columbine Hall in Suffolk open obelisks provide support for old-fashioned annual sweet peas.

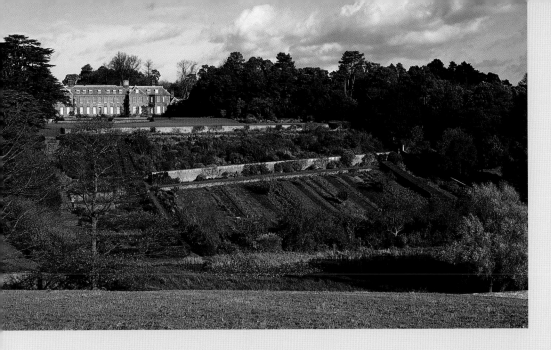

At Upton House in Warwickshire the walled vegetable garden occupies a steep slope running down to the River Severn, so it is not seen from the house.

In Sweden, gardeners take advantage of the long summer days by growing annual vegetables from scratch. A walled garden like this one at Läckö Slott in the west of the country will have a life of no more than five months during the growing season (pp. 74–77).

the huge area of 4 hectares (10 acres). The secret in planning such a formidable and controlled space is to divide it up. Areas can be given to wide grass paths, chessboard squares of beds, sunken ponds and fountains, raised terraces, and, best of all, tall divisions made of espaliered fruit trees, tunnels of climbing gourds (Helmingham Hall in Suffolk has a splendid example) or trellises holding old-fashioned roses, sweet peas or other climbers. Wrought iron can also be used for pergolas or dividers; painted black it will virtually disappear, leaving the climbing plants to add a touch of irregularity in a disciplined space.

The Italian garden designer Arabella Lennox-Boyd created at Fort Belvedere in Windsor Forest, Berkshire, a walled parterre that exerts strong control over the generous space. A central fountain in an octagonal lead tub is bordered with disciplined herbs of grey and green, while ogee-arch bowers are interspersed with beds of vegetables edged with box. Ornamental bay trees (their leaves edible, of course) in tubs increase the formality, as does a walk walled with trellis. At intervals in the trellis, green topiary arches lead back into the main vegetable area.

At Upton House in Warwickshire space is taken up with a river: a sloping vegetable garden, with a high wall at one side, meanders down towards a wide stretch of water, beyond which is a further wall. This is not the sort of idea you can easily copy, but it shows that a river can be incorporated into the plan. A vegetable garden in Connecticut uses another natural feature – living rock – for the walls: designer Nancy McCabe has carved a small plot of great formality into a landscape wild with rock formations and dense forest.

Formal walled vegetable gardens can be made in the most surprising places. The owners of ancient Scottish castles set in moorland might wall off a promisingly sunny area a good walk from the house to give vegetables a chance over a short season. Swedish *slotts* (castles) in the most inhospitable areas have gardens walled with wood – there is plenty of it around – and grow annual vegetables in the long light days between May and September, only expecting a crop in July and August. Vegetables grow in the shade of olive trees in Italy and Spain, and in the countries surrounding the Mediterranean every tiny plot of land is walled and watered. In the United States the cult of regional cuisine, pioneered by Alice Waters of Chez Panisse in California, means that those who cannot get to the San Francisco farmers' market now adapt parts of the garden to grow heritage vegetables; there is lively competition among seed merchants, as there is in England and France. The walled vegetable garden has taken some time to make a recovery, but everything is now moving in its favour.

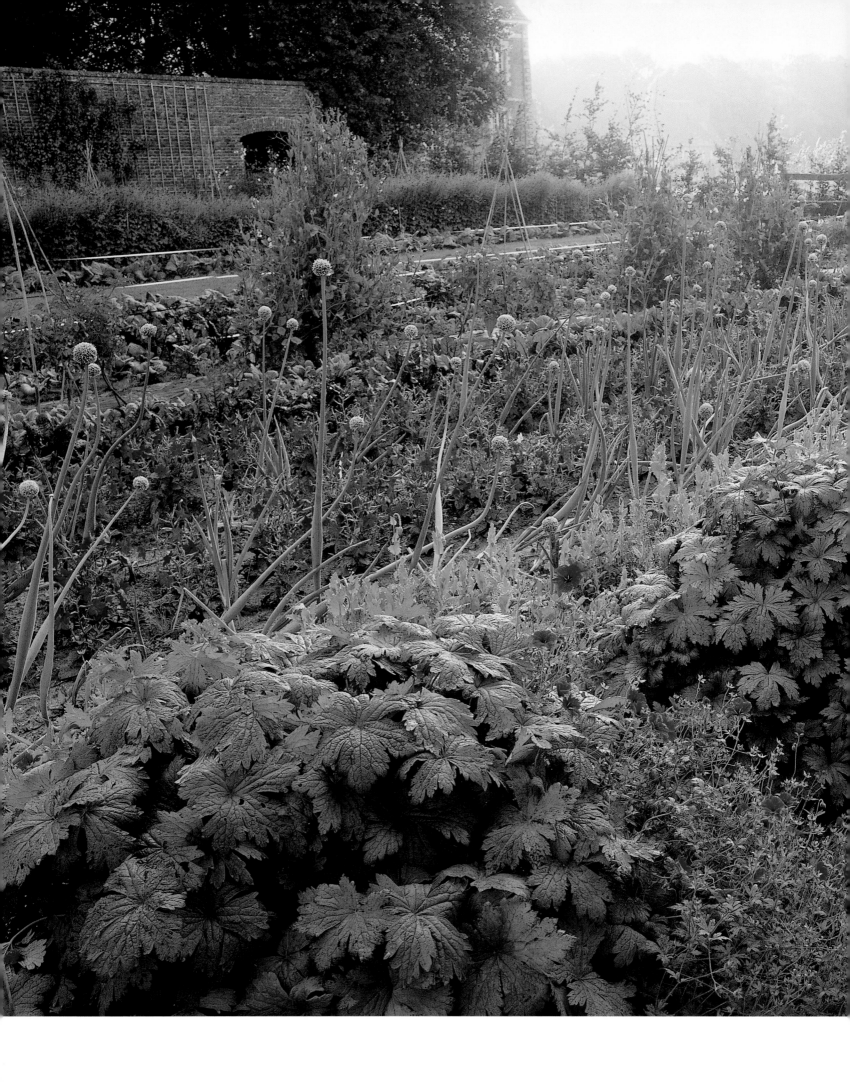

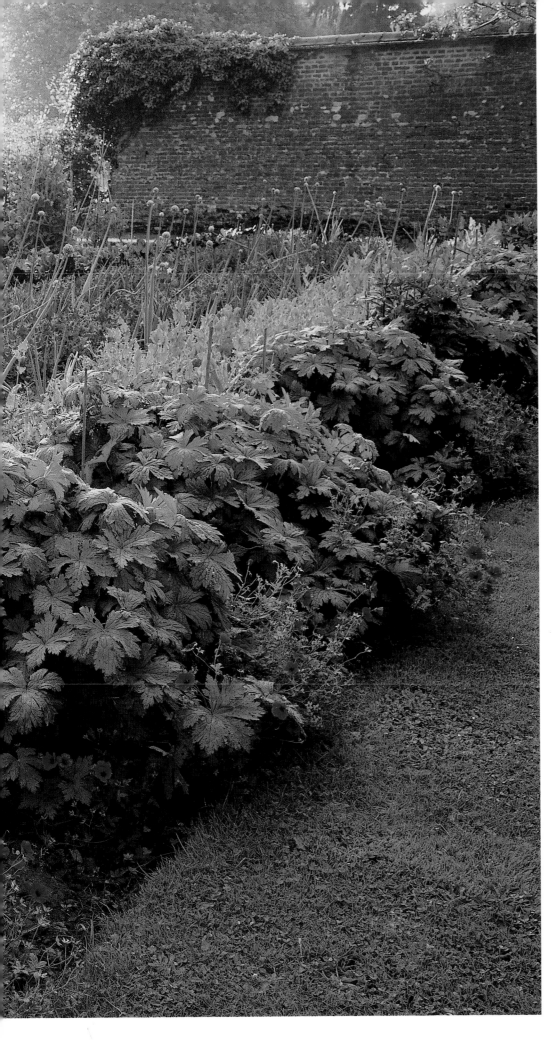

Château de Bosmelet
Normandy, France

My introduction to the gardens of Château de Bosmelet in Normandy was through the Chelsea Flower Show. In 2000 the castle's owners, Robert and Laurence de Bosmelet, teamed with the late garden designer Ryl Nowell to create Cabbages and Kings, a show garden inspired by the chateau.

Having seen that, I had to visit the real thing, which turned out to be a large garden of 1 hectare (2½ acres) surrounded by eighteenth-century brick walls. (Compare this with the similarly sized garden at Villa Gamberaia [pp. 42–45], where there are parterres, a wood, a bowling green and lemon houses.) At the centre is a circular pond that divides the space. On one side is a flower garden, but the real star is the Rainbow Kitchen Garden, where – in the French style – vegetables as decorative elements are treated with the same reverence as flowers. Laurence de Bosmelet's inspiration came from the colours of the chateau itself: the blue-grey roof slates, the sandy mortar between the rosy bricks, and the white of the stone quoins.

The garden is divided into four large rectangles, each 23 metres (75½ feet) long, edged with a small box hedge, and further

Each of the four main beds displays plants of a single colour, each colour having been chosen to complement those of the chateau. The Garnet bed takes its cue from the rosy-red bricks of the building.

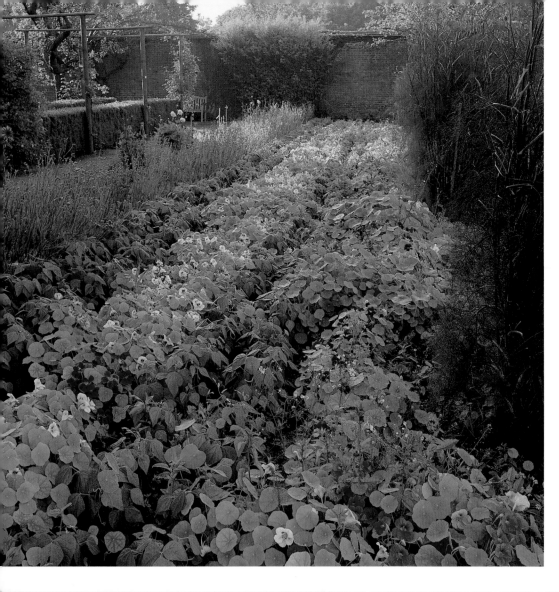

Left In the Rainbow Kitchen Garden vegetables are treated with the same thought as flowers. Laurence de Bosmelet pores over the catalogues to find just the right habits and colours.

Below In the floral section of the garden the planting is more diffuse and less disciplined, but care is taken to make this a vibrant area with typical French planting of bright dahlias and alliums.

Bottom The garden was virtually derelict until Laurence de Bosmelet decided to rework it as a colour-themed garden, allocating half to flowers and the other half to large vegetable beds.

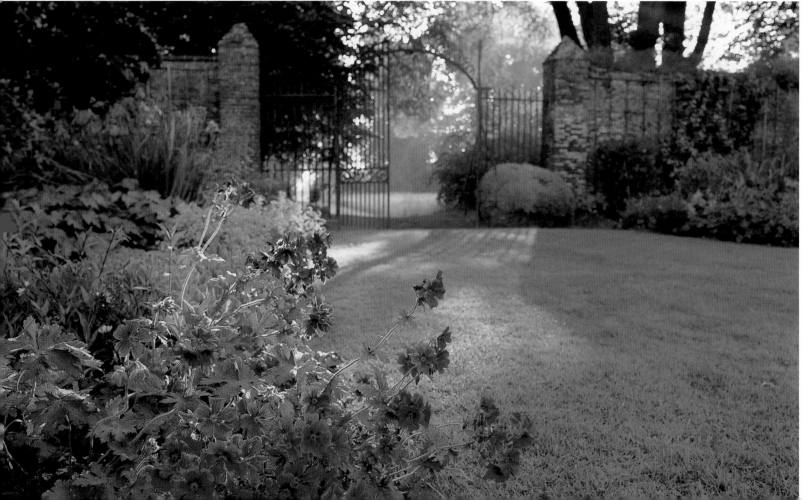

This bed will be Amber when the vegetables have matured. It includes carrots, bronze fennel, striking orange dahlias and edgings of orange nasturtiums.

Garnet is filled with ruby chard, red cabbages, plenty of tomatoes chosen for their colour (ranging from yellow to almost black) and decorative cactus dahlias.

divided with paths so that the vegetables can be tended and picked. Each of the four spaces is named after a colour – Ivory, Garnet, Amber and Sapphire – and the vegetables are chosen accordingly. In Sapphire, for example, there are eight different kinds of cabbage (hence the title of the Chelsea garden), including white with purple veins or blue-green hearts, dark Milan cabbages and the mauve Verona variety. Cauliflowers and broccoli

are purple, as are the climbing beans, which include 'Purple Queen'. The blue leek 'Bleu de Solaise' is used as an upright edging. Sapphire also has purple sage, blue catmint, cornflowers and such shrubs as lavender and rosemary.

Amber, in contrast, has flaming-orange dahlias among carrots, bronze fennel and gourds, with nasturtiums as edging. Ivory, of course, is white, with Chinese cabbages and a white tomato, 'Mirabelle Blanche', along with white radishes and Osaka white kale. Flowers include white sweet peas and poppies. Garnet has strawberries, red-hearted cabbages, carmine cornflowers and chocolate cosmos with decorative cactus dahlias. There is a riot of tomatoes, too, including 'Giant Spencer Scarlet'. These last two beds, like their counterparts Sapphire and Amber, are planted symmetrically so that they match in all but colour.

As this is a French garden, most of the vegetables also pull their weight on the dining table and, indeed, the Bosmelets' table often has a large charger of differently coloured tomatoes picked from the garden, partly for Laurence to study, partly for a salad. These range from the dull brown of 'Noir de Crimée' to scarlet, yellow, white and even striped.

Remarkably, Laurence designed the garden without horticultural training. Robert says: 'She knew nothing about gardening when she came from Paris. The garden can be appreciated in different ways: poetic contemplation beneath the ever-changing light so dear to the Impressionists; nostalgia at rediscovering the tastes and smells of childhood; and serenity inspired by the balance of its well-ordered spaces.'

THE WALLED
VEGETABLE GARDEN

Château de Villandry
Indre-et-Loire, France

Villandry, in the Loire Valley, has what must be the most famous vegetable garden in the world: not because it is typical of this form but because it is one where vegetables are a strictly formal element. Indeed, here they are a metaphor. 'While the potager still forms a major part of the display, admired from all angles,' writes Louisa Jones in *Kitchen Gardens of France* (1997), 'it nonetheless occupies the lowest level of a garden constructed around a symbolic movement upwards from earthy appetite to parterres representing courtly love, and thence to the topmost green and water garden, dedicated to the spirit or soul.'

These gardens, directly inspired by Renaissance gardens that employed such symbolism, are in fact a twentieth-century creation by the owner, Dr Joachim Carvallo. A Spanish scientist who worked in Paris with the Nobel Prize-winner Dr Charles Richet, Carvallo bought Villandry in 1906 with the money of his rich American wife, Ann Coleman. During his research into the plans of medieval gardens in various French Benedictine abbeys, he was reconverted to Catholicism by the monks, and his

In 1906 Villandry was bought by a Spanish scientist who visited French monasteries to research the planting of medieval gardens. The world-famous potager is the realization of his studies.

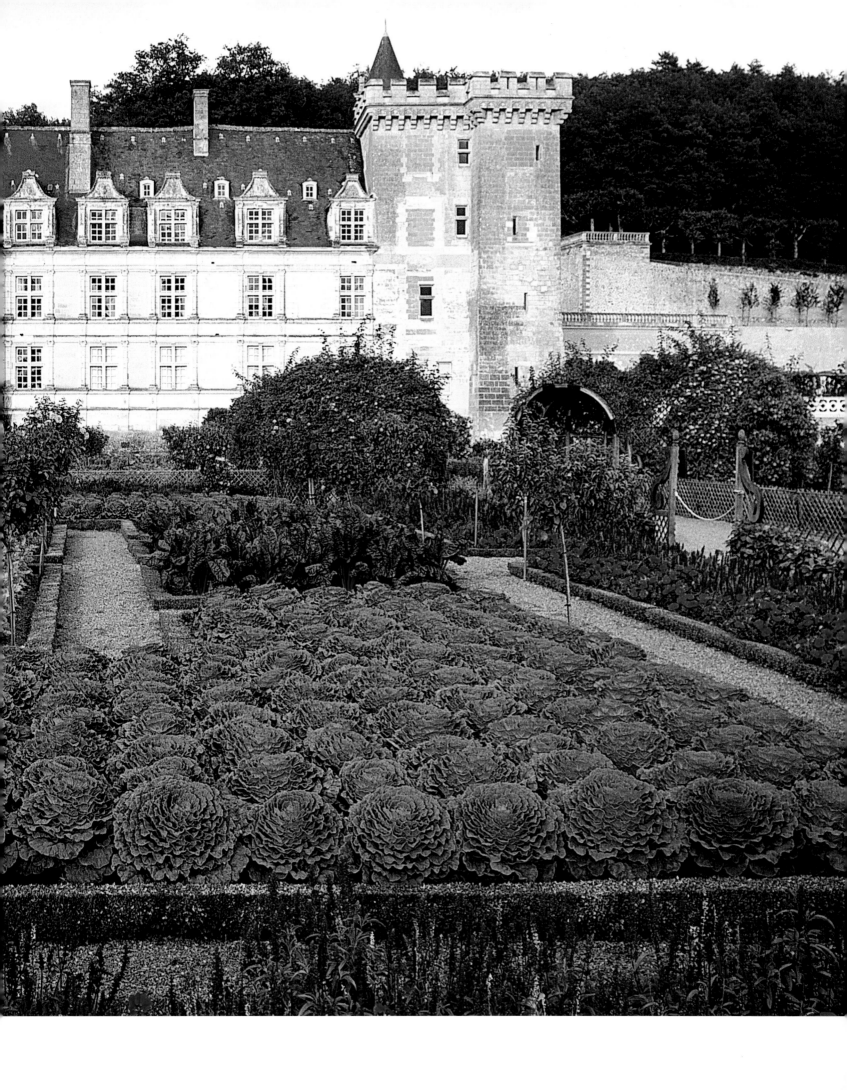

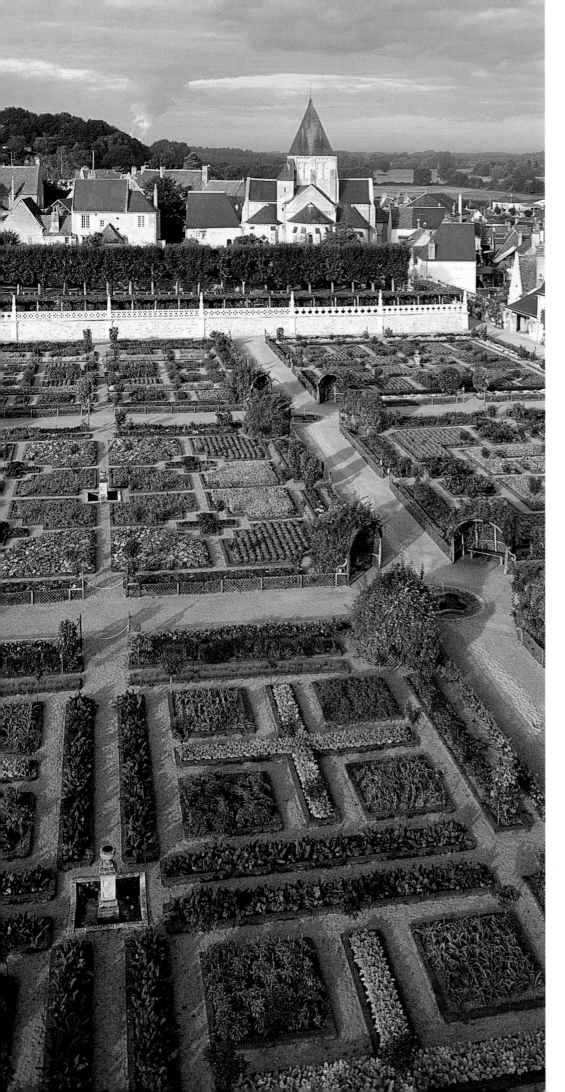

renewed faith was poured into his design. He is also known to have visited the Château Dauphin in the Auvergne, where the vegetable garden is sunken and surrounded by basalt walls. Dauphin's gardens are genuinely medieval, its terraces falling away from the castle itself. However, the symbolism of the planting at Villandry and the relegation of vegetables to the lowest level was ineffective: Carvallo grew to like the potager best and today it is the garden's most popular feature.

Left The gardens at Villandry were directly inspired by Renaissance gardens in that every area has a symbolic meaning. A strict discipline is also applied to the potager, where each bed is planted with a single variety of vegetable.

Above The former owner of Villandry, Dr Joachim Carvallo, is seen in the process of creating his garden in the early twentieth century.

Opposite, left The formality of the gardens was designed to echo that of the chateau, while the strong colours were selected to contrast with its pale stone.

Opposite, right In keeping with the complexities of its layout and planting, the walls of the potager were constructed of local stone and embellished with Baroque balustrades and finials.

David Hicks said that the design of Villandry 'has had an enormous influence on my work … . I find each visit to Villandry more exciting than the last. For me this is one of the seven wonders of the world.' He noted that the vegetable area is in complete contrast with the rest of the garden. 'The beautiful reconstructed sixteenth-century vegetable and flower garden, like something from the *Très Riches Heures du Duc de Berry* … can give ideas for large, medium and small gardens.' His design for the disused walled kitchen garden at Harewood House in North Yorkshire was inspired by Villandry's.

Though the vegetable garden (surrounded by retaining walls) is a huge space, one can understand what he means, for the space is divided, subdivided and divided yet again. One large rectangular bed may be split into sixteen sections, each planted with a different vegetable. These vary in colour and texture but they are kept utterly disciplined, virtually as bedding plants. The smaller divisions are separated with narrow beds shaped like crosses or zigzags, or straight hedges that may be regimented chives edged with box. Each bed is different. Height is added with taller or climbing plants, and with decorative latticed railings painted a soft blue-green. Standard rose bushes, a feature in medieval gardens, are also used.

Dr Carvallo died in 1936 and the gardens fell into disrepair as a result of both World War II and French property laws. But today, restored under the ownership of his great-grandson, they are the most visited in France, and a World Heritage Site.

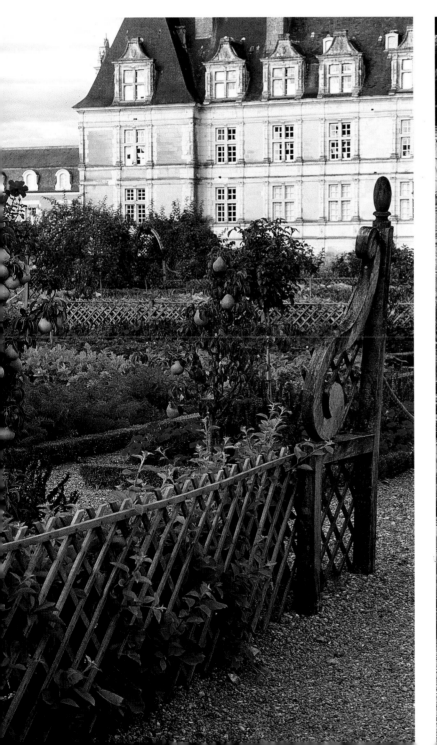

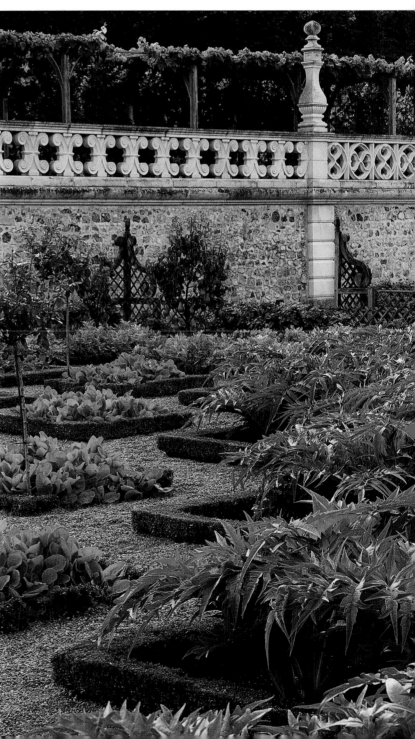

THE WALLED VEGETABLE GARDEN

Glin Castle
County Limerick, Ireland

The FitzGerald family has owned and lived in Glin Castle in County Limerick, Ireland, for more than seven hundred years. The 200-hectare (500-acre) demesne on the Shannon estuary has been farmed by them since the 1220s. They built the walled vegetable garden in the early nineteenth century and saw it fall into decline in the twentieth; now, restored to its former glory, it is flourishing in the twenty-first.

This is thanks to the 29th Knight of Glin (the present head of the family, Desmond FitzGerald) and his wife, Olda, who is known as Madam FitzGerald. While FitzGerald's mother and grandmother were both keen gardeners, they ignored the then unfashionable plot of 0.8 hectares (2 acres) within the stone walls. But when Desmond and Olda moved into the gothicized 'sugar-icing' castle in 1975, the walled garden was in their sights. Madam FitzGerald could see the area filled with vegetables and flowers that could be used within the castle, now an upmarket hotel, and her husband saw the chance to indulge his hobby of creating follies.

Glin Castle's large walled garden, like so many others, declined into dereliction in the twentieth century. It was revived by the present Knight of Glin, Desmond FitzGerald, and his wife, Olda, both gardeners.

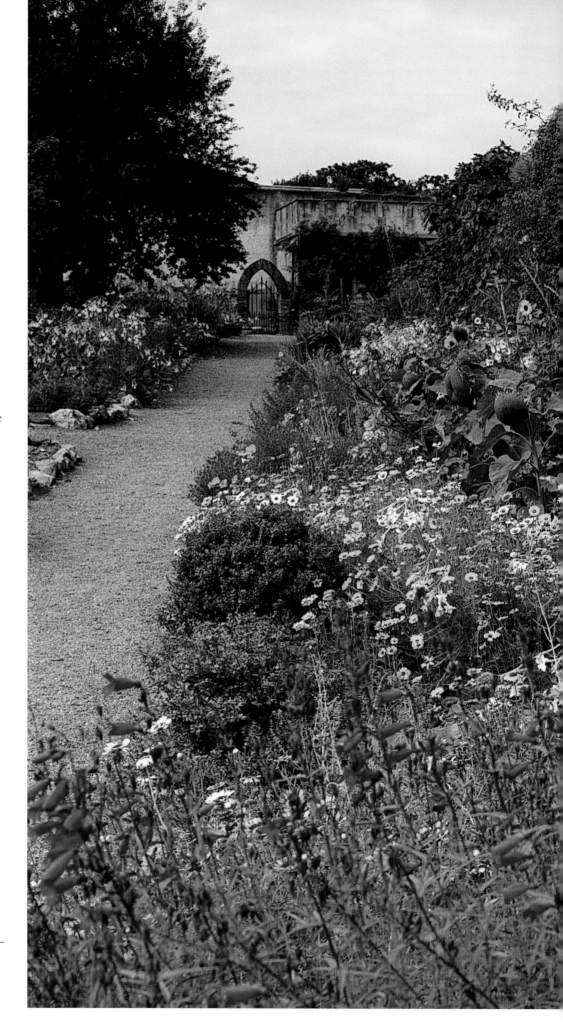

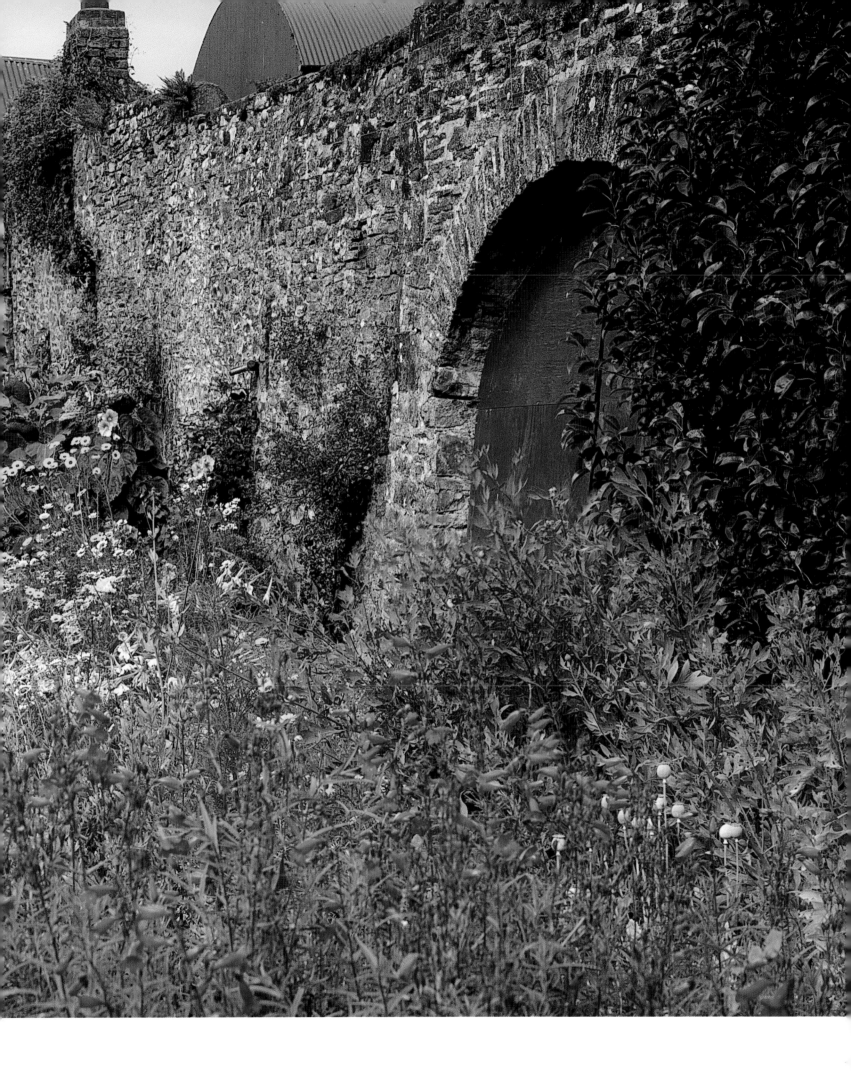

Now the garden's walls contain a castellated hen house – a joky reinterpretation of the castle – and a rustic wooden arbour. In a temple-like haven stands a headless marble statue of Andromeda chained to her rock. The old orchard, within its thick fuchsia hedges (fuchsias grow virtually wild in the soft Irish climate), has been reclaimed. Rows of vegetables thrive in the rich soil: artichokes, sea kale, rhubarb, celeriac and herbs for picking. Espaliered fruit trees – pears, plums and figs – line the walls; I was given Glin figs in honey in the castle's dining-room, which is devoted to the hotel's guests. The Ballymaloe School of Cookery in Cork is a source of inspiration in growing the food; it also sources fish, meat and dairy produce from local estates.

The castle is filled with flowers from the walled garden: sweet peas, cosmos and nicotiana, along with perennial lupins, dahlias and penstemons, are kept in a huge border that leads the eye up the axial path towards the hen house.

This traditional walled garden, used in the traditional way to produce flowers and vegetables for the house, is a magical spot. It is extremely productive and very hard work for the gardeners, but it has an air of timelessness: the stone walls contain a sense of history, of a long-established country estate, cared for and farmed by a family that is a branch of the Norman Earls of Desmond. The FitzGeralds arrived in Ireland in the 1170s and have been a power in the land ever since, though quite often on the losing side. You stand inside the walls, 3.7 metres (12 feet) high and built on rising ground, and look out over the castle and the broad Shannon. Then a giant tanker powers past on its way out to sea, and you are back in the twenty-first century.

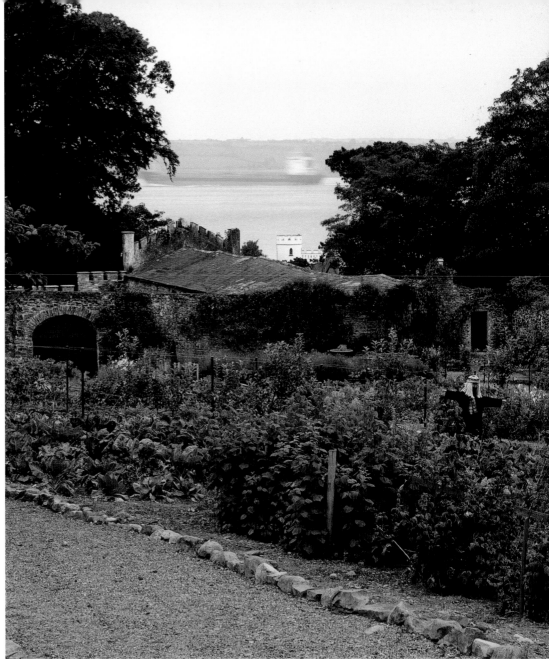

Opposite, left In restoring the garden at Glin, Madam FitzGerald succeeded in making it elegant as well as productive. The 29th Knight of Glin indulged his passion for creating follies within its walls.

Opposite, right Glin Castle is now a hotel run by the FitzGeralds. The vegetable garden provides seasonal foods for the chef, as do the climbing fruit trees growing against its walls.

Above The walled vegetable garden lies a stone's throw from the house, with the land beyond it descending to the River Shannon. Large vessels plying the estuary intrude only briefly on this timeless place.

Left With the help of the Gulf Stream and the mild, wet climate of the west coast of Ireland, the gardens can support plants that would die elsewhere, such as these prolific fuchsia hedges.

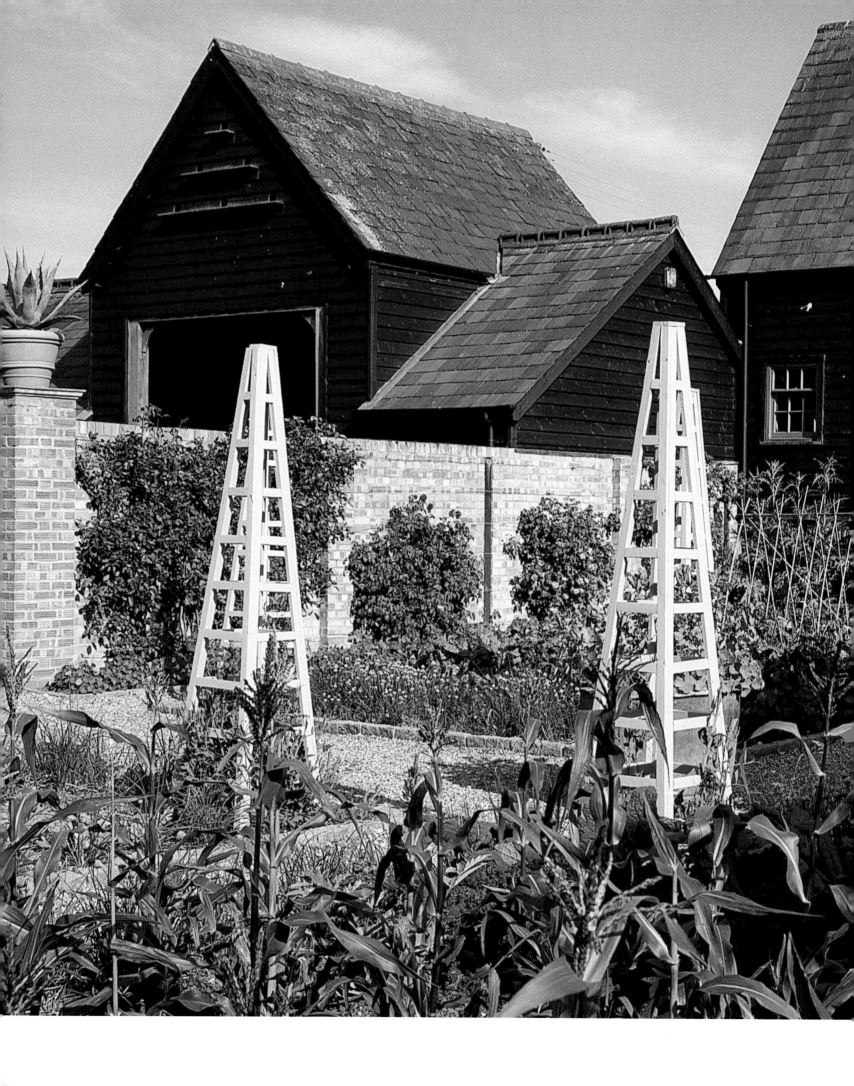

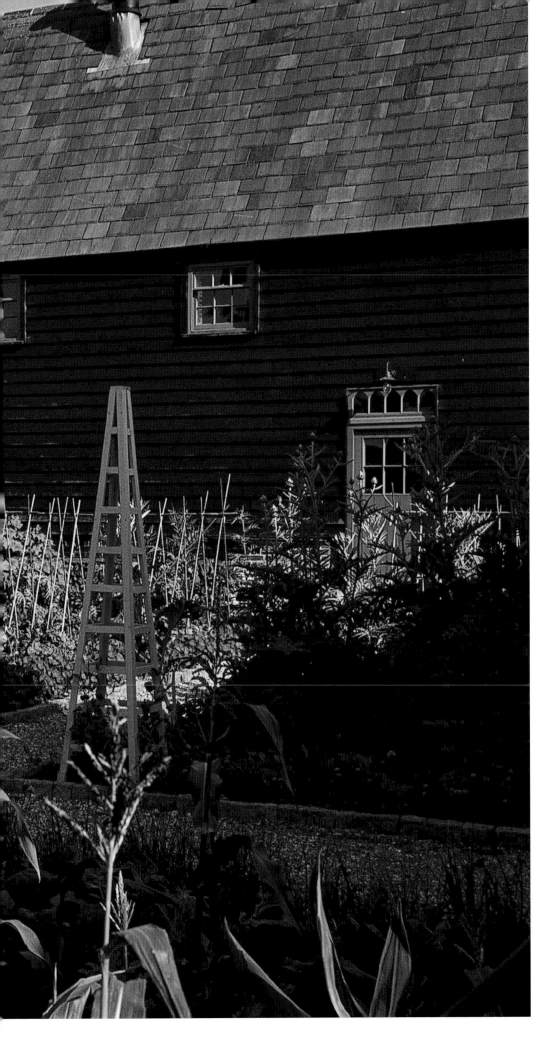

Columbine Hall
Suffolk, England

This is the story of my own walled garden and the making of it, which inspired me to write this book. The garden is at Columbine Hall in Suffolk, part of a mansion of 1390 within a moat. When we bought the house, in 1993, it had become an impoverished farmhouse, empty for seven years, surrounded by a farmyard and two elegant eighteenth-century black-clad barns with accretions of hideous farm buildings, petrol pumps, Nissen huts and lean-tos around their walls. In a small park of 11.7 hectares (29 acres), 1.2 hectares (3 acres) were covered by these buildings or equally ugly concrete.

At first we determined to demolish all that was ugly, but sense prevailed and we waited until we had a clear idea of what to put in its place. Pulling down the asbestos-roofed 1960s sheds would do no more than reveal the fine old barns in a sea of unworkable concrete. Gradually my husband, Hew, and I came to various solutions. We wanted a large working vegetable garden and, inspired by visiting that at the Château de Bosmelet (see pp. 90–93), we determined that this would be as ornamental as it was productive.

Columbine Hall's vegetable garden was made in the 1990s by removing the roof of an ugly modern barn and tidying the walls that enclosed the good-sized plot.

But where ought we to put it? Like many garden owners before us, we decided that the regimental lines of vegetables, however ornamental, were best kept within walls. The walls would provide a microclimate for the vegetables and a site for lots of climbing roses and clematis, and the area would come as a surprise to visitors and would not clash with the formal seventeenth-century gardens, much of which was designed by George Carter, on the 0.4-hectare (1-acre) 'platform' within the moat.

So we arrived at the grand plan of simply removing the roofs of two of the ugly sheds. The first, which abutted one of the attractive barns, was to be our vegetable garden. We left the walls standing, even though they were made of modern bricks. These are covered inside by roses and, on the south-facing wall, a long, lean-to greenhouse (and powerhouse of seed germination by our brilliant young gardener, Kate Elliott).

After removing the puddled clay and lime that made up its floor, we put in drainage and created four rectangular beds with bought-in topsoil. These beds are edged with granite setts. We put a semi-formal gate into the wall that faces the black barn and painted this our signature colour, Chartwell Green. On either side, in summer, stand agaves in two large terracotta pots (a cheaper alternative to the pair of lead ones that inspired me at the Chelsea Flower Show). Crossed gravel paths separate the four beds, the main one, from gate to barn, making a short vista. In the centre is an old washing copper, planted to complement the verdigris of its sides.

Opposite the greenhouse is the black-clad wall of the old stable, which we converted into a cottage with a door leading into the vegetable garden.

The walls of the other demolished shed were also left intact, and this walled area was simply gravelled. At one side we created cart sheds (it turned out that these had existed in this very place fifty years before), and at the other we made a trough fed by a small lead fountainhead, so that in summer there is always the plashing of water. More than a walled garden, perhaps, the result is a walled courtyard planted with vines and wisterias where people can stroll.

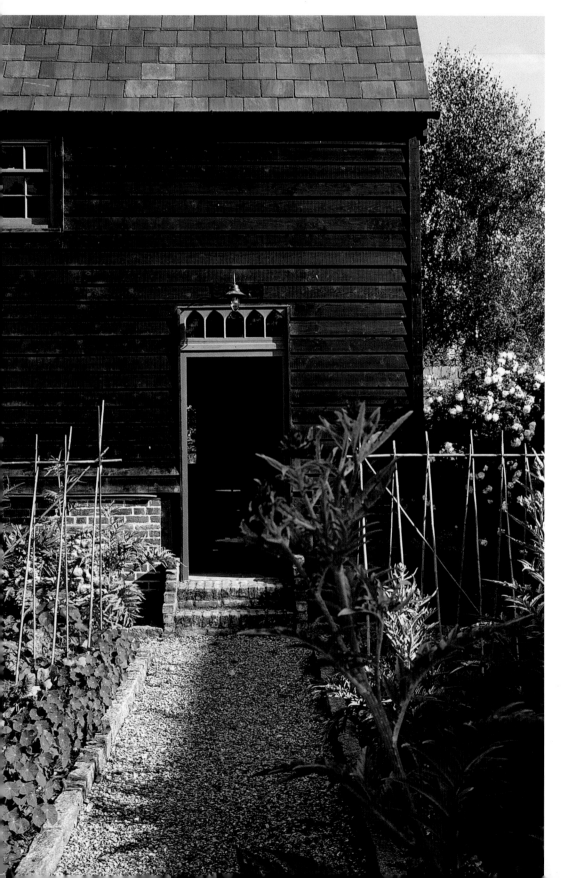

Gravel paths cross the vegetable garden, and each bed is edged with colourful chives, nasturtiums and marigolds, all of which are edible. Contrast is provided by the black clapboard wall of the cottage that forms one side of the garden.

A series of 1.8-metre (6-foot) obelisks was used to structure the garden and raise the eye. These are painted to match the gates and tone with the old verdigrised washing copper standing in the centre.

In many walled vegetable gardens the high walls are used to support a lean-to greenhouse. This large modern greenhouse is used for propagation and for storing tender plants in winter.

An old clapboard stable has been converted into a small cottage with a Gothick doorway that gives on to the main axis of the vegetable garden.

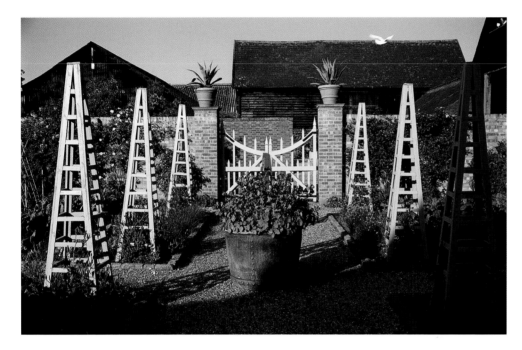

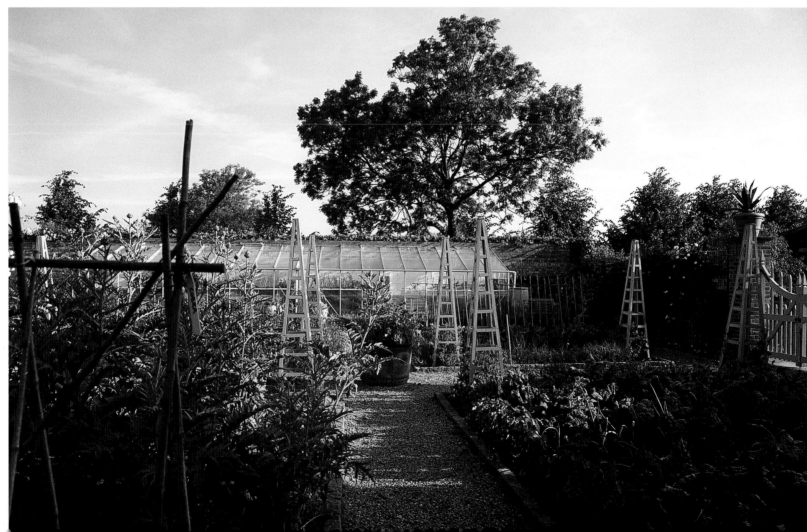

THE WALLED HERB GARDEN

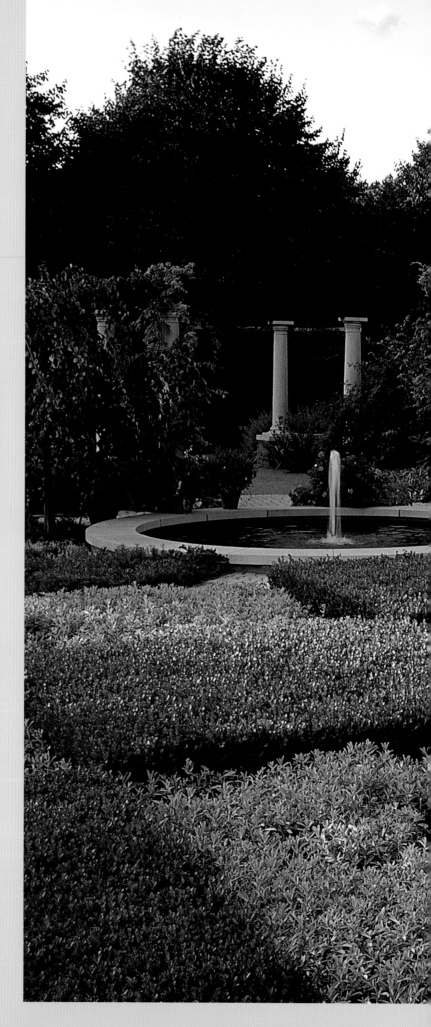

It seems hard today to imagine that only forty years ago almost no one had a herb garden, there were no nurseries specializing in selling herb plants, and it was hard to find out about growing and using herbs in food and medicine. To do so it was necessary to go back to information gathered in the 1930s, when Hilda Leyel founded the Culpeper Society, named after the famous herbalist Nicholas Culpeper.

During the mid-twentieth century herbs were valued less than at any time in the European history of gardening. From the start of the medieval period and most likely during the Dark Ages before that, herbs were grown and in regular use for medicines. The secrets of these medicines remained in the religious orders, as monks and nuns – and their walled herb gardens – were about as secure as anyone could be during the period. Dating from the eighth century, for example, there is a letter from England to a monk in Saxony complaining that it was difficult to get foreign herb plants. A monk named Walafrid Strabo, writing from the abbey of St Gall in Switzerland in the following century, describes the herbs grown there: fennel 'deserves high praise both for its taste and smell and is good for weak eyes'; sage 'of good scent it is and full of virtue for many ills'; and 'mint I grow in abundance and in all its varieties. How many they are; I might as well try to count the sparks from Vulcan's furnace beneath Etna.' In the twelfth century the abbey at Canterbury in England had a herbarium entirely surrounded by cloister walls, so it is fitting that a re-created medieval monastery in New York should have a similar herbarium. Part of the Metropolitan Museum of Art, the building uses stonework rescued from a Cistercian

When the monks gave up tending herbs their role was taken on by botanic gardens. This elegant modern example in the Chicago Botanic Garden, created by the British garden designer John Brookes, uses herbs in chequerboard patterns.

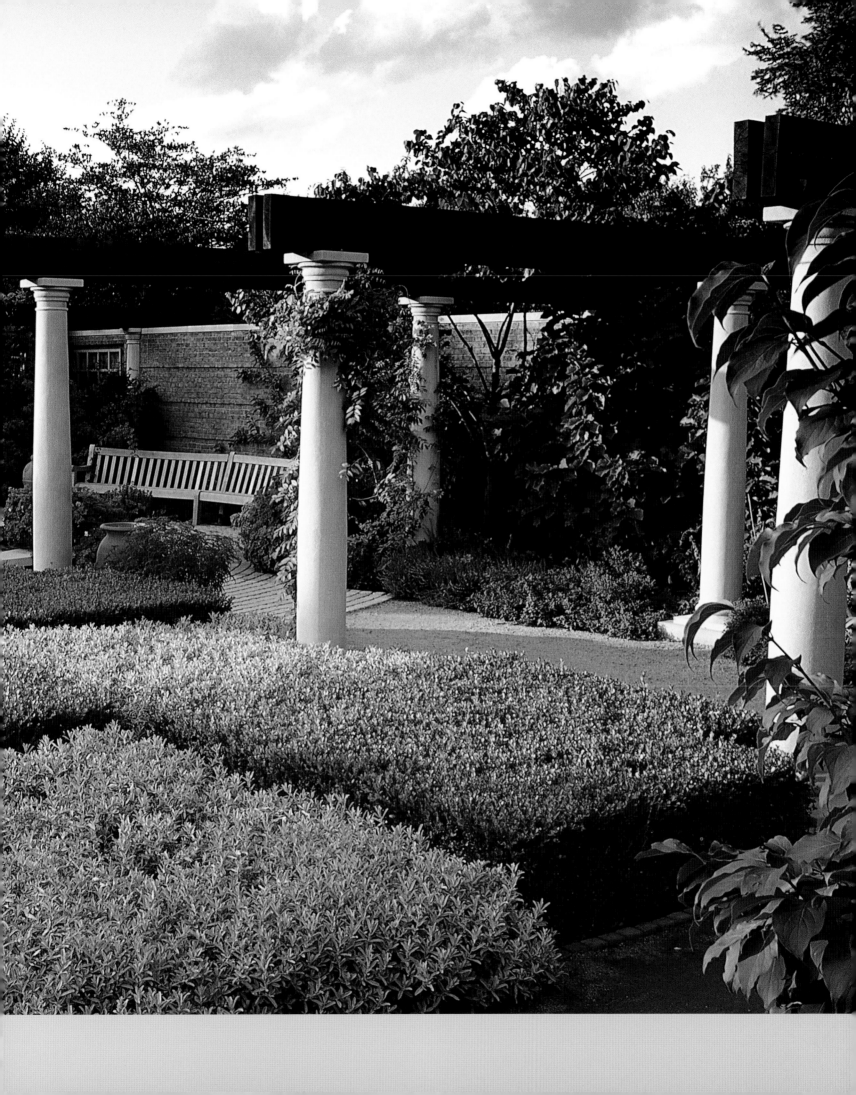

abbey near Toulouse in France. The planting copies that found in illustrations of the medieval 'flowery mead'.

In the centuries that followed, herb gardens were always kept apart from the main gardens and were usually walled or otherwise demarcated, because these were important plants on which the health of the community and of its animals depended. The herbalists grew plants for healing and others that, if not carefully used, were poisonous. The walls were to safeguard grazing animals as well as to keep them from eating the valued leaves.

Even today herb gardens are kept separate and, while many of the plants are unruly – even ugly – herb gardeners try to keep a semblance of formality in regimenting their herbs. One way to do this is to allot a separate bed to the lanky tarragons and invasive horseradish, just as poisonous plants are given their own bed. Once this is done, such plants as thyme (creeping and upright), well-pruned lavender, chives, marjoram, oregano, rosemary and sage are delightful to grow. Many are at only one remove from the wild: in Italy and southern France most of them can be picked at the wayside, where they flower in spring and are generally evergreen. With the addition of flowers that have herbal connections, such as marigolds, violets, pinks and roses, a neat walled garden can be fully stocked.

Many of today's designs for herb gardens consciously follow the medieval pattern: at Eyhorne Manor in Kent, long beds are filled with a single herb, such as sage or southernwood. There is little point in cultivating the plants in countries where they grow wild, but walled herb gardens are found in Britain. Mediterranean herbs survive well even in frosty areas, though the protection of a wall is helpful, and they have no fear of winds and little of drought. A famous version is that created by Rosemary Verey at Barnsley House in Gloucestershire, where divisions made of neat box hedges are filled in with single plantings of, say, chives, rosemary and pennyroyal; in other gardens the box squares and triangles are filled with evergreen herbs severely topiaried. Another famous English gardener, Marjorie Fish (1892–1969), created a formal herb garden at East Lambrook Manor in Somerset, its walls covered with climbing roses and grey-leaved plants laid out against stone paths and box hedges.

In *The New Kitchen Garden* (1996) Anna Pavord describes a typical late twentieth-century herb plot that she made, its small area bounded by walls of Cotswold stone. Its beds are edged with miniature box (a common feature of herb gardens, as will be clear by now) and its paths are of stone. Four beds surround a central feature that ought to be a fountain but is here a large

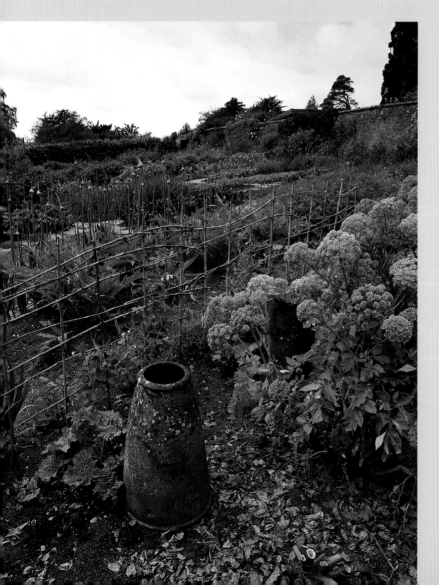

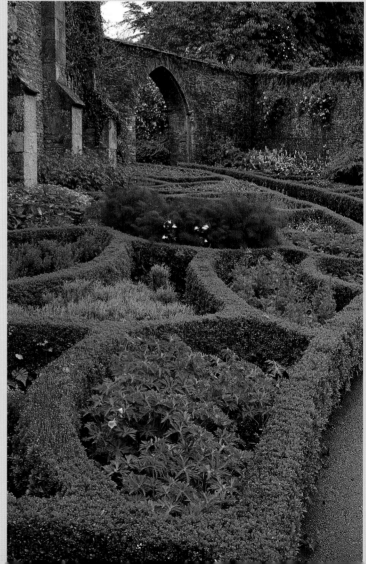

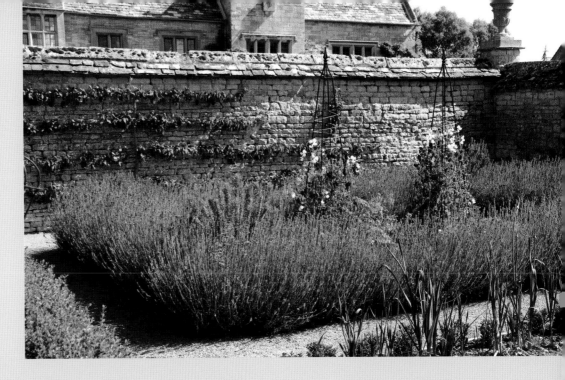

The stern grey walls of this herb garden designed by Dan Pearson in Warwickshire are a foil for the plants within, particularly the lavender hedges. The walls also serve as supports for espaliered trees, while iron obelisks draped with sweet peas lend vertical interest and colour.

Walled gardens are often created on sloping, terraced sites, which are common in Italy. One wall of the herbery at Villa Capponi, near Florence, is a retaining wall, the others highly ornamental.

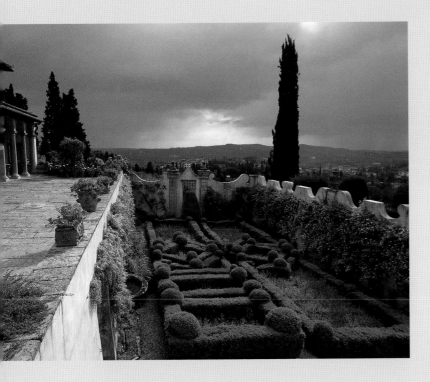

Opposite, left When the walled gardens at Hadspen in Somerset are not brimming with flowers, they are full of herbs and vegetables planted with the same care. Here angelica sits alongside rhubarb.

Opposite, right The ancient walls of Buckland Abbey in Devon have been underplanted with herbs massed in the medieval knot garden. Herb gardens were always found in monasteries because monks were usually responsible for treating the sick.

terracotta pot with stakes for growing climbing beans; chives surround the pot and their purple 'pom-poms' feature heavily in the surrounding beds. The whole is no more than 2.2 square metres (24 square feet) and the book helpfully gives an exact planting plan, though anyone who has made a herb garden will know that the plants have ideas of their own. In a garden he designed in South Africa, David Hicks kept control of the herbs by growing them in gaps between flagstones and against a wall with a central lead cistern as a focal point. This is unusual, for most walled herb gardens have a fountain, water butt or some eye-catcher at the centre of the geometrical layout. Hicks also flouted convention with white walls to make an effective contrast with the herb leaves. I have not seen whitewashed walls used in this way before but, like much of Hicks's work, it is both striking and practical.

Walled herb and physic gardens have long been common features of botanic gardens. In 1673 the Chelsea Physic Garden in London was founded as an apothecaries' garden to teach herbalists to recognize the plants they used. Much is still planted there, with herbs used in medicine, perfumery and aroma-therapy. In the Chicago Botanic Garden, John Brookes designed a walled English garden that relies heavily on such herbs as fennel, allium and southernwood planted in formal chequers.

Since the 1970s the walled herb garden has become recognized as a garden type in its own right, and examples are now being created all the time. Herb nurseries specialize not just in herbs but in single varieties, such as thyme, lavender or Strabo's mint, and books abound on ways to plan them. My own, divided from the rest of the garden with simple ornamental palings, gives me sorrel soup and tarragon chicken, bouquet garni for the stew, thyme to scent the vinegar, and a great deal of pleasure.

Downderry Lavender Nursery
Kent, England

Downderry Nursery, near Tonbridge
in Kent, is neither a typical walled
herb garden nor a typical nursery, but
it deserves to be included because it
demonstrates how the discipline of
growing a single genus within a large
walled garden can be both beautiful and
commercially successful. For Downderry –
the creation of Dr Simon Charlesworth,
who describes himself as 'oracle and
director' of the firm – is devoted to
lavender in all its many and surprising
forms, planted within a nineteenth-
century traditional brick-walled enclosure.

Walled gardens were often turned
into nurseries when the big house could
no longer maintain them – the 4-hectare
(10-acre) one at Holkham Hall in Norfolk
is an example – but Dr Charlesworth's
decision to grow only lavender means that
the crop also looks beautiful. Gardeners
might like to consider limiting their own
planting to a single genus, whether they
grow for commercial reasons or not.

Lavender has many advantages. Some
varieties, such as 'Maillette', grown in
France for its scented oil, look terrific
in long, undulating rows. These can be
straight, as the farmers grow it, or
S-shaped, as Piet Oudolf might. Or the

An old walled garden has been turned into a nursery –
a common fate – but one devoted to all the many
forms and colours of a single herb, sensitively planted.

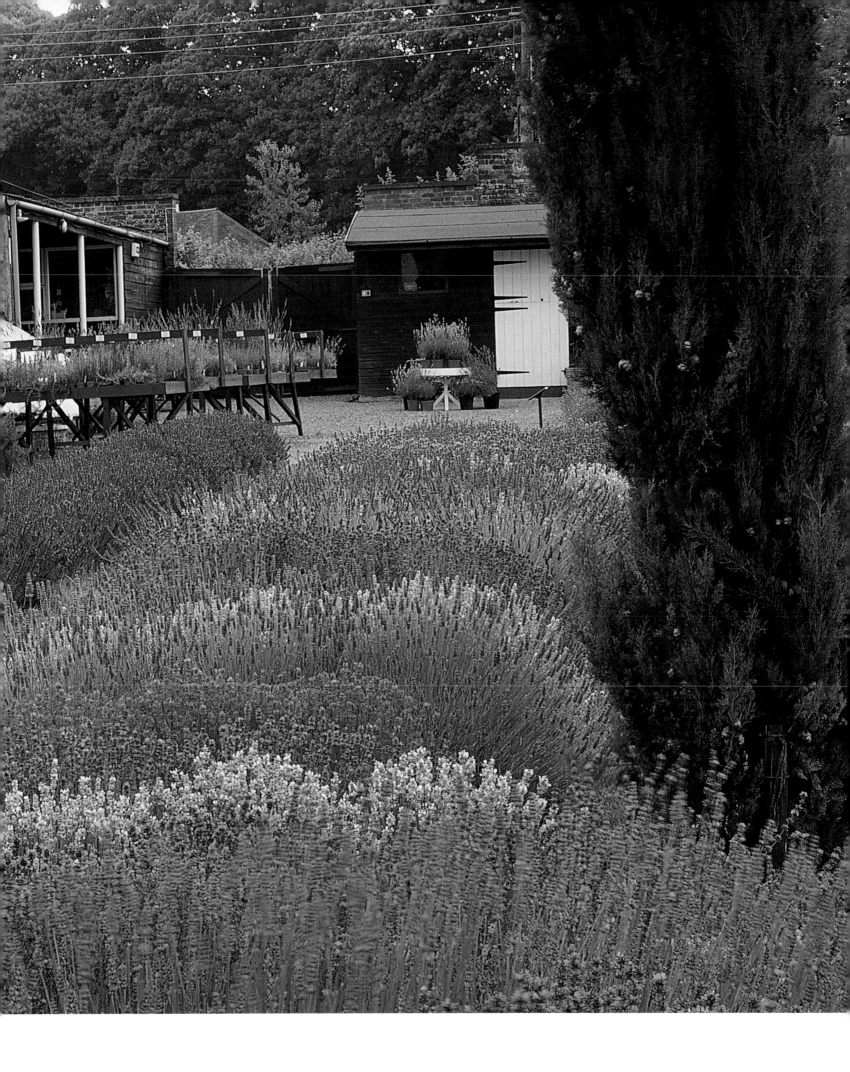

long rows can be planted in different colours, a regimented blue followed by white followed by dark pink, for example.

The same shades, more subtly blended, can be arranged in drifts in the style of Gertrude Jekyll, moving from pale 'Blue Ice' through the stronger blues of steely 'Compacta' to the dark purple of 'Hidcote'; then perhaps a shock of pure-white 'Blue Mountain White' before moving gradually through the pinks from, say, pale 'Hidcote Pink' to 'Rosea' to the strong pink of 'Miss Katherine'. Then the sequence starts again.

These are all cultivars of *Lavandula angustifolia*, true lavender, but there is also *L. × intermedia*, or lavandin, which is similar in appearance and equally hardy. The lavenders of the *pedunculata*, *stoechas* and *viridis* varieties look emphatically different to the regular types, with flowers that appear to have ears on top like a rabbit's, and they, too, can be grown in drifts. Most of these are also hardy. Finally, there are the half-hardy and tender lavenders with velvet foliage, cut, toothed, tactile and even greyer than ordinary lavenders. These are best grown in pots and over-wintered in the greenhouse.

Since Downderry holds the British national collection of lavenders, many are also for sale there (and those that are not are also planted in the walled garden).

Added to the fine range of flower and leaf colour is the advantage that lavenders are evergreen, so that, carefully arranged, they resemble topiary in winter. Lines of lavender seen in frost and snow are sculptural and as effective as box hedging. And you can harvest the seed heads, dry them and use them as potpourri or to hang with the linen. You can even eat lavender.

Above Downderry Nursery holds Britain's national collection of lavenders and is in the care of Dr Simon Charlesworth. This is his *Lavandula × intermedia* 'Grosso'.

Below The nursery's lavenders are planted in masses of contrasting pinks and purples. Dark, evergreen yew trees provide height and depth.

Opposite This brilliantly colourful walled garden demonstrates what can be done with a single garden plant: in this case lavender in a multiplicity of varieties.

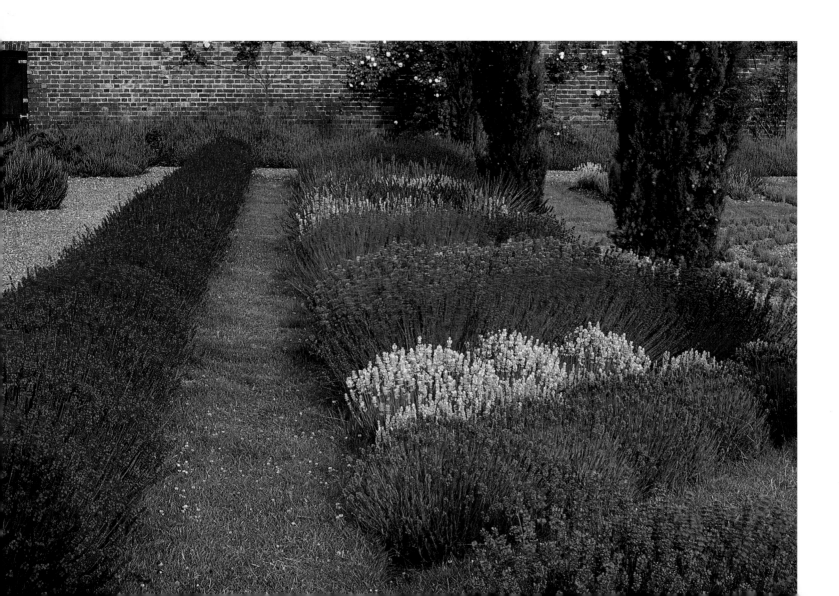

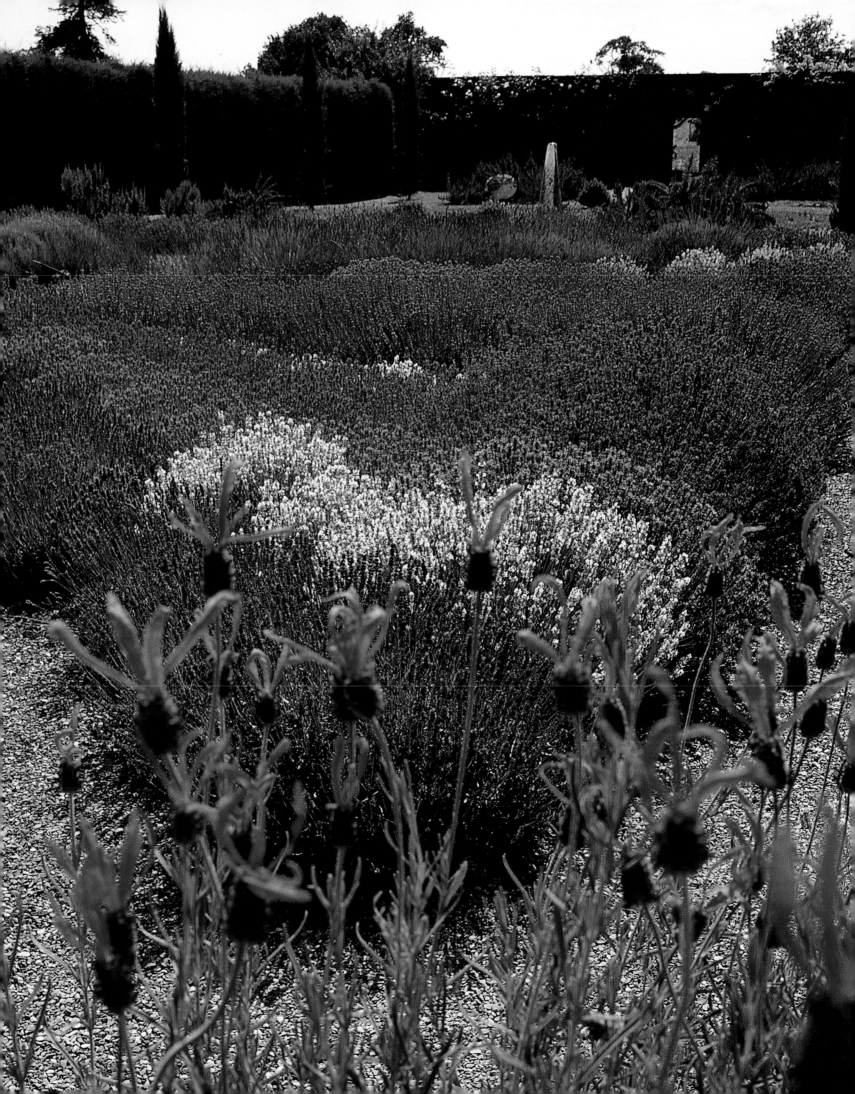

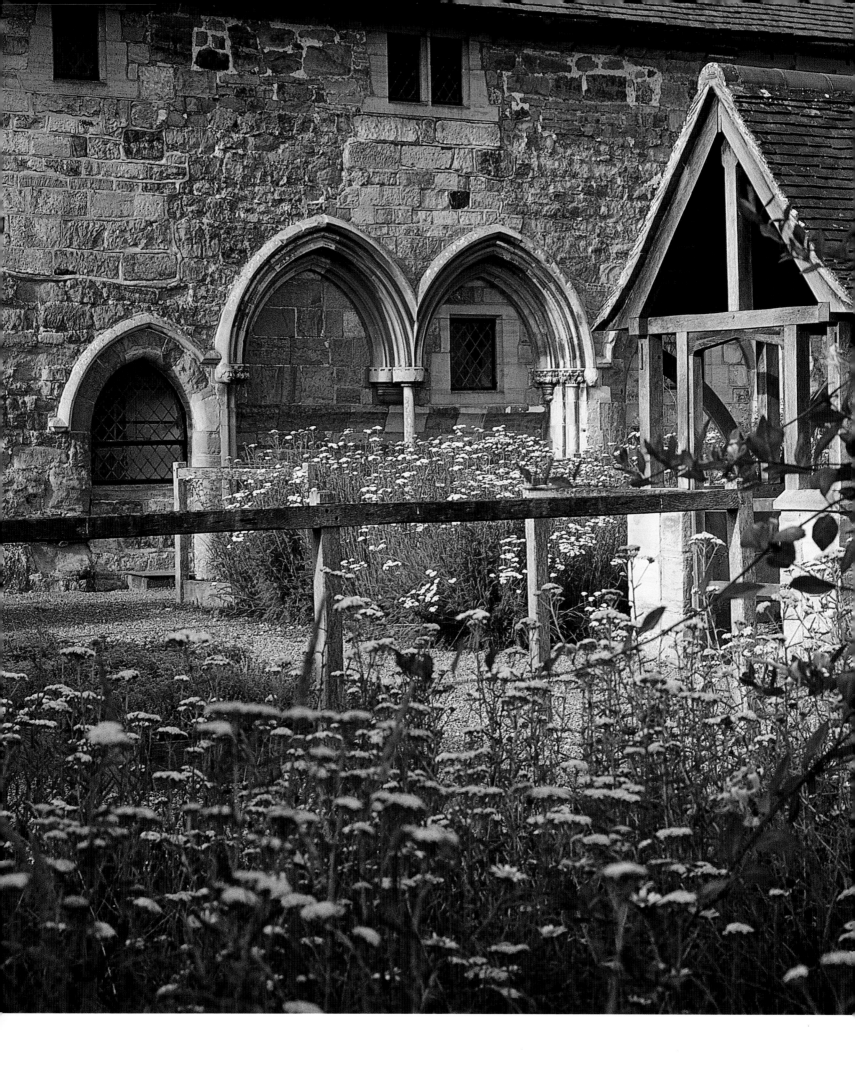

Michelham Priory
East Sussex, England

Michelham Priory is the perfect tourist attraction. A Tudor mansion stands on the remains of an Augustinian priory founded in 1229, and remnants of this medieval building still exist in the cloister garden. Even earlier, William Rufus, King of England and son of the Norman Conqueror, stayed here. It has the longest medieval moat in the country – over 1.6 kilometres (1 mile) of water – and several ghosts. There is apparently a girl in a tattered dress with ribbons in her hair, the inevitable monk, music from a phantom harpsichord and the occasional waft of incense.

The famous physic garden was inspired by that at St Gall in Switzerland commissioned by the Holy Roman Emperor Charlemagne in the eighth century. Now the gardens at Michelham are enjoying a new lease of life, as parts of them within the moat are rescued. The medieval stew ponds, originally used for keeping fish, have been excavated, filled with water again and planted with water-loving plants with dramatic foliage. There is a formal ornamental potager that combines vegetables and flowers and has a central pergola within walls of yew. The cloister garden itself, in the well

Michelham Priory has a long history. The remains of the early thirteenth-century building provided the foundations for a fine Tudor mansion.

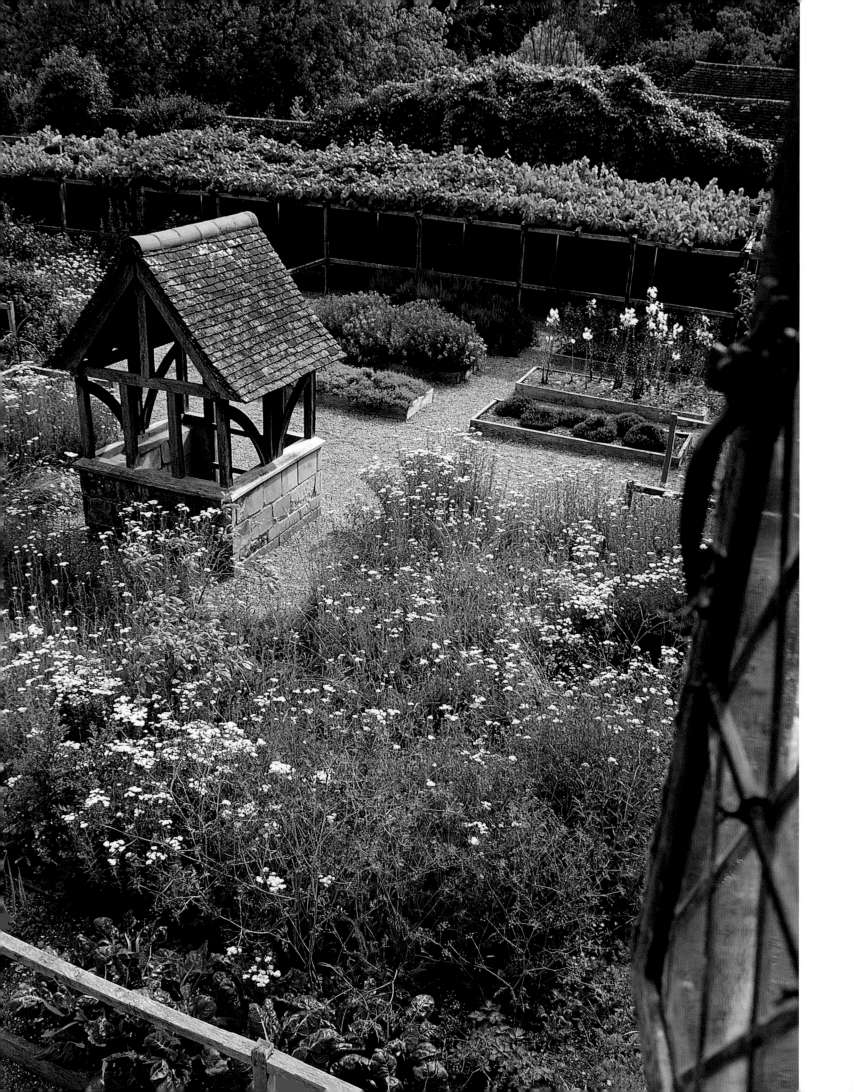

courtyard, is inspired by medieval Marian gardens shown in illuminated parchment manuscripts, and has the essential arbour, typical raised beds filled with herbs, and a turf seat.

The whole is a fine mixture of authentic medieval gardening, the early *hortus conclusus*, and new ideas for historic areas, such as the stew ponds. Despite being owned by a group called Sussex Past, Michelham Priory has not let itself become a museum.

Opposite Gardens like this, complete with wellhead and turf seat, are depicted in many medieval tapestries and parchments, generally with young lovers in bowers.

Below, left How could one not plant a herb garden alongside medieval arches like these? Michelham's was inspired by the herbery commissioned by Charlemagne at the monastery of St Gall in Switzerland.

Below Planting of the medieval 'flowery mead' inspired the modern wild-flower garden. At Michelham the Middle Ages meet the twenty-first century.

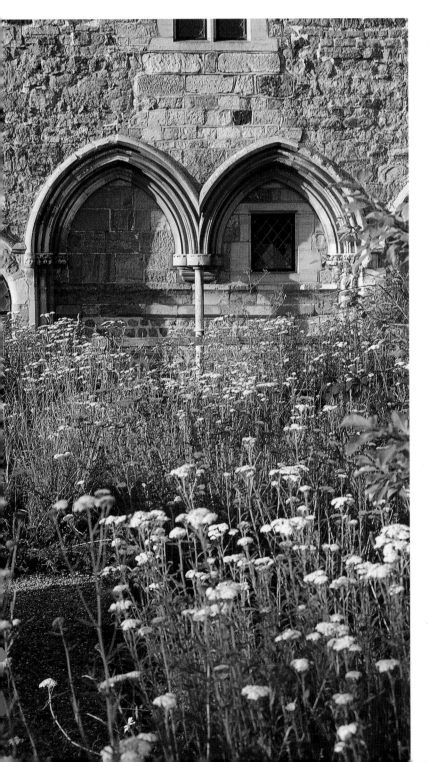

THE WALLED HERB GARDEN

The Geffrye Museum
London, England

The East End of London was once a green and peaceful area, notable for its market gardens, its fields of grazing cattle and its plant nurseries. This is hard to imagine now in a quarter historically known for its entrenched poverty, its waves of immigration and the battering it took during the Blitz. However, in a small corner a local museum has tried to bring back this more pleasant past.

The Geffrye Museum in Hoxton was built as almshouses by the Worshipful Company of Ironmongers (one of the City of London's guilds) in 1714, and today the elegant buildings are used to exhibit the styles of English interiors – ordinary rather than grand ones – from 1600 to 1950. But in 1991 the trustees decided to add a 'green' outdoor room to the museum, in the form of an eighteenth-century herb garden. As the museum explains, 'herbs with their ancient uses and historic associations provide us with both a tangible link to the past and an alternative for achieving a more natural way of life'. The intention was to recall the times when this area of London was a centre of the nursery trade. Thomas Fairchild, a nurseryman, wrote to novice gardeners in 1722 that they should 'view

This neat little garden is in the East End of London, once a place of grazing cattle and plants but now better known for its inner-city grittiness.

Opposite The garden is divided into twelve brick-edged beds and criss-crossed by brick paths. At its heart stands a fountain designed by Kate Malone.

Top Sage, horseradish and mint are still used daily in our kitchens, while the medicinal herbs grown in the Geffrye's garden are enjoying a return to popularity.

Above The museum established this external 'green' room in 1991 by converting an adjoining disused industrial site. Two of the walls date from the eighteenth century.

Above, right The herb garden is intended to resemble the one that thrived in Hoxton in the eighteenth century, when that area was the hub of London's nursery trade. Eight collections of herbs in 170 varieties are planted here.

the gardens at Hoxton and other places near the Town, where they may see all the variety of flowers that blow [bloom] in the Spring Summer and Autumn Seasons'.

The museum took over an adjacent derelict industrial site, bounded on two sides by eighteenth-century brick walls and on the others by a distressing collection of rusty wrought iron. First the ground was concreted and then the two walls were increased to four to make a walled garden; in one a wooden door was made, while the three others had seats and arbours, which were covered in roses. The brick walls contain twelve geometric beds, separated by brick paths, and at the centre is a modern fountain, designed by a local potter, Kate Malone. The garden is planted with 170 varieties of herbs divided into eight types, and the fact that none is a modern hybrid contributes to the authenticity of this re-creation. In 1992 the garden won the London Spade Award for its use of green space in the city.

Since that time the use of herbs has grown hugely. Among the culinary herbs planted here, sage, tarragon and horseradish are in daily use. In the cosmetic herb area grow such plants as sweet marjoram, cowslip and pot marigold, which are made into organic ointments and lotions. The medicinal herb area features herbs that today are widely used for ailments – evening primrose, St John's wort, comfrey, elder, garlic and mint are examples – while the aromatics, such as bergamot, lavender and thyme, are used to scent candles and soap, joints of lamb and pots of jam. The other areas include bee plants, such as catmint, honeysuckle and hyssop, and dye plants, such as woad, sorrel and weld. The bed of salad herbs has fennel, orach and chicory, all of which can be found in packaged supermarket salads, and we still use such household herbs as mugwort, fleabane, pennyroyal and tansy in mixtures in our continuing battles against lice, fleas and moths.

WALLED GARDENS BY TWENTIETH-CENTURY DESIGNERS

Arguments over the style of the twentieth-century garden started towards the end of the previous century, with Sir Reginald Blomfield (1856–1942) in the architectural, formal corner and William Robinson (1838–1935) in the plantsman's corner. In 1870 Robinson, a pugnacious Irishman, published *The Wild Garden*, and in 1892 there appeared Blomfield's rather smug *The Formal Garden in England*. Robinson was pioneering a new kind of gardening that included the new herbaceous border, wild-flower meadows and meticulous plantsmanship. Blomfield championed all things Italian, including the walled gardens that surrounded the Tuscan Medici villas, which themselves drew inspiration from the architecture of Classical Greece and Rome.

Robinson won the battle, at least in the twentieth century, when he was hugely influential. Now-famous gardeners – among them the British Gertrude Jekyll, Vita Sackville-West, Rosemary Verey (1919–2001) and Christopher Lloyd (1921–2005), the Americans Lawrence Johnston (1871–1958) and Lanning Roper (1912–1983), and the Australian Edna Walling (1896–1973) – were all directly inspired by Robinson's contention that plants should not be disciplined. Most of these figures were equally influential on the gardening public because they wrote regularly for magazines and newspapers, as well as many books.

Christopher Lloyd wrote a weekly column in *Country Life* from 1963 until his death, and more than twenty books about his planting theories, which tended towards the experimental and exotic. He was helped by the fact that his garden at Great Dixter in East Sussex benefited from the architectural form imposed on it earlier by Sir Edwin Lutyens. In this way, many of the 'wild gardeners' were able to create their planting schemes with the

David Hicks was the resourceful designer of this beautiful little walled garden in an uninspiring corridor at The Grove in Oxfordshire (pp. 138–41). Controlled colour and uncontrolled abundance are the keys to success here.

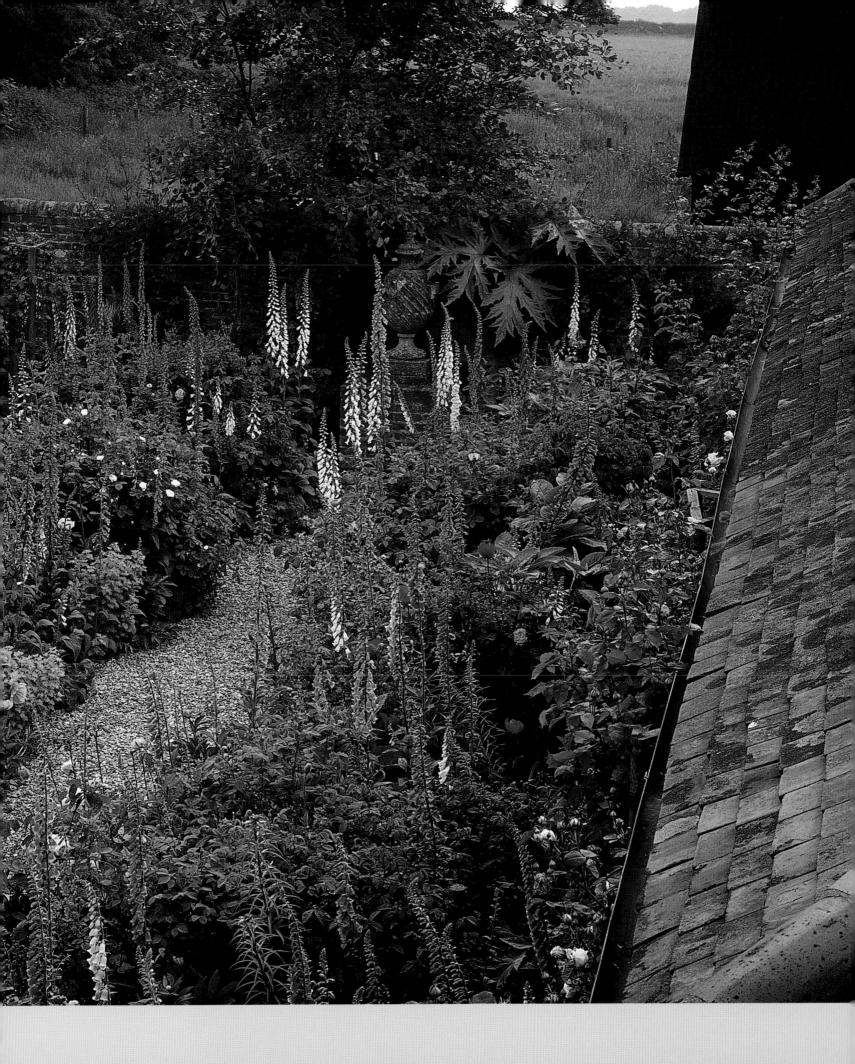

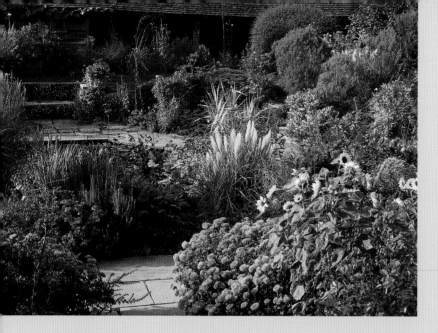

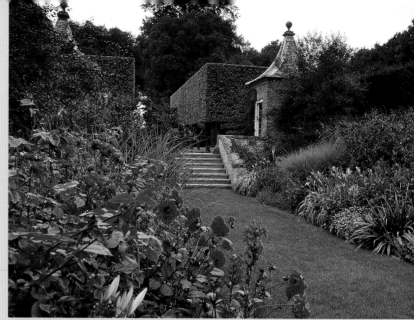

backdrop of a walled garden, as a series of outdoor rooms or beside a historic house. Gertrude Jekyll, a regular columnist for *Country Life*, and Vita Sackville-West, who wrote for *The Observer*, were lucky to work alongside Lutyens and Harold Nicolson respectively, both of whom were in the formal camp. The two women's planting schemes at Hestercombe and Sissinghurst respectively are successful because the formal bones have been carefully planned.

Lanning Roper, who wrote for the *Sunday Times*, was a prime mover in the style of the mid-twentieth century, when walls were decorated with old-fashioned roses, and the borders before them were moving from the high-maintenance herbaceous to the mixed border of shrubs, perennials and a few annuals. Graham Stuart Thomas championed old-fashioned roses as the perfect plant for old walls, and, as an adviser to the National Trust, practised what he preached. He also wrote about his horticultural passions. Marjorie Fish, using the old stone walls of her Cotswold manor house at East Lambrook, was another writer who was passionate about the wild, self-sown garden, which, in her case, was full of cottage-garden plants. She and Jekyll both took their style from the unpretentious gardens of working people, and so perpetuated both the vernacular unconsidered planting of the small garden within low walls and many of the lowly plants loved by cottagers.

Lawrence Johnston was hugely influential in creating the English country garden. His work at Hidcote Manor in Gloucestershire combined the warring approaches of formal design and wild planting by using Sackville-West and Nicolson's technique of creating a complex design of enclosures, belvederes and long vistas with technically brilliant herbaceous planting, and he plucked inspiration from Classical, Mediterranean, and Arts and Crafts gardens. It is not surprising that Hidcote is one of the most reproduced gardens in the world, nor that Johnston's schemes, such as the red border, are widely copied as a foreground to walls.

Yet the formal walled garden, though ailing, by no means died in the twentieth century, and in the new century it is showing definite signs of a revival. Blomfield's contemporary Sir Harold Peto championed the Classical Italian style, not least in his own garden at Iford Manor in Wiltshire (pp. 46–49). Peto, who trained as an architect, imported statues and columns from Italy, along with colonnades and ornamental buildings. His restrained planting, designs that involved the greater landscape, and relaxed formality managed to end the Victorian fad for the grandiose 'Italian' formal walled garden.

Just as the plantsmen and -women taught one another in a direct line from Robinson to, say, Dan Pearson (born 1964), a prominent figure today, so the architectural gardeners' designs descend from Peto to Lutyens to Sir Geoffrey Jellicoe. He was an architect who turned to garden design after visiting Italy, and his work at Sutton Place in Surrey and Shute House in Dorset combined the formal Italian garden with elements of the twentieth-century art movements of Cubism, Surrealism and Minimalism. Jellicoe, however, always included some plants in his schemes (though he once told me how much he disliked gardening), whereas the true pioneers of architectural gardens did not. Designers who made gardens of walls, stones and gravel with only a token plant or two include Isamu Noguchi (1904–1988), Luis Barragán (1902–1988) and José de Yturbe (born 1942); the designs of these last two, both Mexican, show a particular ease with brilliant colour and cool water within walls surrounded by a harsh landscape.

The use of colour, whether on the walls or within them, was a major development of the twentieth century. Whereas the seventeenth and eighteenth centuries relied on natural shades of stone, plaster and marble for the walls, and the nineteenth century on close bedding for huge splashes of colour within natural walls, the twentieth saw the development of the garden room, where the walls would be plastered and, like the furniture used within, painted.

Opposite, left In later life Christopher Lloyd loved to shock, and adored brightly clashing flowers. His border at Great Dixter in East Sussex epitomizes this rebellious outlook, but it works brilliantly.

Opposite, right Hidcote Manor in Gloucestershire is one of the truly great gardens of the world, created by an American, Lawrence Johnston, in the English manner. His red border is the herbaceous border taken to extremes.

At the other end of the design spectrum, Gabriel Guevrekian's Villa Noailles at Hyères combines the discipline of French planting, the serenity of Zen gardens and the lines of Cubism.

Jellicoe, for example, created a whole 'bedroom' with bed and chequered carpet made of plants within hedged walls, while David Hicks planted his Red Room with dark-purple beech hedges. This influence is very visible today at the Chelsea Flower Show, where, in 2006, Tom Stuart-Smith placed his plants against high walls painted the colour of rust, and Christopher Bradley-Hole set lines of colour alongside caissons of broken concrete.

However, if you ever thought that Modernism owed nothing to the past, consider Gabriel Guevrekian (1900–1970) and his design of 1927 for Villa Noailles, at Hyères in the South of France. The Istanbul-born Armenian created a Cubist garden within walls where coloured rectangles of orange and sky blue are interspersed with planted squares of flat green. Cubist it is, but then the art movement of this name also owed much, variously, to African art, the non-figurative aspect of Islamic art, and the stark architecture of stones and gravel pioneered in China before Christ.

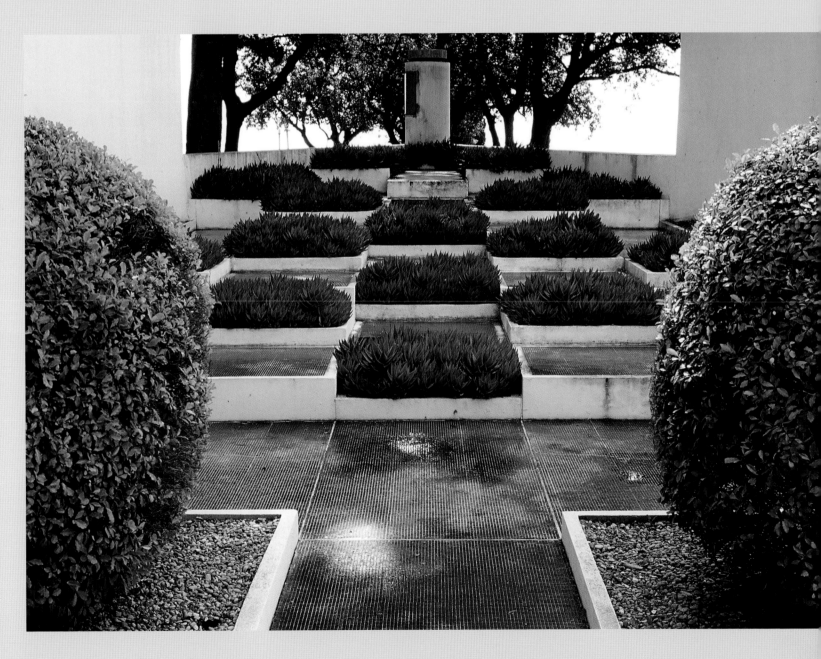

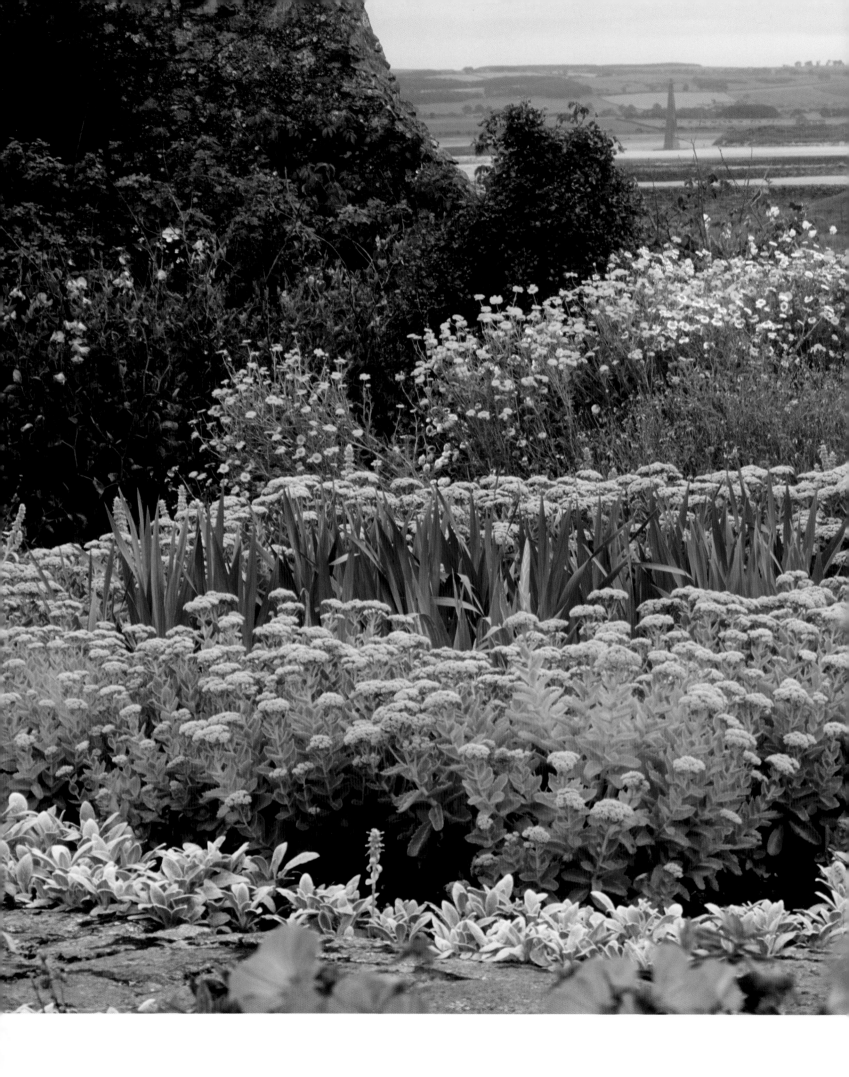

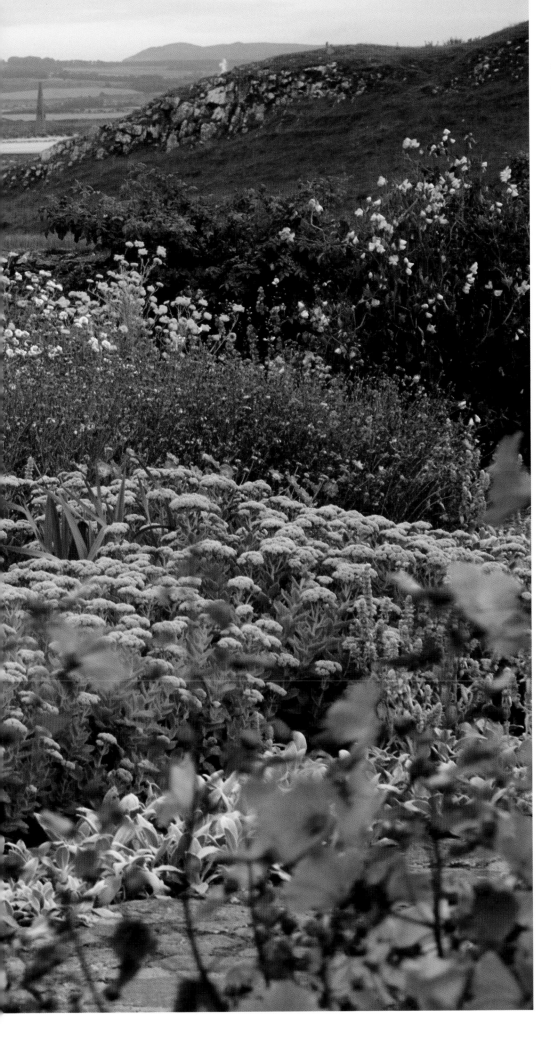

GERTRUDE JEKYLL
Lindisfarne Castle
Northumberland, England

Gertrude Jekyll's little walled garden on Holy Island, off Northumberland, is by no means typical of her work, which was generally much larger and grander. But it shows how effective a small walled garden can be.

Like many other of Jekyll's gardens, this was a collaboration with Sir Edwin Lutyens, the architect who transformed Lindisfarne Castle on Holy Island for Edward Hudson, the owner of *Country Life*. Jekyll (1842–1932) first visited it in May 1906, travelling up by train with Lutyens, three shillings' worth of bull's-eye sweets and a raven. While Lutyens made a cage for the bird, she walked all over the island to get its measure.

The garden, laid out by Lutyens, is a fair walk from the castle but in its full view. It measures only 24 by 20 metres (78 by 66 feet) and has high walls on three sides, while on the fourth side it dips gracefully so that the planting can be seen from the castle, and the castle from within the garden. The plan is simple: there are fairly wide beds against all four walls, and a square central bed surrounded by island beds, two plain rectangles alternating with two L-shaped beds. The paths are of stone.

A chance discovery in California of Gertrude Jekyll's meticulous planting plans – which she invariably produced – allowed the National Trust to re-create the garden of Lindisfarne Castle as faithfully as possible.

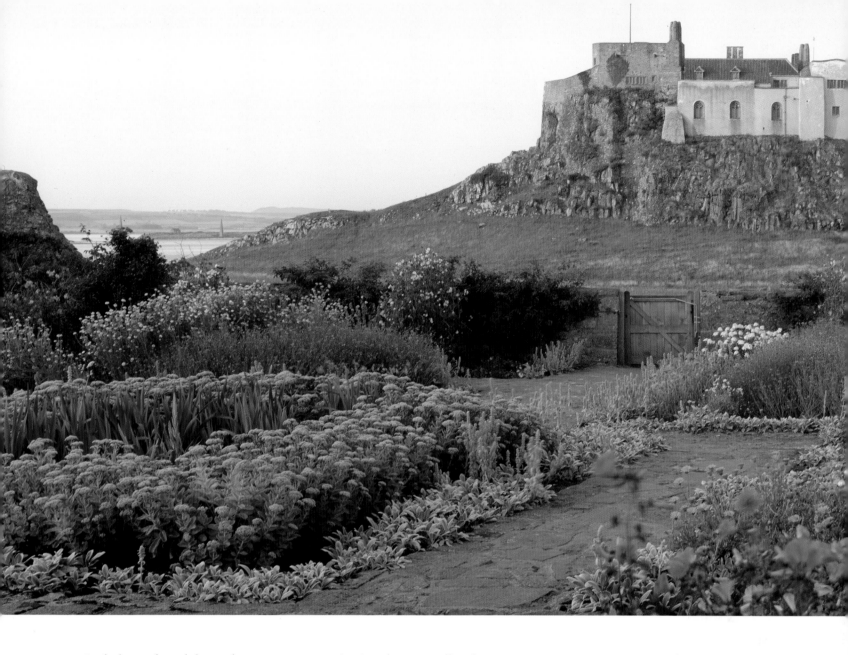

Both the castle and the garden are owned by the National Trust, which in 2002 began to restore the garden to Jekyll's detailed plans, which had been discovered in California a decade earlier. By the spring of 2003 planting had begun, following the original scheme and using wherever possible exactly the same plants, or, if these could not be found, the nearest alternatives. When Hudson sold the castle in 1921, the new owner had asked Jekyll to redesign the garden, and it was loosely maintained to this plan thereafter. Rosanna and Michael Tooley, who wrote the informative brochure about the garden (including a complete planting plan that the reader can implement), say it became 'Jekyllesque' rather than a true Jekyll design.

Against the west wall such roses as *Rosa* 'Madame Abel Chatenay', *R.* 'Hugh Dickson', *R.* 'Killarney' and *R.* 'Zéphirine Drouhin' are planted with mignonettes beneath. Directly opposite is a bed entirely made up of vegetables and espaliered fruit according to Jekyll's original plan. Lamb's ears ('*Stachys × byzanthina*') – some 280 plants – lines all the centre beds and the edges beside the gate; a typical grey that Jekyll often used and which is perfect in this stony landscape.

But the plan is by no means dull, for there are fuchsias, delphiniums and sweet peas (unusually for Jekyll), such as 'Miss Willmott', 'White Supreme', 'Queen Alexandra' and 'Mrs Bernard Jones', along with poppies and gladioli, such as *Gladiolus* 'Cartago', *G.* 'Beauty Bride',

G. 'Santa Lucia' and *G.* 'Phyllis M'. Marigolds provide bright oranges, and there are scarlet bergamot and white poppies. The long northern border contains sunflowers, mallows, hollyhocks, and Japanese anemones in repetitive drifts, stabilized by *Fuchsia* 'Riccartonii'. About half the plants are hardy annuals, chosen because they do not need to cope with the fierce autumn and winter weather of Northumberland's coast.

Just as the garden can be seen from the castle, the castle forms an impressive backdrop to the garden. The planting is far from drab in this bleak environment: simple, bright colours contrast with the rugged scenery, and massed marigolds provide a sense of warmth and sunlight.

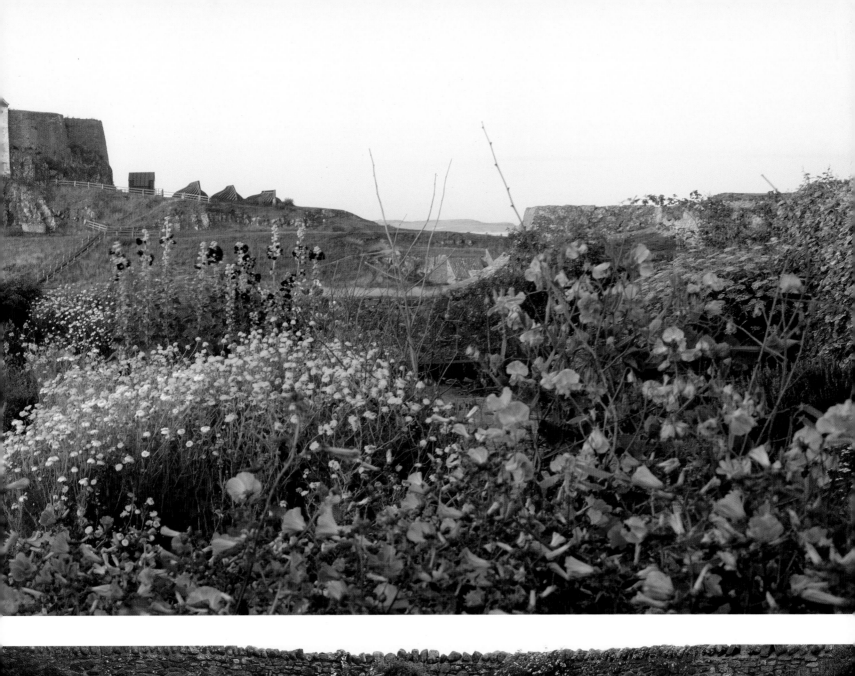
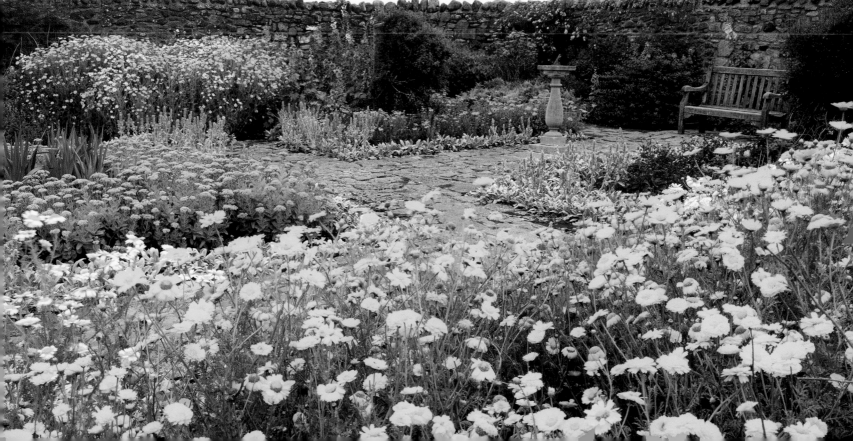

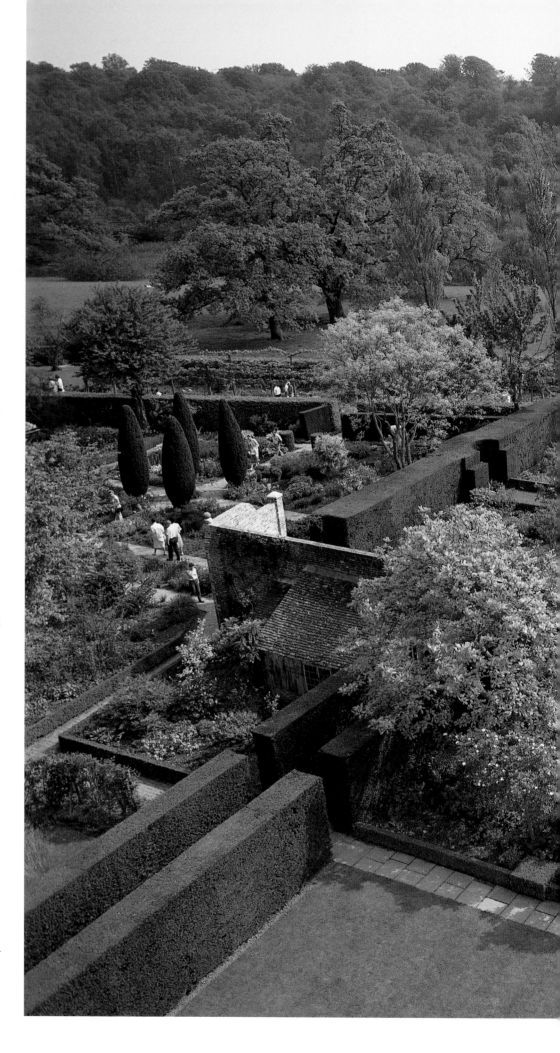

WALLED GARDENS BY TWENTIETH-CENTURY DESIGNERS

VITA SACKVILLE-WEST
Sissinghurst
Kent, England

Sissinghurst is one of the most famous – and therefore most influential – gardens in the world. It is entirely the work of Vita Sackville-West (1892–1962) and her husband, Harold Nicolson (1886–1968), who played a more important part in its creation than many give him credit for. The couple bought the estate in 1930. Vita first visited it on a nasty April day, fell in love with it and within three weeks owned the farmhouse, the separate Tudor tower and 162 hectares (400 acres) of land. An aerial photograph taken two years later shows, attached to the tower, an incomplete walled vegetable garden. It was another three years before the house had water and electricity.

Within 2.4 hectares (6 acres) of the estate, the couple set about making a formal garden with a series of rooms, many of them walled. The first is the courtyard, deliberately plain in plan, which takes visitors through the open gateway of the farmhouse to the tower beyond. The centre is of grass, the only planting being luscious old-fashioned roses that scramble up the brick walls of the house, and perennials, casually planted beneath them, that flop over the flagstones bordering the walls.

The walled garden at Sissinghurst is only part of a complex plan devised by Harold Nicolson. This bird's-eye view shows how it fits into the whole and how the design complements the countryside beyond.

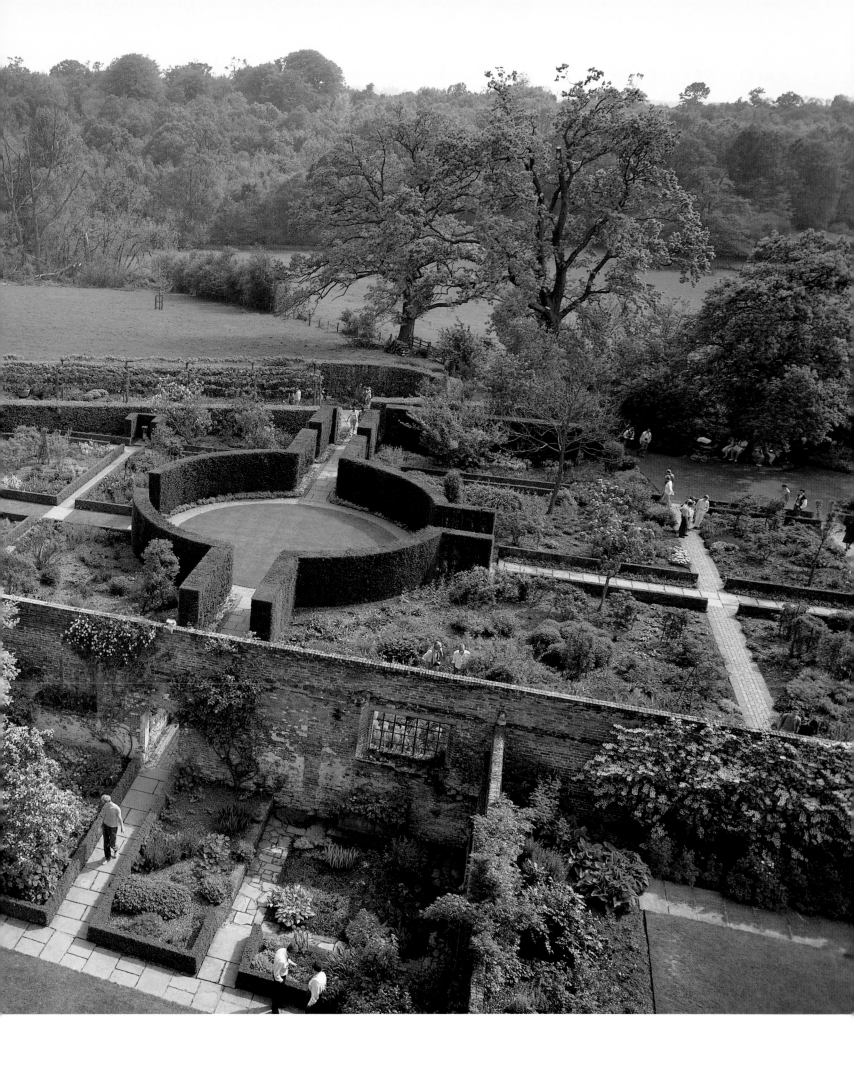

Beyond the tower is another plain lawn, walled on one side and hedged on the other by the long Yew Walk. Indeed, Nicolson contrived a whole series of 'walled' spaces by using surviving old brick walls and yew hedges that matched them in height. He built three more walls: the north wall of the Front Courtyard, the Bishop's Gate wall by the White Garden, and the wall of the Rose Garden. 'By this means,' said his son Nigel, 'he divided the six acres into separate gardens, each with its own shape and character, and linked them by vistas formed by gaps in the walls and hedges, leading the eyes to distant views of the Weald.' Nicolson senior said that his aim was 'a combination of expectation and surprise' and 'a series of intimacies'.

Within these Sackville-West spun her plantswoman's magic, creating such iconic gardens as the White Garden, which is reached by passing through a dainty wrought-iron gate in a brick wall. Here white plants contrast with others that are grey-leaved. The Cottage Garden, the first one planted (because they lived in the cottage), follows a yellow, red and orange scheme. It was also the most personal, said Nigel Nicolson. Harold would pick flowers there to take to his London flat; Vita would work there in the early morning.

'If [Harold's] taste was classical, preferring geometrical patterns and the symmetrical arrangement of steps, paths, pots and statuary,' wrote Nigel, 'hers was romantic, in that she enjoyed a certain abandon in her garden. If roses strayed over a path, or herbs crept on to it, let them stay there: the visitor must duck

and tread carefully.' This abandon did not, however, permit unclipped hedges or weedy beds. Nigel Nicolson is absolutely right: the collaboration worked perfectly.

In *Influential Gardeners* (2002) Andrew Wilson writes that Vita Sackville-West knew and was influenced by William Robinson's garden at nearby Gravetye Manor in East Sussex, and that her own designs in turn influenced two other English lady gardeners, Rosemary Verey and Penelope Hobhouse, and, of course, millions of fans around the world.

Opposite, top A walled garden can be as interesting from the outside as from the inside. While many traditional gardens have bare exterior walls, Vita Sackville-West decorated this venerable wall with climbers.

Opposite, bottom left Sissinghurst's unique charm is the combination of disciplined structure, provided by Harold Nicolson, with the loose but inspired planting of Vita Sackville-West.

Opposite, bottom right The Tudor tower presides over one of the world's most cherished gardens, created from scratch in the 1930s. Its warm pink tones are echoed by the mellow bricks of the garden's weathered walls.

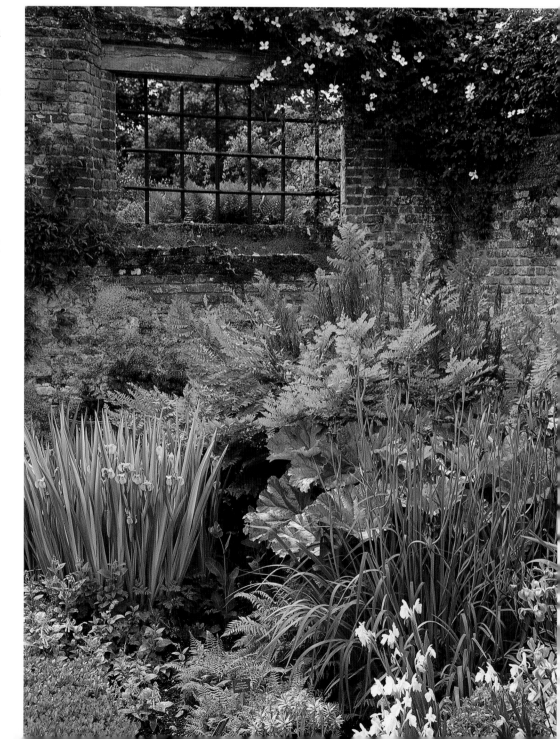

Walled areas can hint at views beyond. Here a false window with stout bars offers a tempting view of the garden outside. *Clematis montana* drooping over the corner adds a hint of the English cottage.

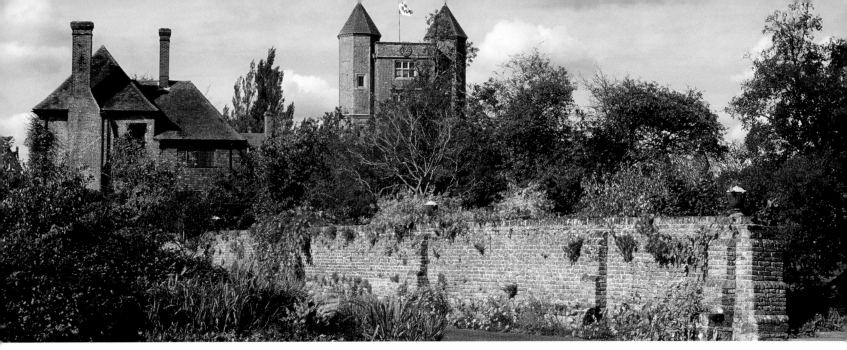

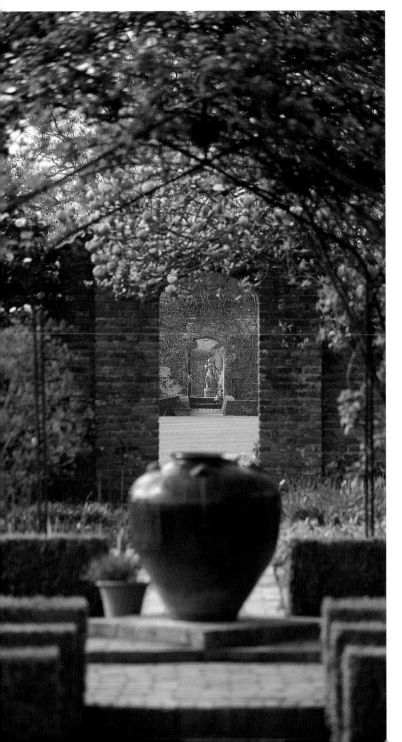

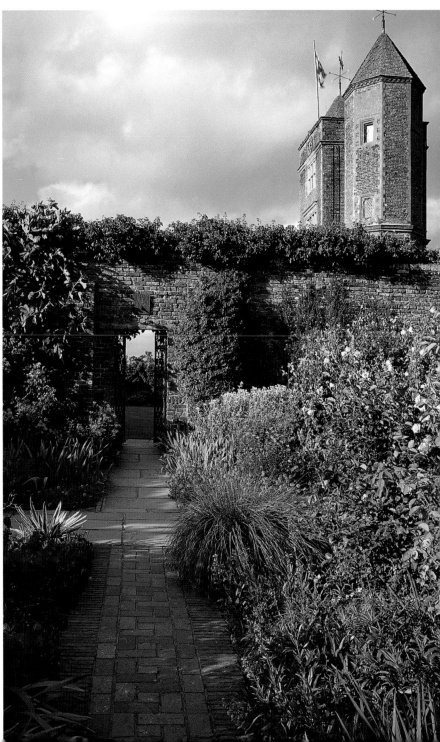

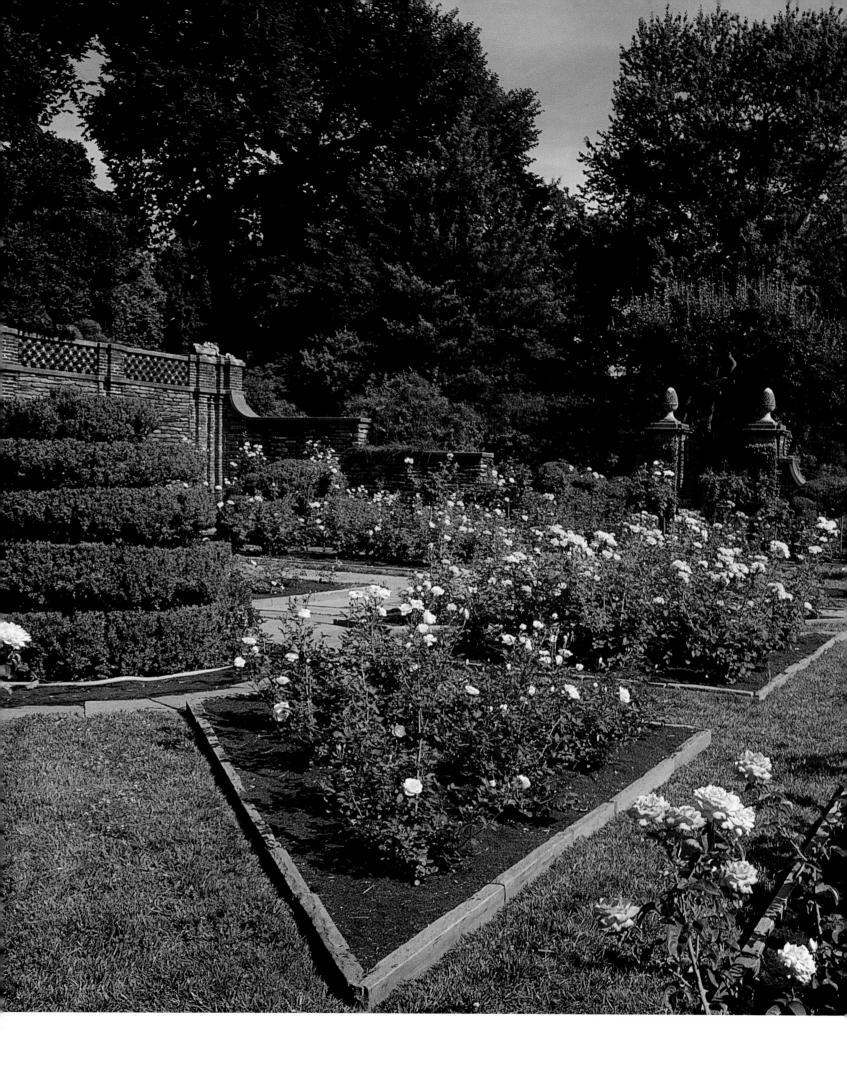

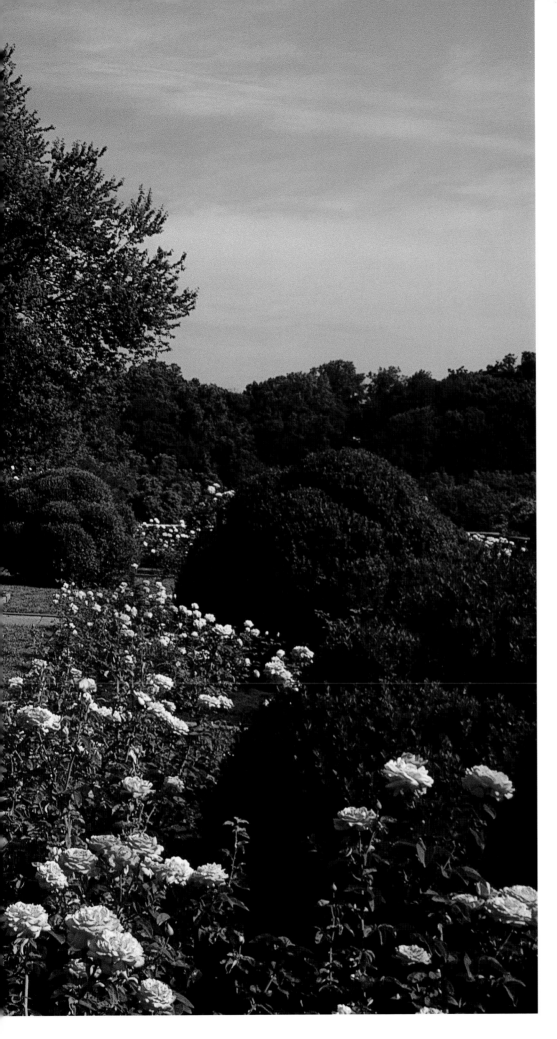

WALLED GARDENS BY TWENTIETH-CENTURY DESIGNERS

BEATRIX FARRAND
Dumbarton Oaks
Washington, DC, USA

The gardens of Dumbarton Oaks in Washington, DC, remain today virtually as they were planned in 1922 by Beatrix Farrand (1872–1959), thanks to two circumstances: first, Mrs Farrand, one of America's most influential garden designers then and now, left a manual on how the gardens should be continued into the future; and secondly, they were given to Harvard University in 1941. Better still, most of her correspondence with the then owners, Robert and Mildred Woods Bliss, has survived.

Dumbarton Oaks, in its unlikely setting on a hill in Washington, was always intended to be a country-house garden, and Beatrix Farrand took many ideas from the trips she made to Europe from 1895 onwards: for example, the ogee buildings that flank the walled kitchen garden were inspired by similar designs at Traquair House in Scotland dating from the seventeenth century. Much else of the formal plan she derived from Italian gardens (her aunt was the novelist Edith Wharton, a champion of the Italian style), while the planting was very advanced for the period: she met William Robinson, the doyen of 'wild

The gardens at Dumbarton Oaks retain their original 1920s character, with formal rose beds, lawns and topiary. They are now owned and well maintained by Harvard University.

135

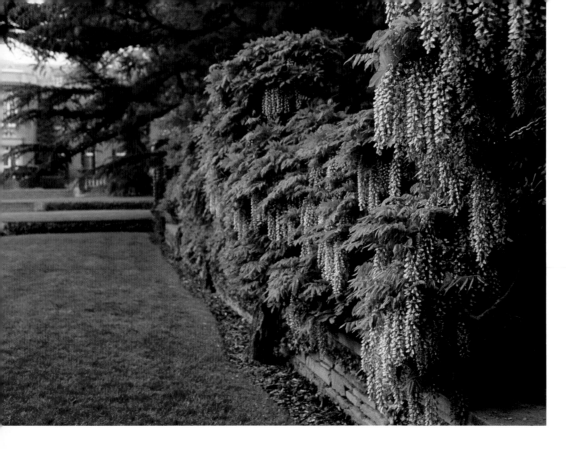

gardening', at his home, Gravetye Manor in East Sussex.

The gardens at Dumbarton Oaks – a series of rooms, walled or hedged, linked with lawns and vistas – were created on ground that sloped down from the nineteenth-century house at the top of the hill. The Blisses, who had bought the house when Robert was assigned to the State Department in Washington, were keen not to offend their influential neighbours. Farrand wrote to the couple: 'While in no way should the planting on R Street look as though it were intended to close out people's view of the place, it should in effect do this but by giving them interesting and pretty plants to look at, with occasional calculated glimpses of the place, arranged so that they will not rake the windows and gardens … .'

This was entirely to the Blisses' taste: 'You have made us purr with contentment', Mildred wrote to Farrand. 'You have got it exactly in every respect!' The designer had first visited the gardens in June 1922, and work started that year, continuing over the years even while both parties were away (Farrand designing gardens

in Europe and the Blisses sent to Sweden for four years and later South America). 'Never did Beatrix Farrand impose on the land an arbitrary concept', Mildred wrote later. 'She "listened" to the light and wind and grade of each area under study. The gardens grew naturally from one another.'

When they returned to Dumbarton Oaks in the 1930s, the Blisses made sure that the gardens were enjoyed to the utmost, not least by holding a party every June, when six hundred guests from the State Department could wander through them. The multiple rooms, and a clever design that provided constant surprises and walks that led naturally from area to area, could swallow even this number. Nowhere was out of bounds: the kitchen garden with its tool houses cunningly designed as pavilions would lead to a second, walled, cutting garden in one direction or a long pergola in the other. Different levels were reached via formal stone steps and magnificent gateways, to be succeeded by informal forsythia paths and a laurel-edged pool further down the hill.

Above, left The gardens are a series of rooms, their boundaries made of walls or hedges that are typically linked by lawns and vistas. The use of wisteria to soften brick is an Italian idea.

Above Money was no object for the owners, Robert and Mildred Woods Bliss, so Beatrix Farrand was able to build charming small pavilions, ideal for the guests who attended the couple's huge garden parties.

Farrand planned the gardens in 1922, and today they are very much as she intended them to be, thanks to the survival of her detailed manual.

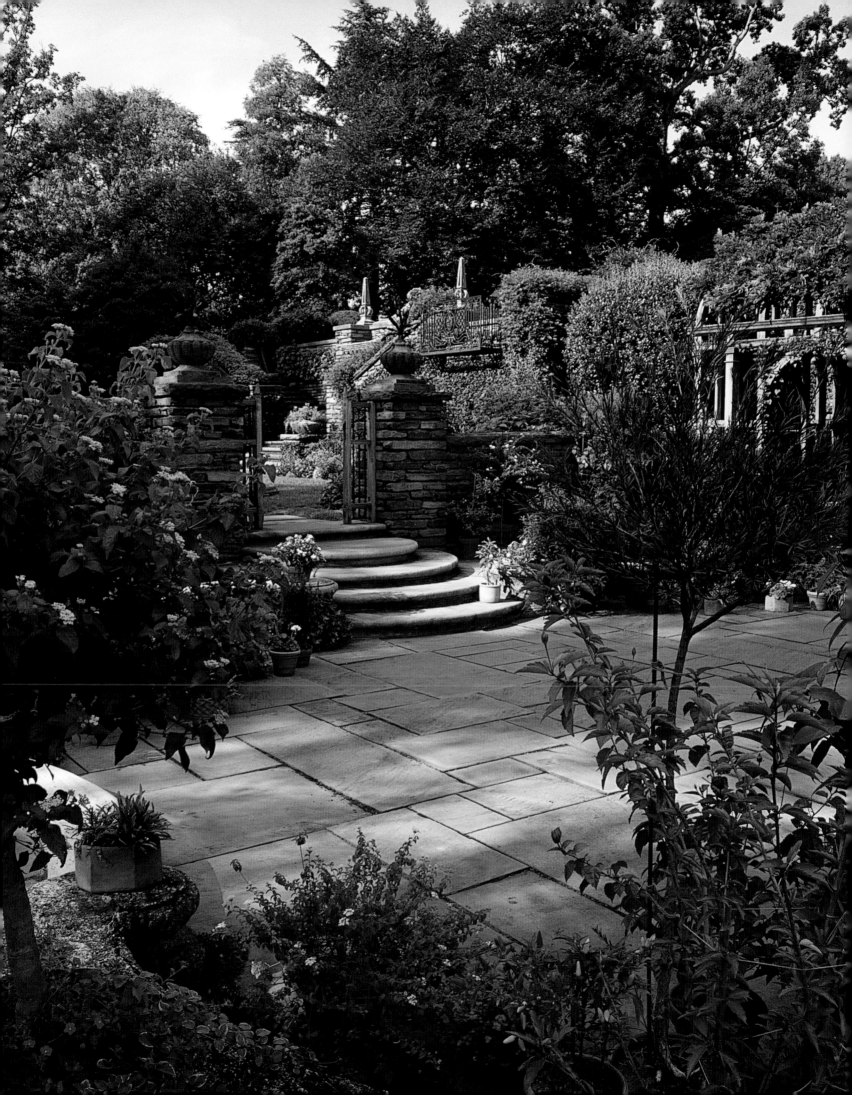

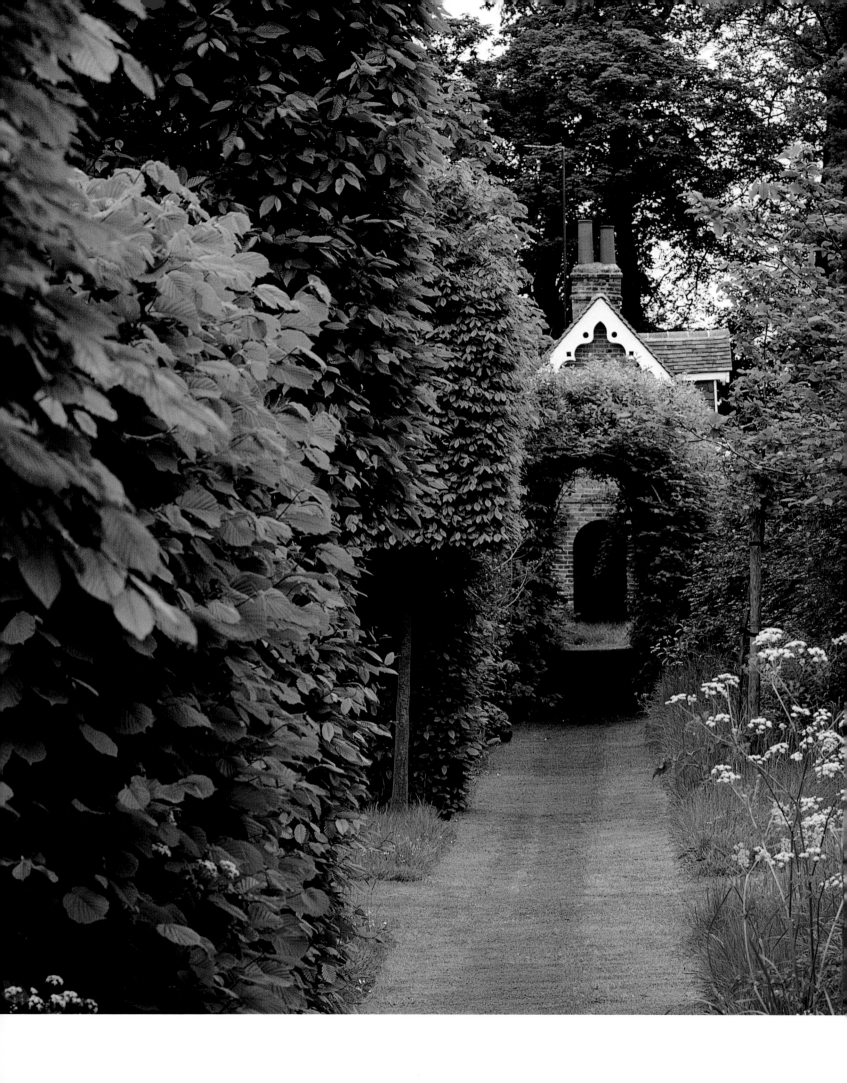

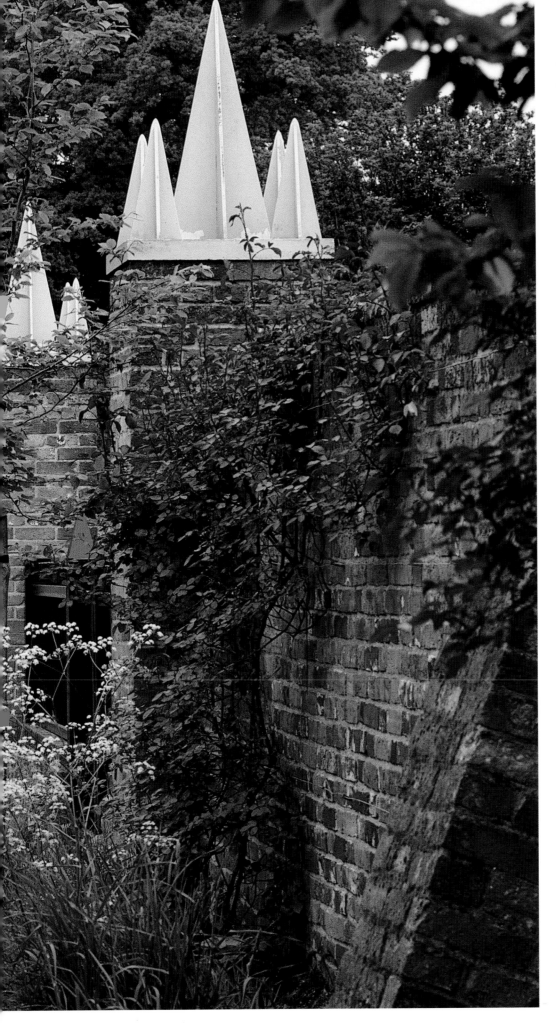

DAVID HICKS
**The Grove
Oxfordshire, England**

The Grove, a superior farmhouse in
Oxfordshire, was the home of the garden
and interior designer David Hicks from
1980 until his death in 1998, and with it,
as he put it, he 'started garden designing
in earnest'. The reason was that, unlike
his former house, at Britwell Salome (also
in Oxfordshire), which was set in spacious
open land with fine views, The Grove sat
in flat land and was enclosed everywhere
by walls and barns that blocked the views.

At first he started to open up the area,
but when his wife, Lady Pamela, gave him
a sixtieth-birthday present of a pavilion to
his own design, he began to create a whole
new area of garden, of small spaces and
secret walled-in rooms. The pavilion is
surrounded by a moat with its own
drawbridge. 'It causes great amusement.
I raise it from within by a hand-cranked
mechanism when I desire isolation from the
world', he said. The building is a tiny castle
with ogee-arch windows, an exercise in
grandeur, a folly in the typical Hicks style.
It stands at the corner of the secret garden,
which is surrounded by a high brick wall.

So as not to make it too secret, Hicks
gave the garden a pierced arched door,
painted a subtle green. 'Pierced doorways,

Nothing is left to chance at The Grove. From outside
the walls, decorated with multiple pyramidal finials
designed by Hicks, an inviting, narrow path leads the
eye to a secluded doorway.

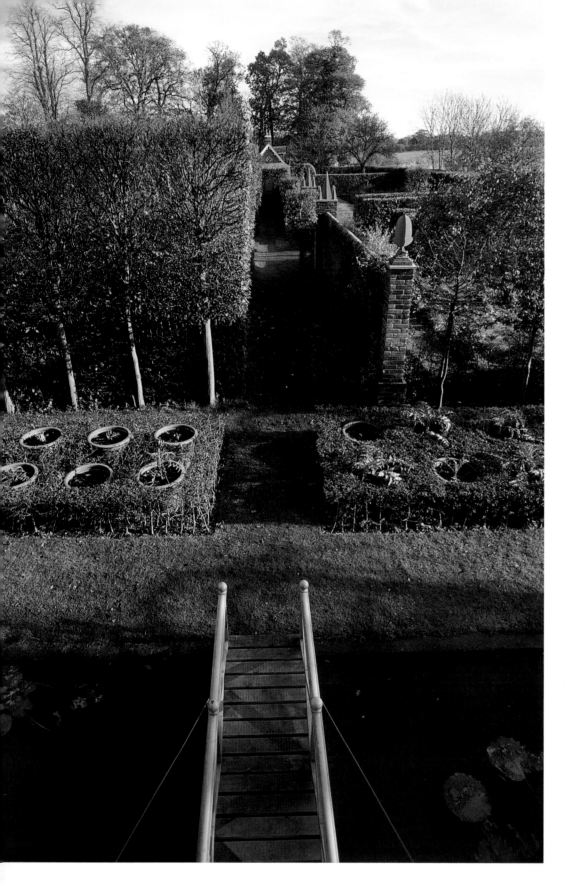

David Hicks was famous as an interior designer, but his inventive gardens brought him equal renown. He treated his own at The Grove as a series of rooms to be decorated.

Hicks was a man of strong opinions, freely expressed. Why, then, while professing a hatred of copper beeches as 'completely out of place among the soft greens of England', he should create a separate garden entirely walled with them is a mystery. He merely said it delighted him to create this Red Room, surrounded by leaves of the darkest copper augmented by the brilliant-red rose 'Danse du Feu'.

Elsewhere at The Grove there are elements of such Italian gardens as that at Villa Gamberaia (pp. 42–45). An *allée*, enclosed by high hedges, leads to a deliberate vista of fields, framed by piers with amusing painted pinnacles designed by Hicks. Other hedges are used to create dark, narrow passages leading to eye-catchers, such as statues, urns or *cottages ornés*.

This is a garden by a designer at the height of his powers, and it was fully documented by Hicks, who kept all his sketches. It is complex, formal and informal by turns, and full of surprise glimpses through ornate doorways. As Hicks said, 'apertures are extremely important in garden design. A tall, narrow gap between hedges, an opening in a wall, the way through from one part of a garden to another lends excitement and drama to the atmosphere.' The garden is a theatrical experience.

whatever the style, add enormous interest to a garden when carefully integrated with their surroundings. The arched gateway … framed the carefully positioned urn completing the vista.' Then the master of formality adds a rider: 'I sometimes found myself becoming over-preoccupied with straight lines, so I allowed the element of human error to creep into the most formal of approaches. This gives a certain warmth to what could otherwise be too austere.'

Left, top Hicks once said: 'I sometimes found myself becoming over-preoccupied with straight lines, so I allowed the element of human error to creep into the most formal of approaches.'

Left, middle The designer used prosaic MDF to create this modern take on a Gothick pierced doorway. Painted dark green and arched, it gives a beguiling view from inside the walls out to a pleached hedge.

Left, bottom The influence of Villa Gamberaia is evident at The Grove. A formal lion's-head water spout is surrounded by decorative stones and shells, whereas the Tuscan original has tufa.

Below A turreted pavilion recalling a tiny castle was a birthday present to Hicks from his wife, Lady Pamela. It stands at the corner of a secret walled garden and has its own moat and drawbridge.

WALLED GARDENS BY CONTEMPORARY DESIGNERS

The present interest in walled gardens created by contemporary designers probably stems in large part from their work at the Chelsea Flower Show in London. In a way, almost every show garden – that is, those outside the marquee – is a walled garden, because each designer has to cope with the obtrusive background of the show. Whether this is the unsympathetic, bright-white backdrop of the new plastic marquee or the slightly more accommodating vista of brick walls, fences and roads, all such views are best hidden. Each designer must therefore erect some kind of elegant barricade. Walled gardens, as explained in the introduction, are places where the wall is used to separate one section of a garden from its neighbours. The minuscule but majestic Chelsea show garden certainly qualifies for this description.

Modern garden designers seem little concerned with the great sweeping landscapes of the eighteenth century; there are some, but they are not particularly recent examples. They include Charles Jencks (born 1939), whose most famous design is the Garden of Cosmic Speculation, near Dumfries in Scotland, where terraced earthworks are certainly in the landscape tradition, and Ian Hamilton Finlay (1925–2006), at whose long-term project, Little Sparta, the bleak countryside of Lanarkshire in Scotland is incorporated into a philosophical and poetic design.

The courtyard, roof garden, desert garden and oasis garden are more the focus of current practice. Take, for example, the garden designed in 1997 by Ron Herman, heavily influenced by the gardens of China and even more so by those of Kyoto in Japan. In a courtyard in San Francisco, bamboos are placed against off-white walls, with chequered terraces of moss and pebbles.

Another example from the same city, and created in the same year, is Topher Delaney's roof garden for the Bank of America.

Andy Cao, a South Vietnamese now based in San Francisco, alludes in this Los Angeles garden to his country's salt industry by setting heaps of glass in water.

Here, again, Japan is a dominant influence, with 'scholar' rocks carefully placed against a base of plain tiles. The only planting is a spare line of spiky foliage against a low wall, but colour and movement are provided by a series of windsocks of red, puce and sky blue that strain against the ever-present breeze in San Francisco. Delaney has thus replaced plants with another unpredictable, natural phenomenon, the wind. And, like Herman (and Jencks and Hamilton Finlay), she uses the garden as a metaphor. In New York another rooftop takes up the theme of chequers with squares of charcoal and creamy-white pebbles almost randomly planted with mauve and white foxgloves. This is the work of Madison Cox for a Manhattan showcase block. The roof's 'walls' are an evergreen hedge with a white-painted chimney hung with box trees in ornamental pots. This garden combines the influences of the Orient, Le Nôtre and Cubism.

While these American designers are all influenced by the East, Andy Cao is a designer who was born there, in South Vietnam in 1965. In his Glass Garden, in Los Angeles, the carved wooden walls are painted purple, and blue glass chips (which are safe to walk on) are spread out to form a 'lawn'; piles of plain glass chips are half-submerged in a blue pool in a reference to the mounds of roadside salt Cao remembers from Vietnam (pp. 142–43). Glass has become a common feature of modern gardens of all types. Plastic is another material that is much used in today's walled gardens. In his Plastic Garden, in Northampton, Maine, Dean Cardasis uses sheets of red and yellow plastic to make walls. An area of plain gravel is intended to reflect the patterns and colours when the sun shines through the walls. In the Site of Reversible Destinies in Kyoto, a collaboration between the Japanese Shushaku Arakawa (born in Nagoya in 1936) and the American Madeline Gins (a New Yorker, born

1941) has created a 'fusion' garden. The blocky surrounding walls are surmounted at intervals by strange green flattened discs, while inside the walls a Japanese strolling garden with evergreens and grasses allows the visitor to experience new vistas and surprises. In this case, however, the surprises come in the form of buried kitchen units, sofas and deconstructed roofs. The garden, like many others recently constructed, is more than it seems; its intention, say the designers, is to destabilize the visitor before opening up a new horizon.

Another Japanese designer, Tadao Ando (born 1941), prefers to do without real plants, though water remains an essential feature, as in many of today's walled gardens. His Garden of Fine Arts, at the Fine Arts Museum in Kyoto, Japan, is bounded by sleek modern buildings with huge glass windows. In a reference to the museum's purpose, Ando has projected a reproduction of Monet's *Water Lilies* on to the bottom of a long, clear pool: planting without plants. In his Courtyard Sculpture Garden (1953) at the Museum of Modern Art in New York, the American architect Philip Johnson (1906–2005) also combined works of art with water in a courtyard. Plants are again subordinated to the hardware: monumental bronze nudes, abstract sculptures and even a small statue of a goat are surrounded by Bauhaus wire chairs, along with a few sculptural trees and ground-cover evergreens. Movement comes from a playful series of small jet fountains that spring up within a rectangular pool. The inspiration for this garden, as for so many Modernist designs, was the German-born American architect Ludwig Mies van der Rohe (1886–1969). Another major influence is the multicoloured tiles beloved of the Spanish architect Antoní Gaudí (1852–1926). Raymond Jungles (born 1956) – aptly named, for his garden in Florida abounds with huge bananas, chunky bamboo and palms

– uses mosaics of cracked multicoloured tiles to decorate the surrounding walls and, once again, a chequer-pattern floor made up of flagstones and pebbles.

So, where next? Are plastic, glass, infinity pools and manufactured mist played out? Will the herbaceous border return after decades of bamboo and two irises? There are signs that Modernism, seen at its most extreme in the brutal concrete constructions of the twentieth century, is beginning to relax. Designers, having shown that superb walled gardens can be created without a single plant, that brilliant colour is not anathema to nature, and that technology certainly has its place, feel they have now proved themselves. After just a few years, the shock that some felt on seeing concrete caissons taking the place of vines and ivy, and violently coloured plastic used as a substitute for the glories of bougainvillea, has dissipated. The walled gardens of the second half of the twentieth century are as much design classics as are the Eames chair and Norman Foster's revamped Reichstag in Berlin.

Following Japanese tradition, Tadao Ando designed his Garden of Fine Arts in Kyoto without plants. The 'walls' are encircling Minimalist buildings.

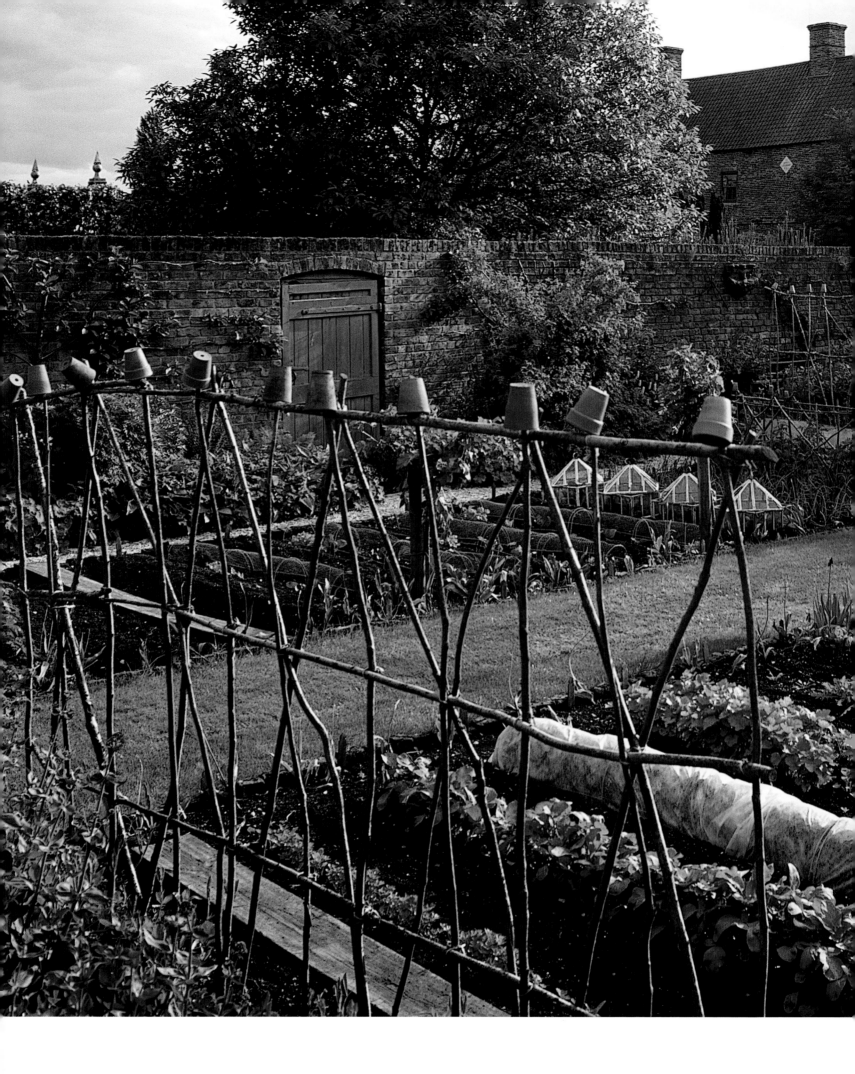

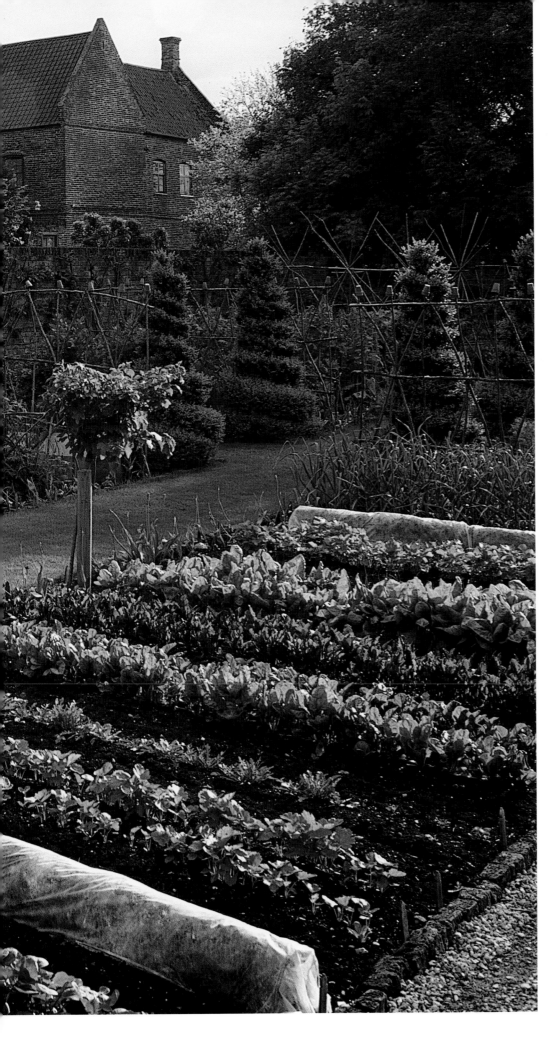

ARNE MAYNARD
Guanock House
Lincolnshire, England

Guanock House is set in the flattest part of Lincolnshire, a place of dykes and immense, unhedged fields. The house is a fine, upstanding farmhouse of mellow brick with a tiled roof and eighteenth-century windows added to a sixteenth- and seventeenth-century structure. However, it would be hard to imagine a more difficult place to make a garden: the site is not just flat but also surrounded on all sides by cornfields.

But this is where, in the 1990s, the garden designer Arne Maynard decided to settle and create his own garden, before he became well-known (his reputation was already becoming established when the garden he co-designed with Piet Oudolf won 'Best in Show' at the Chelsea Flower Show in 2000, against hot competition). Even during his early designs for Guanock he was already showing the combination of sensitivity, simplicity and willingness to continue traditions that inspire his work.

Maynard understands flat landscapes, and in *Gardens with Atmosphere* (2001) he writes that these are 'powerful and dominant. The sky is huge and the vistas stretch to the horizon, almost unimpeded … . Such a landscape is full of energy and

The walled garden at Guanock is mostly given over to vegetables, planted in the traditional manner. Here the designer's intention was to be as invisible as possible, with no fancy tricks.

147

can be invigorating.' However, gardens in these places need 'hedges and walls, which create a comforting, safe haven and a sense of scale in such a vast sea of land'. And this is what he has made at Guanock.

The gardens were 'haphazardly dotted with silver birch trees, elders and rusting corrugated iron sheds'. The walled vegetable garden did not exist, so Maynard built the walls, which look ancient, and brought in tonnes of the rich black soil of the Fens to replace the worn-out earth. 'The walls gave the kitchen garden a microclimate that was quite different from the rest of the cold, exposed site, and once they were in place I could grow the plants I wanted.'

The walled garden is now reached through a wooden door that gives no hint of the pleasures within. On one side there is a series of outbuildings, handy for potting and storage. Maynard speaks of its 'overall sense of safety, serenity and protection, but each room has a different mood'. The mood of the vegetable garden is traditional, prolific yet controlled. It stands on the boundary of the farmhouse's land and is reached through a series of trees (pleached or in avenues) and then by a formal lawn parterre. 'When I open the oak door in the wall and step into the garden, I have an overwhelming sense that I have come into an oasis in an unrelenting and rather forbidding landscape of prairie and sky.'

The use of traditional methods of vegetable growing helps this feeling of security: to support the runner beans Maynard uses bean sticks with old terracotta pots at the top; Victorian square-walled cloches are used to bring on tender plants; upturned horse-shoes found in the garden sit in a row against the brick wall for luck; and a line-winder is employed to ensure lines are straight. 'Old tools like this are a marvellous link to the past', says Maynard. He makes labels for the vegetables from off-cuts of wood, and at the end of the year he puts them all in a box as a record of what was grown that season, for he is also a passionate cook.

Maynard simulated ancient garden walls by using warm-coloured salvaged bricks to create a rectangle, one side of which is old brick garden sheds.

A wooden door leading into the new walled garden deliberately keeps the secrets inside. The designer has made no attempt to impose his personality.

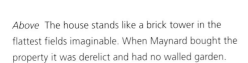 *Above* The house stands like a brick tower in the flattest fields imaginable. When Maynard bought the property it was derelict and had no walled garden.

Above, right Traditional propagating and growing equipment is used throughout the walled garden, from these Victorian glass cloches to twigs made for climbers and surmounted with old-fashioned clay pots.

Right Guanock House is set apart from the walled garden, and the whole area is planted to suggest a 'comforting, safe haven and a sense of scale in such a vast sea of land'.

PIET OUDOLF
Scampston Hall
North Yorkshire, England

The story of Scampston Hall's walled garden is a classic one: in 1933 twenty-two gardeners were employed at the house, but after World War II the number dropped to eight. A gradual slide into dereliction began, and when Sir Charles Legard inherited the estate in 1984 the 1.8-hectare (4½-acre) walled space was used as a sheep paddock. When they had sorted out the house Sir Charles and his wife, Lady Caroline, turned their attention to the walled garden and made a brave decision to call on the famous Dutch designer Piet Oudolf to make the necessary transformation. In 1998 Lady Caroline had visited Bury Court in Surrey and seen the garden he had created; there she had met Oudolf himself and decided that he should be their designer.

Lady Caroline's brief to Oudolf was clear and simple: keep the listed walls, greenhouse and elliptical pool, and the rest is yours. Oudolf started by dividing the huge space into eight separate rooms that were all rectangular but by no means similar or symmetrical in shape. An avenue of limes extending along three of the four walls directs visitors around the edges of the garden before they reach the centre.

The perennial meadow at the centre of Scampston Hall's walled garden is planted for maximum colour, but Piet Oudolf also had his eye on different textures and leaf forms.

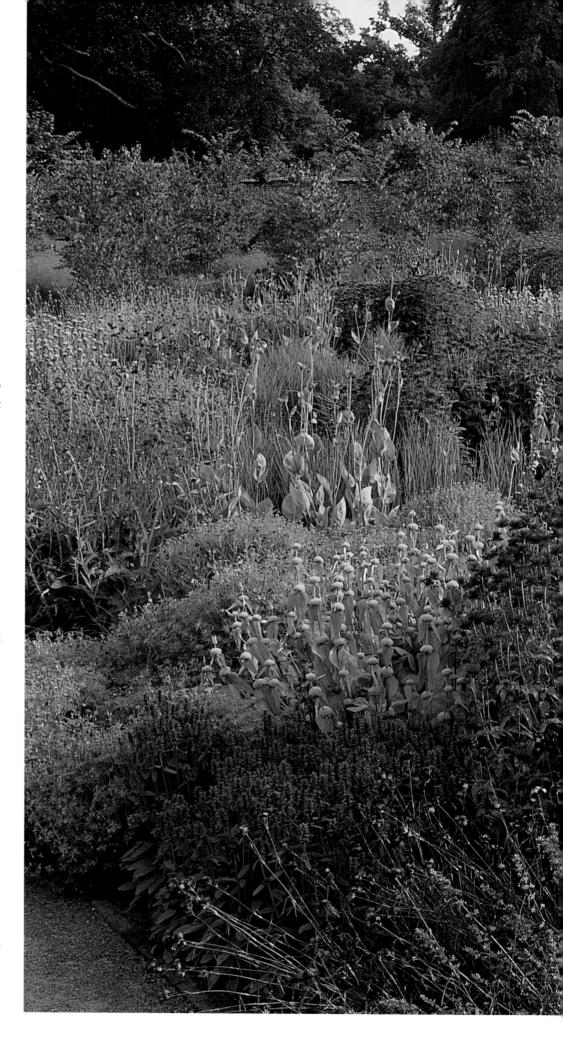

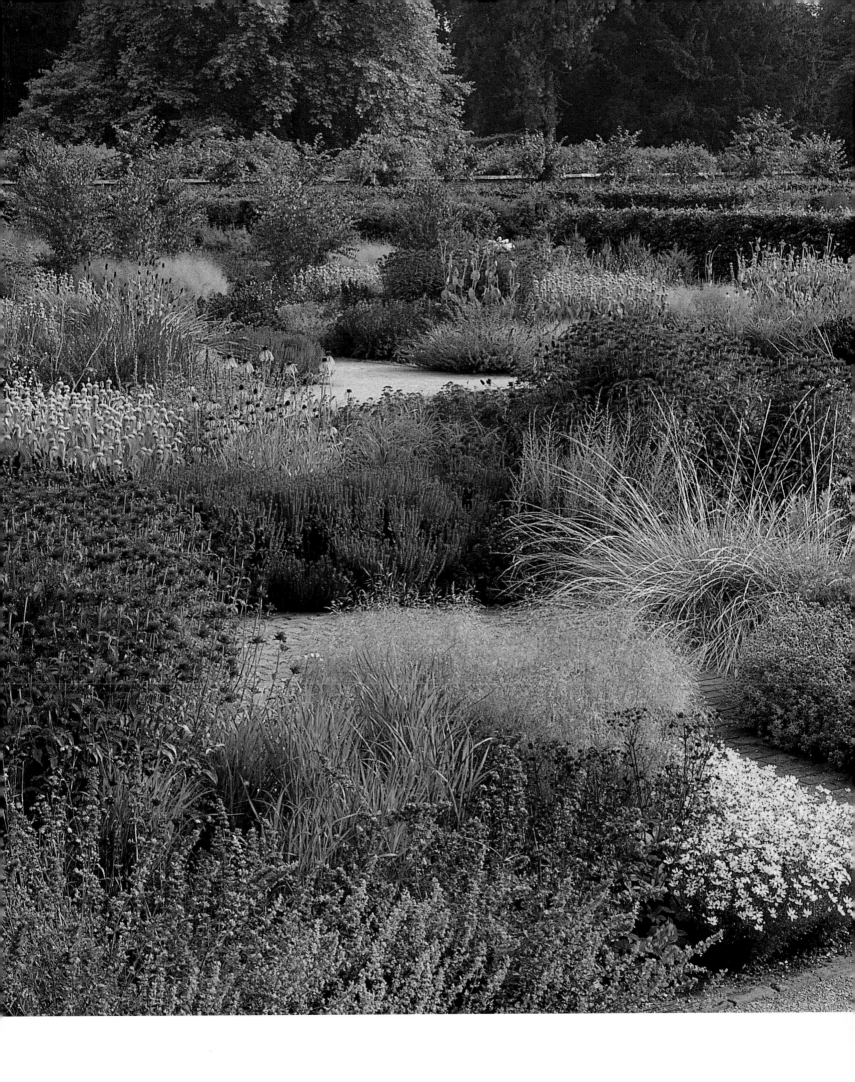

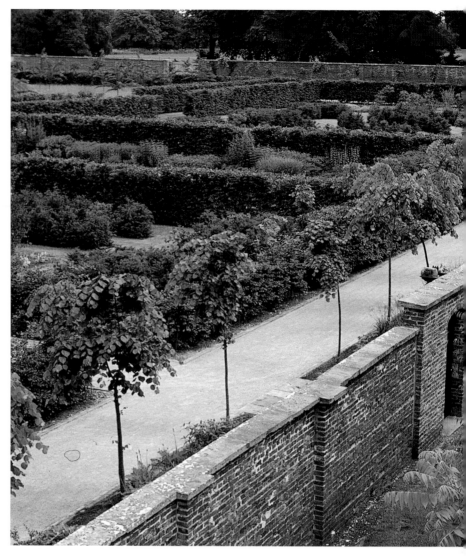
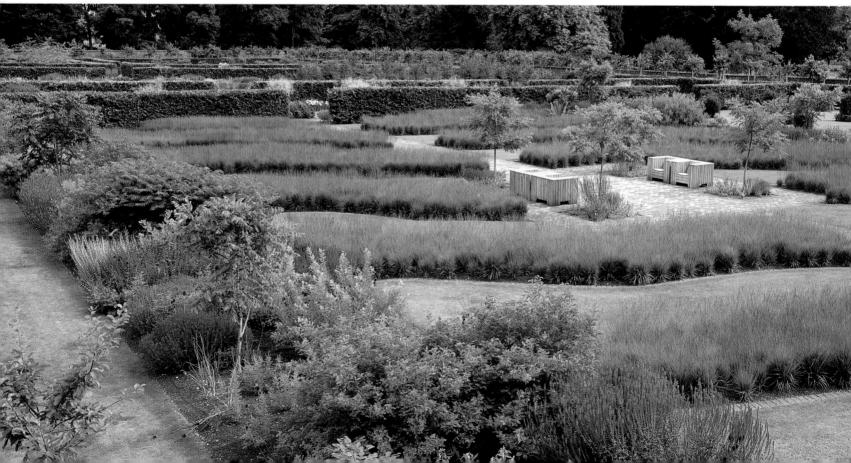

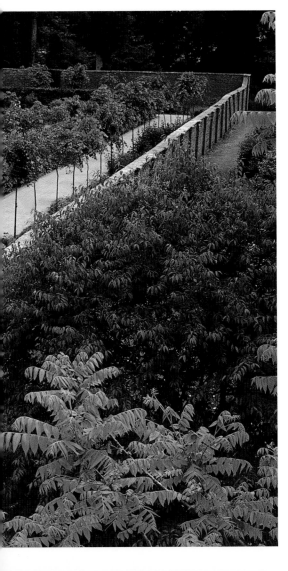

There, Oudolf made distinct gardens named the Serpentine Garden (snakes of clipped yew), the Silent Garden (round columns of yew intended to reach 3 metres/ 9¾ feet high), the Perennial Meadow (drifts of perennials around the pool to give maximum seasonal colour) and Drifts of Grass (swathes of molinia contrasting with a close-mown lawn). The Katsura Grove has *Cercidiphyllum japonicum* underplanted with woodland-loving plants, and there is a mound from which the whole design can be appreciated in a bird's-eye view.

Planting of the hedges and trees to define these gardens began in 1999. (By coincidence, this was the year when Oudolf and Arne Maynard were composing the garden that won 'Best in Show' at Chelsea the following summer, cementing both designers' reputations.) The huge work of propagation, by Scampston's head gardener, Tim Marshall, was already in progress. The 1.6 kilometres (1 mile) of hedges needed four thousand beeches, and two hundred limes were planted for the avenues around the edge of the garden. This took until 2000; shrubs

came next, followed by perennials in 2003. Oak chairs and benches were designed by Oudolf's colleague Piet Hein Eek. At the time of writing, a mere three years later, the garden's planting and plans are clear, even though the yew and box bushes are still immature.

As Dan Pearson, another leading garden designer, points out, Scampston is not typical of Oudolf designs, which rely heavily on grasses: 'Interestingly, the rooms beyond [the Drifts of Grass garden] are clear of perennial grasses, which gives a more traditional feel than one usually expects from an Oudolf planting. I particularly liked one of the garden rooms of simple still water and yew columns that acted as a counterpoint to the undulating meadow.'

Indeed, Scampston is a garden that works on all levels, including the aerial view. There are areas of calm and serenity, busy rooms where the wind blows the grasses, and clever vistas, all of them stopped at some point. Visitors are offered an additional treat, for there is a first-class restaurant and delicatessen.

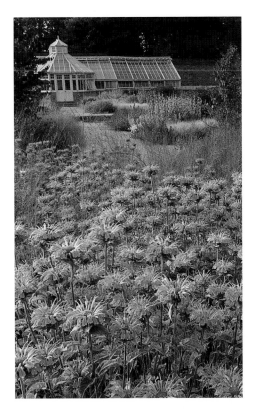

Opposite, top left Faced with 1.8 hectares (4½ acres) of derelict walled garden at Scampston, Sir Charles and Lady Legard took the brave step of calling in Piet Oudolf, one of the world's leading garden designers.

Opposite, top right Oudolf designed a gravel path to run right round the garden's walls, with fairly narrow borders of herbaceous and shrubby plants edged by a formal lime avenue along three of the four walls.

Opposite, bottom Among Oudolf's signatures is the planting of areas of waving grasses, as he enjoys their movement. In his Drifts of Grass, wavy beds of molinia contrast with smooth, formal lawns.

Left Huge blocks of colour are a characteristic of modern Northern European gardens. Here the designer has planted a great swathe of bright-purple asters with a large greenhouse as a backdrop.

153

HENK GERRITSEN
Waltham Place
Berkshire, England

Waltham Place has been owned by the Oppenheimer family since 1910, but it was a trip to Priona, Henk Gerritsen's garden in The Netherlands, that inspired the present Oppenheimers, Nicky and Strilli, to ask the Dutch designer to rework their old walled garden. Gerritsen's first aim was to loosen its formal structure: 'I chose a diagonal box hedge to break the almost stifling formality and to add depth. However, a straight diagonal hedge would not have been sufficient. Therefore I wanted the hedge to move back and forth and to be clipped in irregular shapes to add even more depth and, most of all, playfulness, a quality that, in my opinion, is bitterly lacking in any formal garden.' This is his Box Caterpillar.

'Though it might have been obvious to choose the same kind of planting on either side of the box hedge–lawn strip, the need to cut down on maintenance, and Strilli Oppenheimer's wish for a garden that would not need watering, made me choose gravel and a drought-resistant planting on the hot, south-facing side whereas the cooler, north-facing side could be lush and bold. I've been told the garden kept up remarkably well, without any watering, during a drought.'

Waltham Place's planting is very unusual, with weeds among the plants. A mass of bright-green euphorbia bulges in front of an old brick building.

Strilli Oppenheimer refuses to allow
the use of chemical fertilizers or
pesticides. This is a garden that breaks
many rules: one area has been filled with
plants that attract butterflies, and another
with native plants and herbs, and even
weeds are not rooted out: ground elder
is encouraged and tall wigwams are used
for bindweed. 'I am a gardener of place
who seeks to work with nature', says
Mrs Oppenheimer.

Gerritsen's planting, he explains,
is designed to connect the two different
sides of the garden: 'I have introduced
a number of biennials like mullein and
umbellifers like hogweed which will be
allowed to seed freely. In due time a
balanced picture will develop – I hope!'

Left Here are the grasses in December, still glowing in
the winter sun. The calamagrostis complements rather
than challenges the soft-red-brick walls.

Below, left Strilli Oppenheimer's brief was for a low-
maintenance garden that would need no watering in
summer. Gerritsen chose drought-resistant planting
for the hot, dry areas.

Opposite, top The walled garden in June with water
lilies afloat in the old pond. Like many Northern
European designers Gerritsen works with grasses,
which he plants for their movement and colour.

Below A series of paths and trees holds the whole
informal design together. At the very end of summer
grasses continue to supply colour.

Opposite, bottom right The walled garden is almost
wild in its atmosphere, as in this area filled with
brilliant heleniums, where a blue-and-white Chinese
seat provides colour contrast.

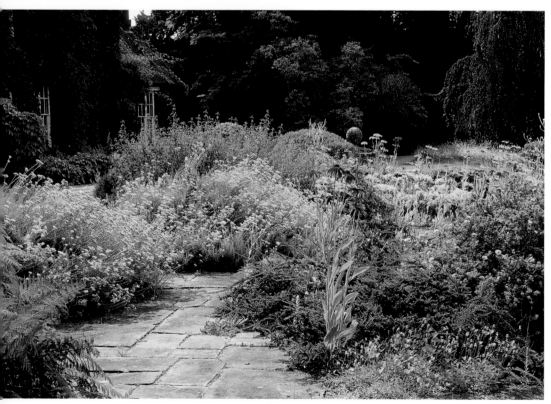

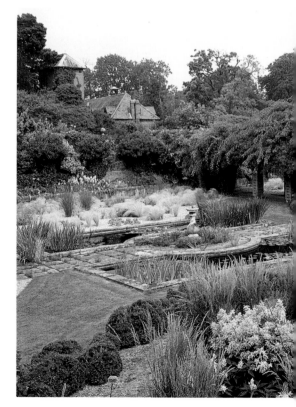

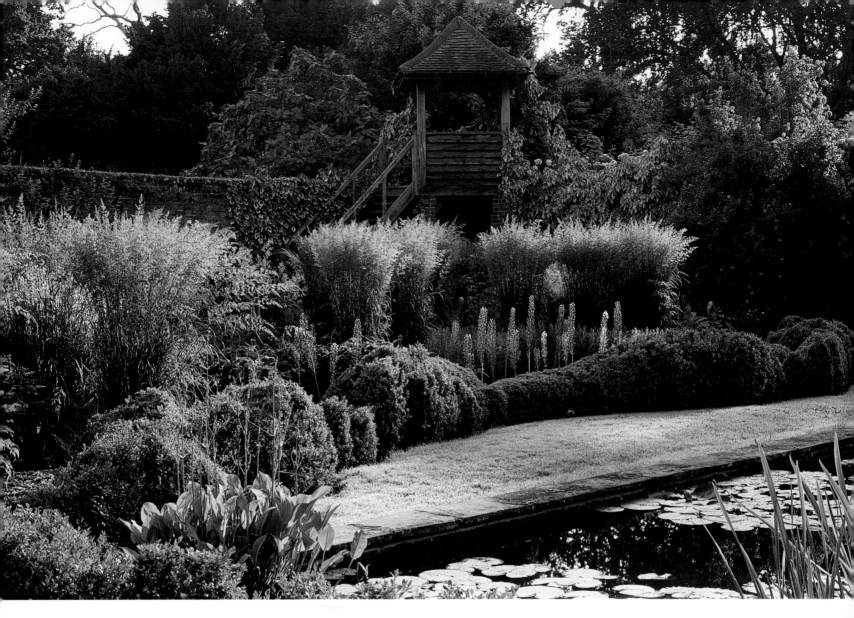

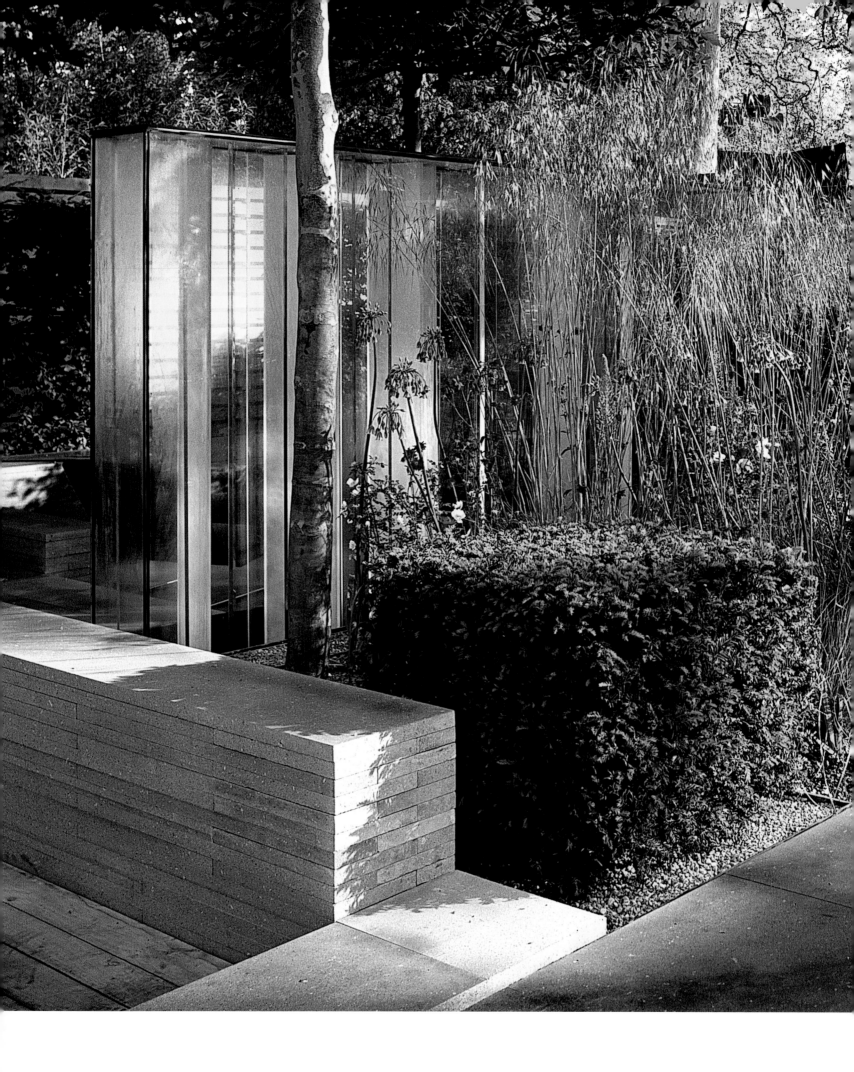

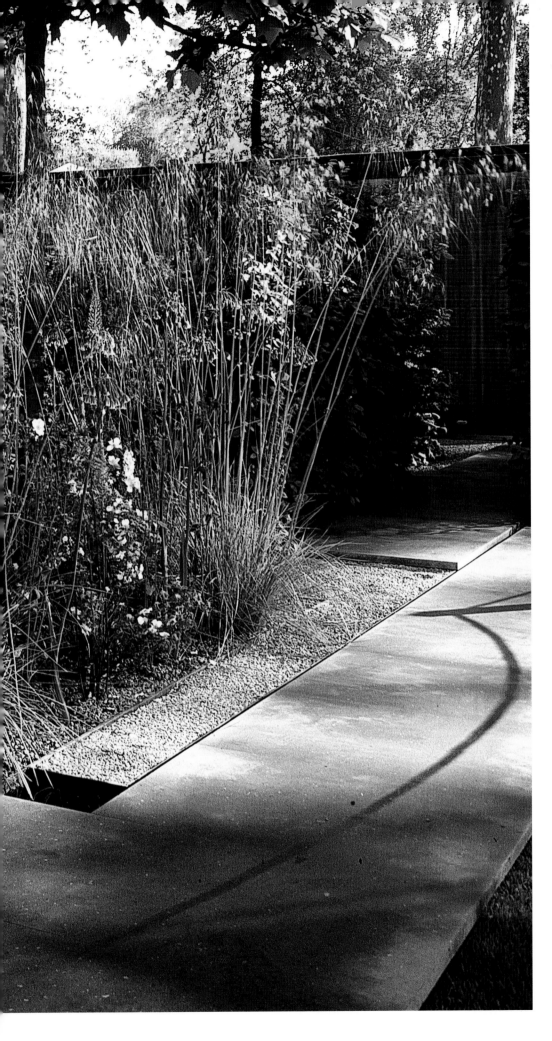

CHRISTOPHER BRADLEY-HOLE
Hortus Conclusus
Chelsea Flower Show 2004
London, England

Hortus Conclusus was designed by
Christopher Bradley-Hole as a show
garden at the Chelsea Flower Show
of 2004, and so no longer exists. It is
included here because it is a twenty-first-
century vision of the age-old walled
garden. Indeed, Bradley-Hole says as
much in his explanation of his design:

'Our modern garden is inspired by
the tradition of enclosed gardens, such
as the early Islamic gardens. Historically
the enclosed garden was a reaction to its
setting. In contrast to the barren landscape
by which it was surrounded, it brought
shade, water, planting and order. The
idea of enclosure was practical but it
also engendered an emotional feeling
of shelter, control and abundance.

'This concept can be traced through
the medieval period when the garden was
seen as an expression of the surrounding
landscape while also excluding it. Such
ambiguity is one of the reasons the concept
of the *hortus conclusus* is so intriguing
… . Our garden at Chelsea is inspired by
these historical developments but also
by Modernist principles so that it is a
modern abstract expression of an idea
fundamental to garden-making
throughout history.'

A plain stone bench and lofty *Stipa gigantea* provide
the foreground for a series of glass fins, encased in
more glass, forming a central barrier.

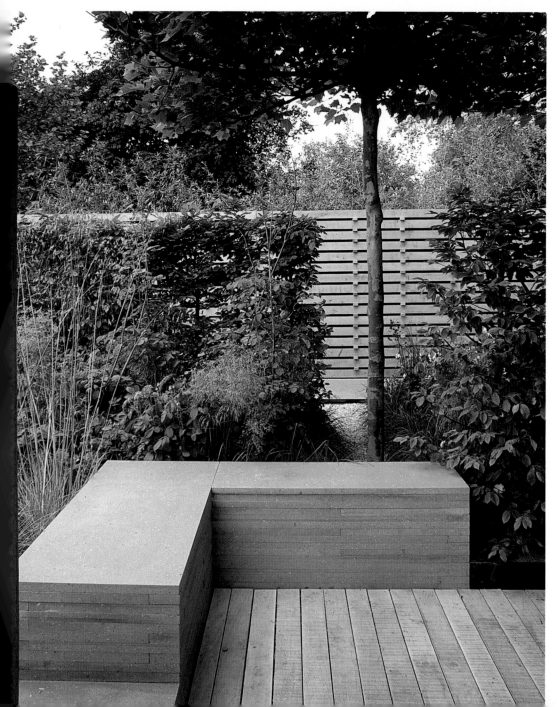

The garden plan is severely geometric. It is walled on one side with horizontal planks of green oak, its texture deliberately left rough, and at the back with laminated basalt intended to look like stratified stone. The ground is flagged in grey volcanic basalt. As in all Islamic gardens, water is crucial: rills and still pools of water run throughout the garden, visible through cracks in the paving, and there are fountains and a waterfall at the far end. Glass fins in a glass case make a synthetic hedge, as does a quincunx of oak slats, a pattern used in ancient Arabian gardens. Within this minimal plan Bradley-Hole has created planting that is both carefully considered and lyrical. Six pruned plane trees sit at the garden's centre, providing a leafy canopy above and dappled shade below. Hedges of bright-green hornbeam and dark yew further divide the garden.

Colour comes from no fewer than twenty-two types of rose, most old-fashioned or species. These include *Rosa* 'Blanche Double de Coubert', *R.* 'Charles de Mills', *R.* 'Ispahan', *R. rubiginosa* and *R.* 'Tuscany Superb'. *R.* 'Ispahan', Bradley-Hole remarks, is possibly Persian. The colours are chosen in a range of pinks and dark and pale reds, with the species roses added for form and wildness. Planted among them are such perennials as eremurus, geranium, *Knautia macedonica* and *Nectaroscordum siculum*, along with seven grasses. 'The perennials are chosen for their form and their deep hues [and] the planting is held together by a matrix of grasses. *Deschampsia cespitosa* and its forms, *Sesleria caerulea* and *S. nitida*, *Stipa gigantea* and *Calamagrostris × acutiflora* 'Karl Foerster' set the perennials and roses in a new context appropriate for an enclosed garden of the twenty-first century.'

This *hortus conclusus* combines shade and water, modern and ancient hedges, exuberant (if disciplined) planting, and areas for outdoor enjoyment, all within the smallest of town gardens. Such inspired walled gardens are available to all of us.

Opposite, top The walls of the garden are intentionally severe. On one side there are horizontally placed planks of green oak, with gaps between them to create geometric patterns.

Opposite, bottom Hortus Conclusus is a twenty-first-century adaptation of the medieval enclosed garden and those of early Islam.

Left Bradley-Hole is a plantsman renowned for using surprising plants in disciplined settings. Hortus Conclusus, the designer says, 'is held together by a matrix of grasses'.

Below A quincunx of oak slats makes another barrier, while in the foreground is a bed of colourful roses. Bradley-Hole used twenty-two rose varieties in the garden.

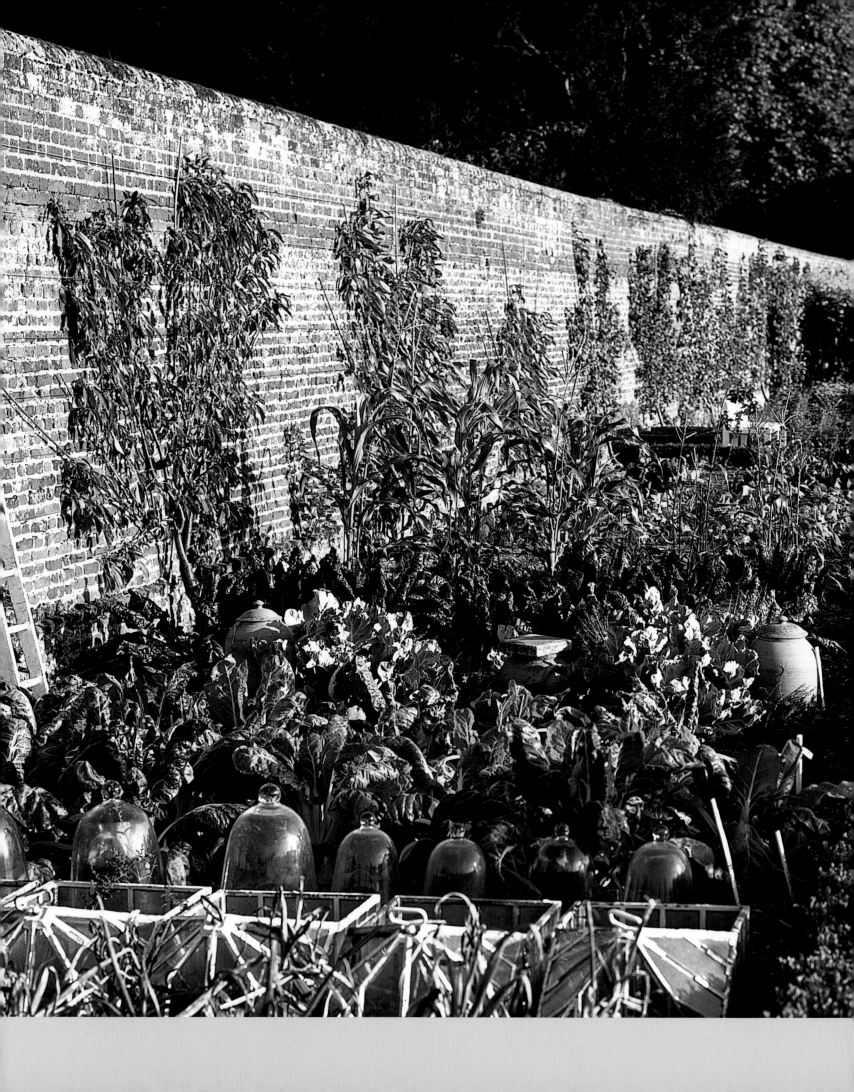

RESTORED WALLED GARDENS

There are two distinct schools of thought about the restoration of old walled gardens. They recall the stance taken by the Society for the Protection of Ancient Buildings and that taken by the Victorian architects who sought to 'restore' churches. The society came into existence in response to what the architects did: wholly altering churches with what were then modern materials. It was violently opposed to such destruction, and insisted on pure authenticity.

While this position is perfectly understandable with regard to a threatened building, it is less so with a garden that has vanished. Yet the preservationists and garden historians are adamant that only true period plants should be used to re-create a monastic herb garden of the twelfth century, a sixteenth-century parterre or a Victorian walled vegetable garden. This causes various problems, not least the fact that many authentic plants of even a century ago have vanished. These have been changed and 'improved' by generations of breeders, so that even if we wanted to we could not reproduce even Victorian vegetables. Moreover, as the gardeners of the English Heritage Victorian walled garden at Audley End (pp. 170–73) have found, there are good reasons why some of these plants have been dropped. Many have little resistance to disease, and, while the gardeners strive for plant authenticity, at Audley End they have given themselves an added handicap: the garden is grown organically, which is something the Victorians, who liberally poisoned pests, never bothered to do. So, should we struggle with unhelpful plants while ignoring the dangerous chemicals and pest-killers of that era, which are equally authentic?

The answer is a qualified 'yes'. There should be somewhere that reproduces as exactly as possible a medieval herb garden;

Like many historic gardens that had fallen into dereliction, the Victorian walled garden at Audley End was restored in the twentieth century by government-funded English Heritage. For authenticity, only old varieties of vegetables are grown there.

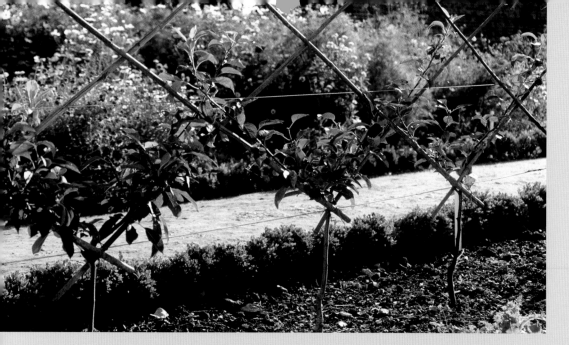

To look their best, all large walled gardens need variation in height. At Audley End fruit trees are espaliered and grown at the edges of the main beds.

there should be a formal walled garden, such as that re-created by Historic Royal Palaces at Hampton Court (pp. 166–69); and the attempts at Audley End are interesting, though the walled vegetable garden is rather disappointing. But such perfect restorations are for museums. The rest of us should have a stab at re-creating the effect and feeling of period walled gardens without becoming too tied up in the obsessive business of exact authenticity.

However, the first step in the restoration of any walled garden should be a visit to one of these living 'museums', for they are an invaluable guide to how to do it: how to lay and space the plants, and how to operate and repair the orangeries, greenhouses, boiler houses and other appurtenances of the big working walled garden. The gardeners there will be full of information: at Audley End their nineteenth-century counterparts had left letters and diaries describing the day's work, and today's gardeners have taken on their skills. They will also know the complications of growing historic plants.

Another reason to visit is that many of these garden 'museums' offer the right kind of plants for sale, whether as seeds or as rooted cuttings. From the Museum of Garden History, next to Lambeth Palace (the London home of the Archbishop of Canterbury), I was lucky enough to get a rooted fig tree made from a cutting of the original planted by the sixteenth-century Roman Catholic Archbishop Cardinal Reginald Pole. Authentic gardens sometimes house plants with such romantic histories.

My opinion on restoration is that the most important part is to get the walls and buildings repaired in absolutely authentic style and to use, where possible, architectural salvage for tiles, bricks, beams and so on. Glasshouses should be restored with glass similar to the original (it can be difficult to find true crown glass but at least the size of the panes should match those of the period). Nothing should be too bright or new: my ideal restored walled garden would always look as though it were well maintained but with a little dilapidation for charm.

When it comes to planting, however, I am less exacting. While I would use old-fashioned roses every time, partly because I love them, I would not care if they were bred in 1670 or 1870 as long as they looked right. The vegetables I would put in my garden would preferably be 'heritage' varieties, but that is because in many cases they taste better. However, if I were lucky enough to have a fourteenth-century cloister wall, I would still grow tomatoes (found with America in 1492), and take advantage of global warming to grow them outside. But I would try to use the plants in a period fashion. I would not, say, use Victorian bedding techniques in a seventeenth-century walled garden; I would try to create my medieval herbery with the typical raised square beds and would use as many 'officinalis' plants as I could. But, if they would grow, I would also have basil and coriander.

The restoration of walled gardens is currently very popular. Where once these calm spaces were treated with disdain – left to become choked with weeds, the old trees ignored, the apples left as windfalls and the espaliered fruit trees entangled with brambles – today they are being reclaimed. Some restorers take the authentic route, putting all the old machinery into working order and going to the expense of reglazing the glasshouses. Others are at least rebuilding tottering walls: one approach is to employ a bricklayer for a few days each week to work his way slowly around the whole, and then leave the ground as plain lawn until inspiration or money arrives. However you decide to do so, it is a great privilege to rescue one of these historic sites.

As the restored gardens at Hampton Court Palace
took shape, topiary, both spiky and rounded, was
put in place to provide variation in height and shape.

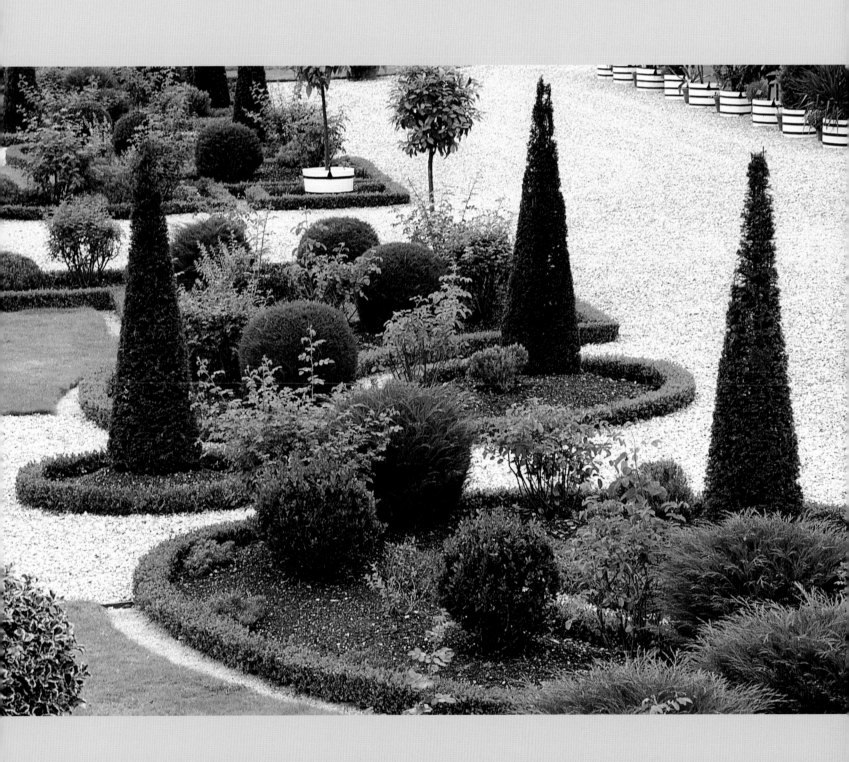

Privy Garden, Hampton Court
Surrey, England

There are two Hampton Courts in
England, and both have a walled garden.
The one shown here is the royal palace
south-west of London, not the grand pile
in Herefordshire, where the garden dates
from the end of the twentieth century.
The first was created by King William III
and his Stuart wife, Mary II, when they
jointly ascended the throne in 1688. It is
a later and possibly grander version of
Het Loo (see pp. 174–77), William's
regal garden in his native country, The
Netherlands. The garden historian Peter
Coats has described the garden at
Hampton Court as the grandest in the
country, with the possible exception of
that at Chatsworth in Derbyshire, but,
unlike that garden, it is in the earlier,
formal Dutch style of many rooms,
walls, fountains and paths.

Hampton Court was also heavily
influenced by Le Nôtre's garden at
Versailles, as William III vied with Louis
XIV for European status and power. In
making his garden William destroyed that
of Henry VIII with its bowling greens,
mound and rose garden. With the help of
Sir Christopher Wren, he had the Tudor
palace and its gardens altered to suit the
times. Wren's is not the only famous name

The Privy Garden at Hampton Court was intended to
be seen from the Palace as much as by those strolling
around its Baroque shapes. Flowers were not needed.

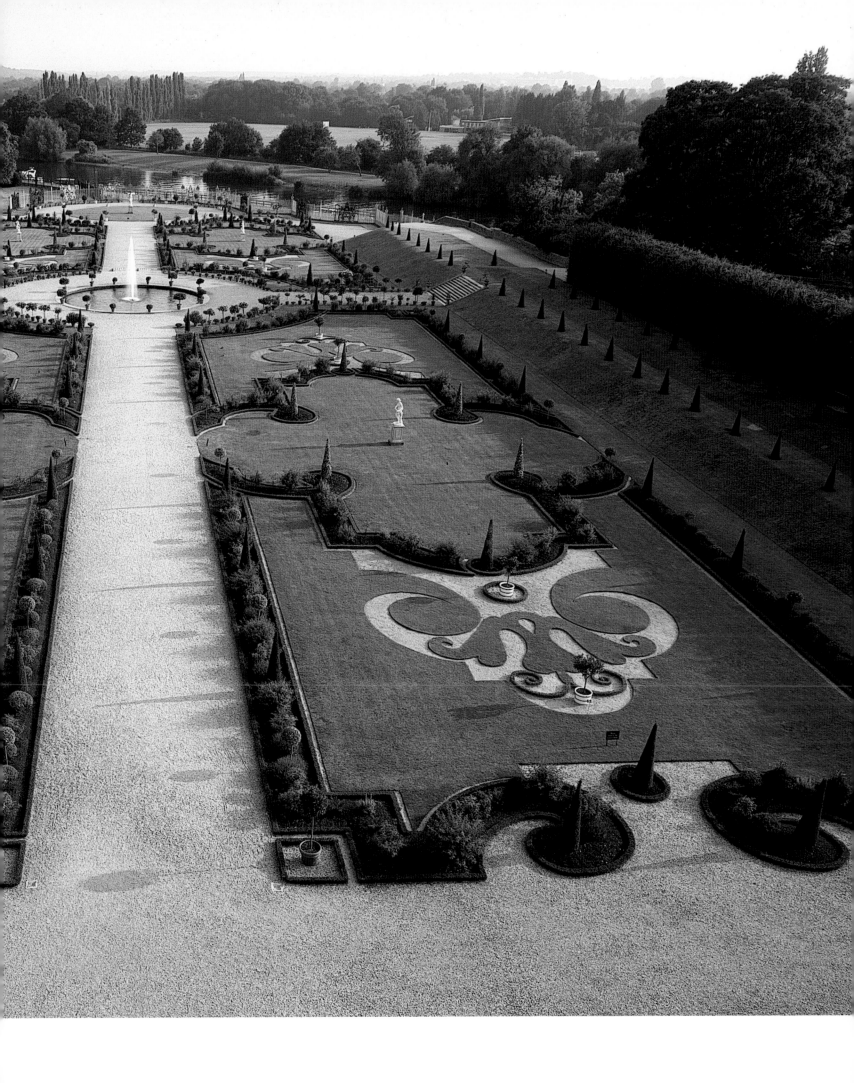

to be connected with Hampton Court; William hired two Frenchmen: designer Daniel Marot, who created some of the parterres, and Jean Tijou, who designed the ironwork grilles (which are still there).

Later George II employed William Kent and Charles Bridgeman, who removed some of William III's formal schemes. In recent years Historic Royal Palaces, the body now in charge of Hampton Court, has set about re-creating parts of the Dutch garden that vanished. The Privy Garden is, says *The Good Gardens Guide*, a spectacular and unique example of the Baroque, with parterres, cutwork, clipped yews, and spring and summer displays of seventeenth-century plants. It now forms a magnificent setting for Wren's south front and the elaborate gilded ironwork railings by Tijou. The restoration was done with extreme care for authenticity, with much examination of the archives and traces left in the ground. Luckily, there is an extremely detailed

drawing of the gardens by Leonard Knyff, engraved by Johannes Kip in about 1690, that shows the gardens in William's day. The Privy Garden is shown both walled and hedged and at right angles to the main axis of the gardens with their complex Baroque patterns leading to a *patte d'oie* series of vistas. A further series of walled or hedged spaces, reducing in size, adjoins the Privy Garden and, in the same way, is bounded by the Thames, which is depicted as busy with barges and sailing boats.

In *The English Garden* (1979) Laurence Fleming and Alan Gore write that 'a certain schizophrenia existed in the English garden at this time. While it was neither wholly Dutch nor wholly French, it was not English either.' Part of the reason was that Dutch garden designers liked their ground flat: a feature common in The Netherlands but less so in England. And, as the engraving demonstrates, this garden is just too formal and ostentatious for English tastes.

Below, left Hampton Court has been owned by the Crown since Henry VIII's time, so the huge archives of the palace and its gardens can be consulted to ensure authenticity.

Below A series of sepia photographs shows the gardens at various points in their existence, charting the changes from highly maintained to almost derelict.

Opposite, top left Over the years the Privy Garden had gradually become overgrown with saplings and weeds, and it was almost impossible to discern the original layout on the ground.

Opposite, top right When restoration started, the first step was to remove all the natural seedlings, saplings and undergrowth and mark out the original design in the bare earth.

Opposite, bottom left After the weeds had been cleared the remaking of the garden began. First the patterned lawns were marked out but not planted.

Opposite, bottom right The planning of such ornate seventeenth-century gardens as the Privy Garden called for intricate geometry. Curves and curlicues like those re-created here could not be left to luck.

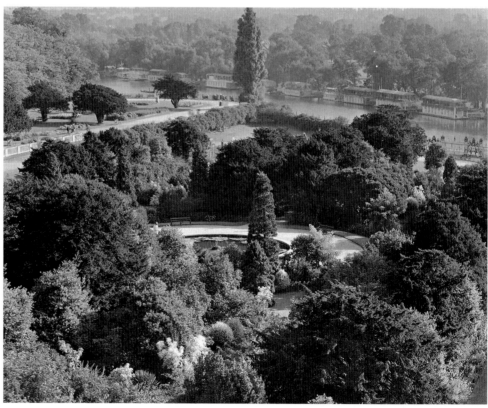

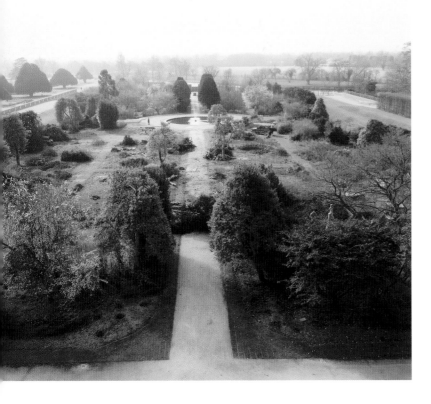

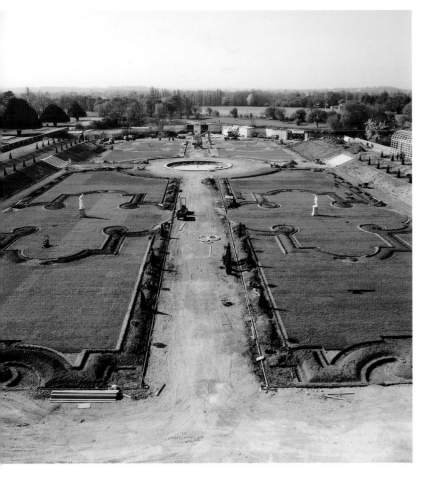
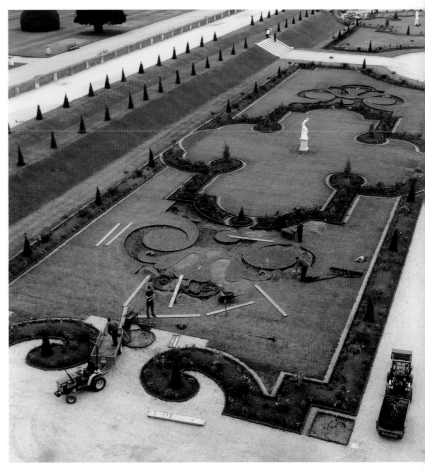

Audley End
Essex, England

Audley End's walled orchard, kitchen
garden and flower garden are particularly
interesting, not only because the owner,
English Heritage, has restored them to
their Victorian grandeur, but also because
it has unearthed an archive – including a
diary kept by one of the gardeners,
William Cresswell, in 1874 – that gives
a clear picture of how this Essex garden
was worked. On 2 June 1874, for example,
Cresswell wrote: 'Wind S. Very close and
warm, and bright. Thunder in afternoon
with heavy showers of rain. Potting off
Tazetes singnata primula [sic]. Mr
Claydon stung by bees whilst swarming.
Stung on eye, swelled very much … .
Catching Bats in evening with net, as they
flew out of corner of room. Sat up late
writing letters to Aunts Mary and May.'

 The boss, perhaps Mr Claydon, was
the head gardener, in rank the equal of the
butler and the agent in charge of the estate.
The holder of this title would be at the
peak of his career. He had status and
security and, at Audley End, lived in the
head gardener's house within the walled
garden (as does the current head gardener).
He would decide the work he did himself,
such expert jobs as grape thinning and

The vegetable garden at Audley End is a complete
Victorian example, from its huge greenhouses
(with vine) to its gardeners' bothies and houses
for growing mushrooms and exotics.

ordering and planting the fruit and vegetables, which were not only intended for the house itself but also sold at market. Another of his roles was that of decorator, which meant supplying cut flowers, potted ornamental plants and buttonholes or corsages for the men and women staying at the house. He would also be involved in organizing exhibits for the local shows, in the hope of winning prizes that would boost the house's standing.

Under the head gardener were foremen, each in charge of a different section: the fruit and vegetable garden, the pleasure gardens and the glasshouses. Under the foremen were journeymen, who at Audley End all lived in the gardeners' bothy. This had a dining-room, a sitting-room and a bedroom for multiple occupation, and local women would come in to prepare meals and clean the rooms. The men were probably not fully trained, and would stay for a few years before being promoted or moving on. William Cresswell lasted only seven months, starting in March and leaving at the end of September. He wrote phlegmatically on 31 August: 'Wind SW, rather strong, fine, though cloudy at times but very drying up till 4pm then became dull and rained (very fine) in evening. Putting netting to Fruit trees in Orchard house. Early potatoes taken up and stored in P-house. Received from Mr Bryan £3 9s 4d for month's wages, also notice to leave at end of next month.'

Below the journeymen were labourers who did the digging on piece- or day work; garden boys who were given such unskilled tasks as stone-picking and bird-scaring; and local women who would clean the paths. The walled garden at Audley End enclosed an office, a boiler pit, a bothy, mushroom and forcing houses, a packing shed for sending produce to customers, a mess room for the day staff, and a tool room. Each member of staff – probably about fifteen in total – had his own set of tools.

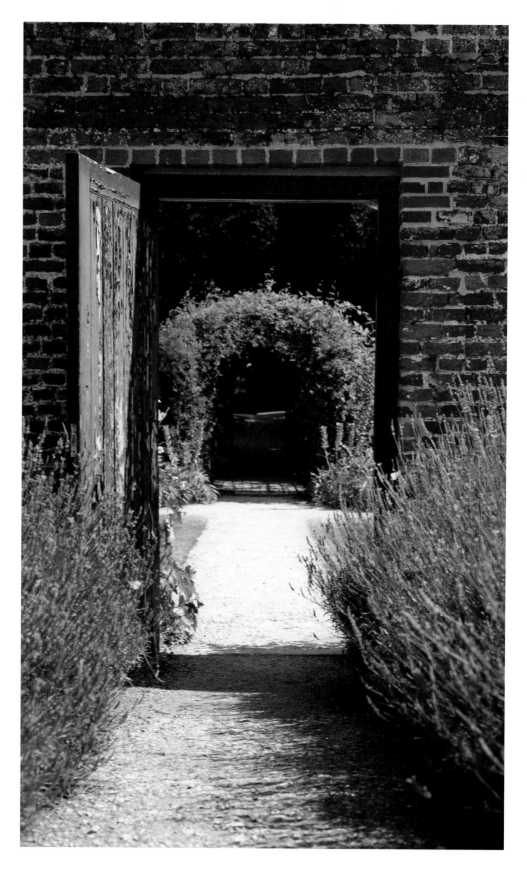

Audley End's archives include a gardener's diary and describe the hierarchy among the many workers. Those employed in the walled garden ranged from the expert head gardener to casual workers picking stones.

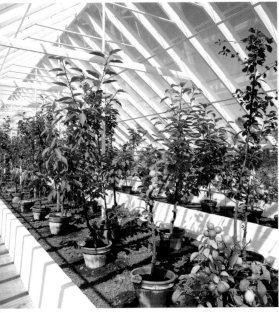

Left, top A wall-mounted lead plaque gives not only the date when the walls were built, 1802, but also the name of the bricklayer. Richard Ward was a proud craftsman.

Left, middle The greenhouse range is used today as it was in the nineteenth century, when it supplied tender plants for the house, and flowers for corsages and buttonholes for visiting ladies and gentlemen.

Left When grandees visited Audley End in the Victorian period, they might well have strolled round the gardens and greenhouses. Special staging was used to create theatrical planting effects.

Above Most large greenhouses in walled gardens were planted with one or more gigantic grapevines. Not only did they provide fruit for the house but they also gave shade. The roots were grown outside.

Het Loo
Apeldoorn, The Netherlands

The breathtaking gardens of Het Loo in
The Netherlands – courtyards, walled
gardens from tennis-court size to plots
of several hectares, parterres, fountains,
cascades and a single 1.6-kilometre (1-mile)
allée from palace to park – were created
for vainglory. Their creator was William
III of England, who bought a medieval
castle in 1684 when he was Stadtholder
(governor) of The Netherlands.

All this changed after he and his wife,
Mary Stuart, ascended to the throne of
Great Britain and Ireland in 1689. William
began to vie with King Louis XIV of
France as potential leader of Europe, by
making Het Loo as much like Versailles as
possible. His team included Jacob Roman,
architect and builder; Romeyn de Hooghe,
designer and sculptor; Daniel Marot,
responsible for the complex patterns on
the ground, and for the fountains and
statues; and Hans Willem Bentinck, a
courtier, who contributed connoisseurship
and his amateur designs. Bentinck was
also the chief superintendent of works.

Despite the inspiration of Versailles,
the gardens at Het Loo remain distinctly
Dutch. The Swedish architect Nicodemus
Tessin reported in 1687 (a year after work

Like that of many seventeenth-century gardens, the
complete layout of Het Loo was captured in artists'
detailed renderings. This contemporary print shows
the grandeur and complexity of the plan.

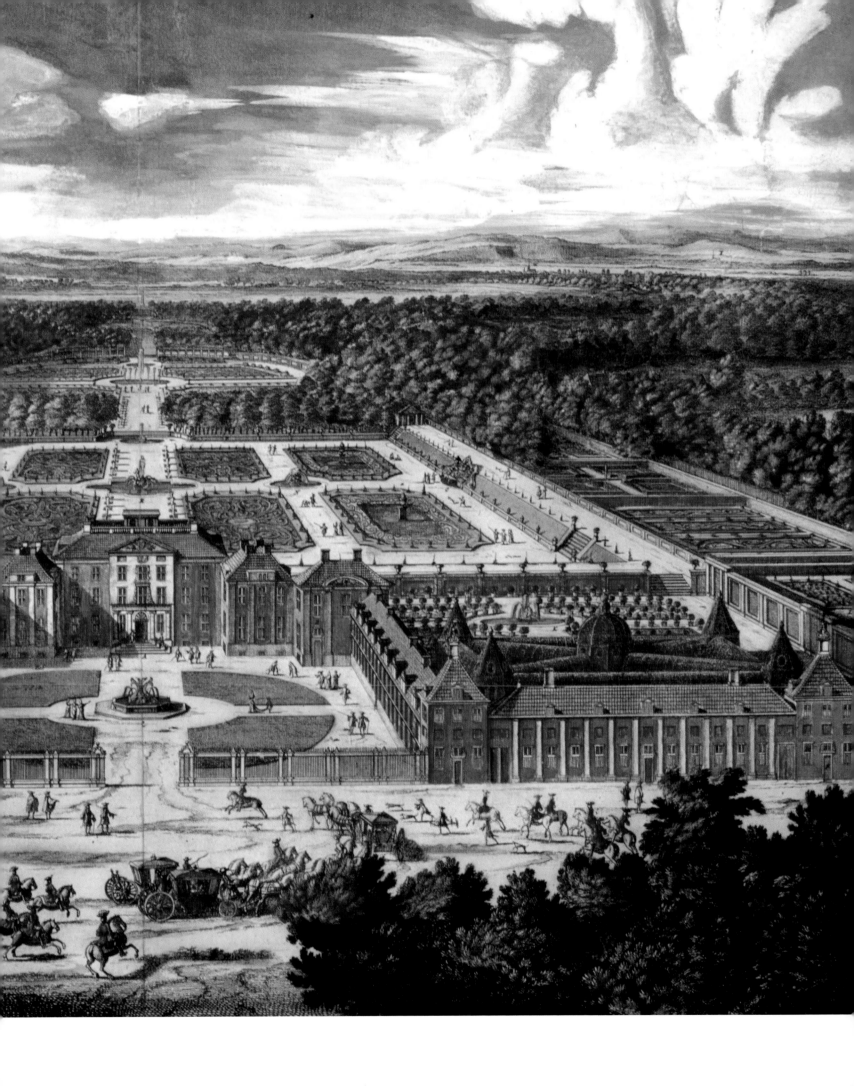

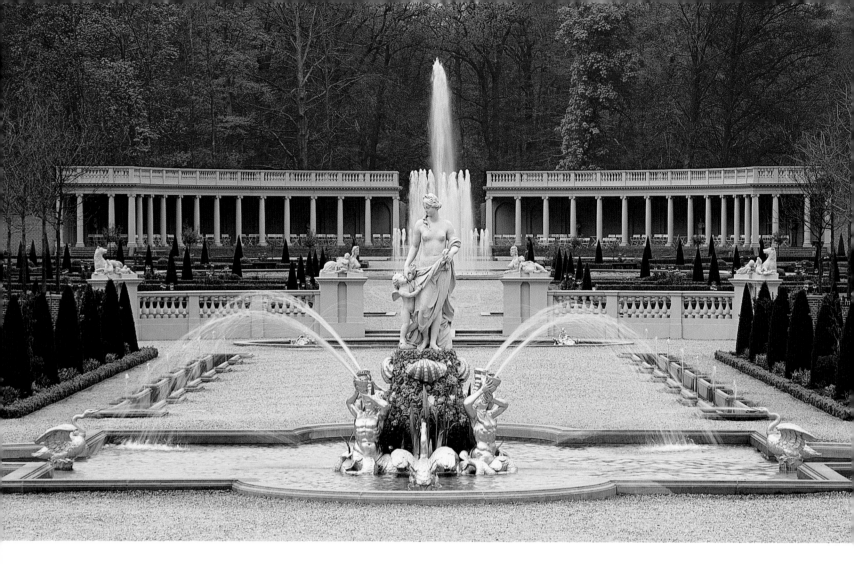

started) that the intention was to make it a presentable country place; that the walled kitchen garden was discreetly hidden by an avenue of trees; and that there were gardens for the Prince and Princess of Orange, as William and Mary then were, one on each side of the new house. Four years later, however, this was not good enough for the new king and queen. The stables were demolished and replaced by pavilions, and the old kitchen gardens (as was a common fate) were removed to make way for yet more parterres and fountains.

All this is known because Het Loo's gardens are depicted in engravings made in 1695, 1698, 1699 and 1702. There are also drawings of the grand statues of river gods, symbolizing fertility, and of William himself, rather ludicrously portrayed as Hercules and Apollo. Mary appeared as Venus.

On the other hand, the royal couple loved this garden. William wrote to Bentinck in January 1690 from Kensington Palace: 'I beg you among your many more important duties not to forget Het Loo nor to go there, and organize what still has to be done; you know how fond I am of the place.'

During the second half of the twentieth century the Dutch government set about the enormous task of restoring Het Loo's gardens to the planting and design that William III would have recognized. The elaborate Baroque parterres of the walled Queen's Garden, the swirling foliage complemented by gravel paths, can now be seen from the rooms of the palace exactly as they appear in the engravings. This garden is a marvellous concoction of curves and blocks disciplined by severe, straight edges, immaculate obelisks and lollipop

trees in square Versailles tubs. At one side is the Berceau ('cradle'), a beautifully clipped green tunnel, like a building in that it has arched 'windows' down the side. Het Loo is the only true survivor of this period of garden design, a style that was once common in England too.

Above Het Loo is The Netherlands' answer to Versailles, although flatter and not quite as grandiose. Jacob Roman, Romeyn de Hooghe and Daniel Marot all worked on elements of its design.

Opposite, top Baroque gardeners did not bother much about colour, flowers or variation in texture. At Het Loo box was used to make a low maze, and the Berceau is seen in the background.

Opposite, bottom Het Loo was created by William of Orange as a challenge to the Versailles of Louis XIV. This high-maintenance garden, now superbly restored, was the result of politics.

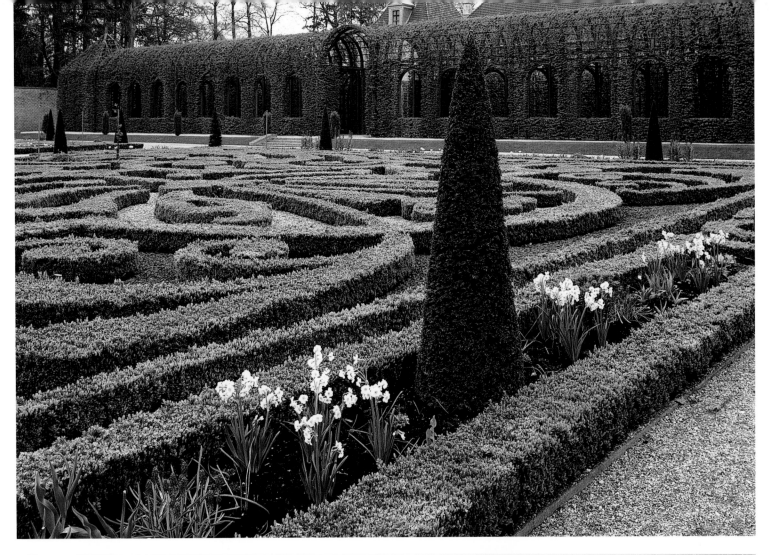

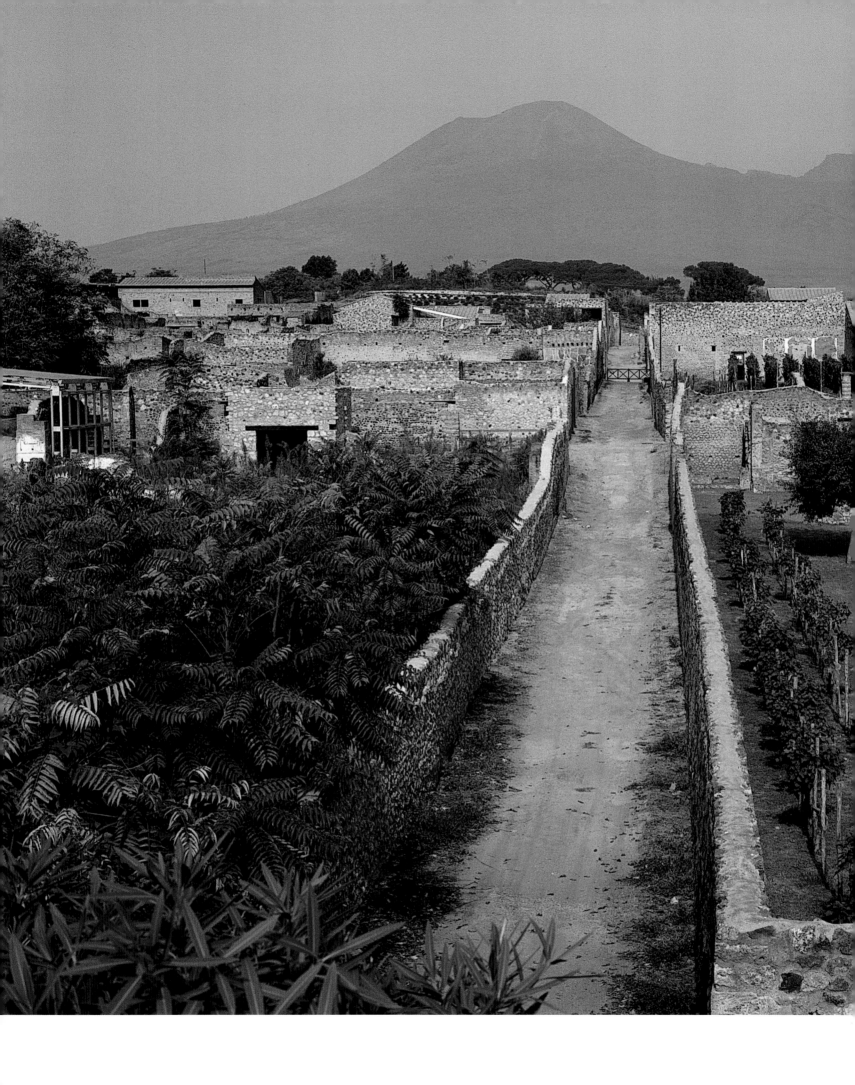

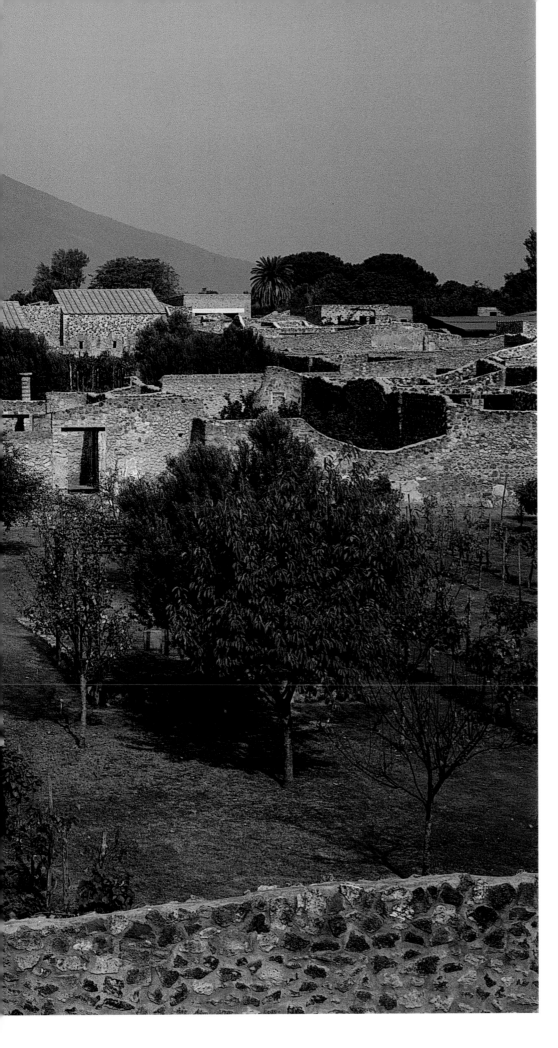

RESTORED
WALLED GARDENS

Pompeii
Campania, Italy

Were it not for the accident of the eruption
of Vesuvius in AD 79 and the subsequent
burial of the whole town of Pompeii, the
only idea we would have of ordinary
Roman gardens would be from the murals
that depicted them, and from descriptions
by contemporary writers.

Pompeii was perfectly preserved until
archaeologists began to unearth it in the
eighteenth century. The frescoes they
revealed are as useful as the buried gardens
themselves as they show idealized gardens
filled with real plants, those that were
then available to the Romans. A mural in
the House of the Marine Venus is painted
with ivy, oleander, myrtle and roses (all
easily available both then and now), with
plane trees, bay trees and arbutus behind
them. The gardens are filled with birds
and pet animals, fountains and statues.
Another mural, in the House of the
Wedding of Alexander, shows white
camomile and small chrysanthemums
blooming in front of plane trees.

These murals showed town gardens,
just as the real gardens were. Because this
was a hot and often arid area, the idea
behind these gardens was much the same as
that which shaped those of Islam: they are

Pompeii was an unimportant Roman town, so the
revived gardens show how very ordinary Romans
lived their daily lives. Most of the grander houses
had courtyard gardens shaded from the heat.

179

peristyle gardens, courtyards attached to or within the house; they are formal in style; and water is important. They would have had the dual function in summer of being a cool oasis and providing cool breezes for the rooms that surrounded them.

Today, using modern technology, we can analyse soil from Pompeii to gain more accurate details of its gardens. The burnt stems and roots of the plants can be scientifically detected, as can pollen, seed heads, fruit and insects on the plants. Double rows of root holes might be formally planted nut or fruit trees (Roman writers described these in their gardens). A technique first used to mould the shapes of vanished bodies within the ashes was used to find out the shape of the roots: from this, fig trees and lemon trees have been identified. Walls had nail holes for the supports of espaliered fruits.

At Villa Julia Felix, the walled garden was probably used for al-fresco meals: the architecture that has been uncovered suggests that diners lay, as was the fashion at the time, on couches beside cooling pools. At the House of the Vetti – a peristyle garden with a pool and fountain – original statues can still be seen where they were when Vesuvius began to erupt, nearly two thousand years ago.

These were the gardens of ordinary people. At Oplontis, however, about 5 kilometres (3 miles) from Pompeii, there is something much grander. A villa set close to the sea, and possibly belonging to the wife of Emperor Nero, has no fewer than thirteen separate gardens, including walled and courtyard gardens. Penelope Hobhouse suggests that this may be the first 'compartmentalized garden' on record.

Planting at Pompeii was typically Mediterranean, with planes, bay trees and arbutus, and murals show ivy, oleander, myrtle and roses. Pet birds and animals lived among them.

As the houses and streets were excavated, the outlines of whole gardens sprang from the ashes. Later archaeological work discovered exactly what was planted in the peristyle walled gardens.

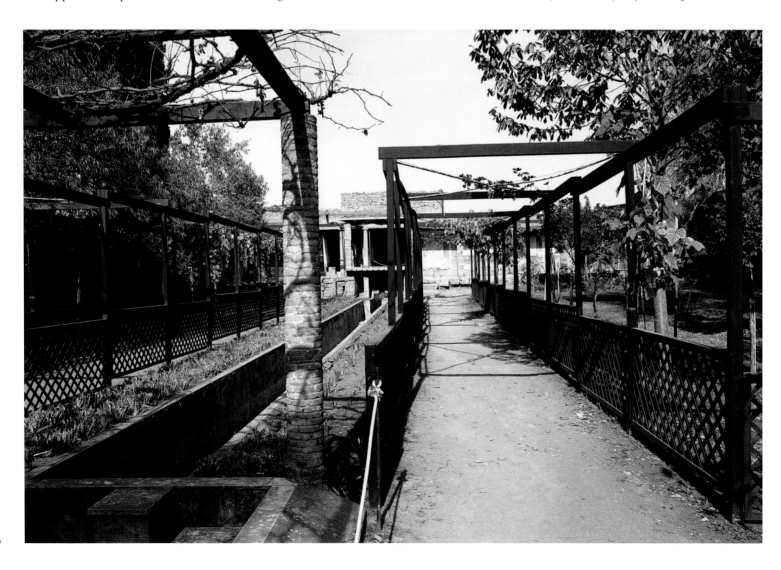

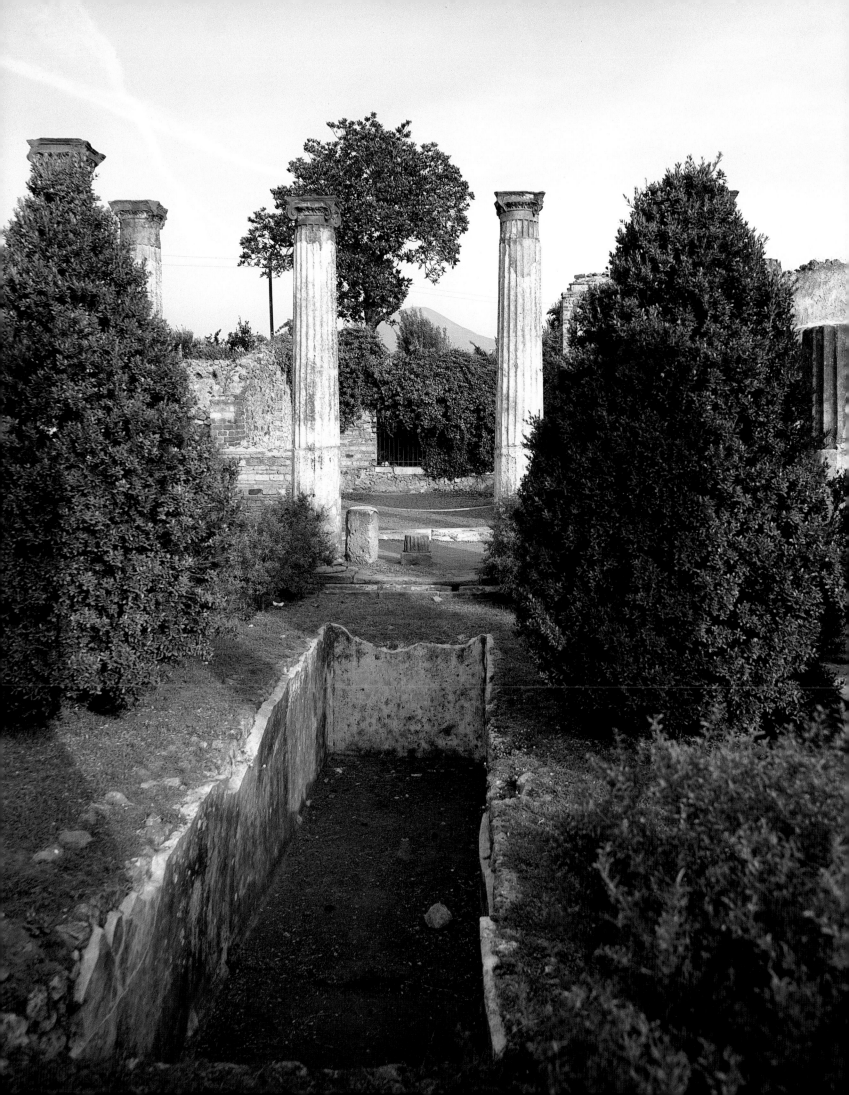

THE FUTURE OF THE WALLED GARDEN

So, what is in store for the walled garden? One thing is certain: in the near future it will thrive. Garden designers have been prominent and known by name since Ineni built Queen Hatshepsut's funerary temple in Egypt around 1450 BC. Before she died Queen Hatshepsut also sent out plant-hunters to bring back incense trees from the Land of Punt (generally agreed to be in eastern Africa). Unlike the fashion designer, which is a relatively recent profession, architects, interior designers and gardening experts have a long history, probably because they were employees of men – and rich men at that – rather than of women.

Nowadays, in large part because of the Chelsea Flower Show, garden designers (as distinct from plant-hunters and nurserymen) are more numerous and prominent than ever before. Gardening is becoming increasingly smart, and this encourages brilliant stylists to move from the equally smart business of creating buildings to that of creating gardens. It is not a new phenomenon for architects to design the surroundings of their buildings – famously, Vanbrugh and Hawksmoor did at Castle Howard in North Yorkshire in 1699 – but in recent times many, from Blomfield to Bradley-Hole, have started as architects but later preferred garden design.

Because of this migration between the disciplines, much modern garden design follows the example of architecture in exploiting new materials and new ways to use old materials. In architecture, new methods of making glass stronger, less brittle and in bigger sections have spawned glass buildings with glass staircases and glass lifts. Nicholas Grimshaw saw the possibilities here when he created his series of giant biomes for the Eden Project in Cornwall in the 1990s. The prospect of gardens with glass walls is intriguing, but how will designers cope with a barrier

Garden design goes in circles and will continue to do so. This one, designed by Vladimir Sita in New South Wales, is a modern take on a typical Japanese garden.

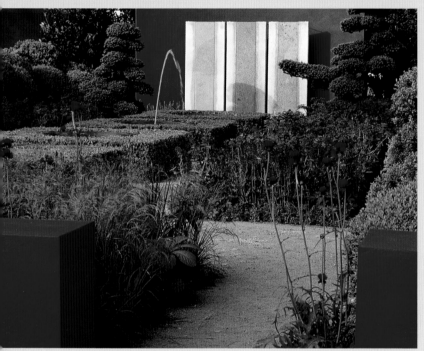

Top In the future plants will be combined in arrangements very different from those seen now, in a kind of fusion gardening, led by Northern European designers. This design is by Tony Heywood of Conceptual Gardens, London.

Above Walled gardens will make ever-increasing use of technological invention. Arne Maynard and Piet Oudolf's garden at the Chelsea Flower Show in 2000 used water and colour in a twenty-first-century way.

Above, right Japanese gardens will continue their traditional minimalist approach, which has been constant for six hundred years. This new one is by Masao Kobayashi.

that is transparent? At the same time, glass can be used in walled gardens as windows, a feature developed by the Chinese millennia ago. It can be sited, like the windows of the Modernist house Baggy Point in Devon, so that clear glass runs from floor to ceiling, admitting vistas where needed but blotting out other sections with opaque glass or with brick and stone. Again like Baggy Point, the glass windows can be retractable, removing the barrier altogether.

The notion of a wall of mirror glass surrounding a garden or parts of a garden has great appeal, given the possibilities of appearing to repeat the planting endlessly. A herbaceous border need be only half as big as what is seen in the glass, while groves of bamboo planted in gravel, Japanese-style, would stretch into the notional distance. Mirror glass, like the transparent version, can both reduce sunlight's harmful rays and incorporate invisible heating elements. The glass used in some dark glasses can change colour in strong sunlight, and if it does not exist already, perhaps soon there will be glass that can be made to change colour at the flick of a switch. Designers are already aware of the uses of stained glass among plants, and it is just another step to create a walled garden where the glass walls can vary in colour according to the season. For example, they could be a soft grey in winter or a cheering berry red; spring could be heralded with bright green to show off blossom before the leaves appear on the trees. Summer demands dark browns and blues to complement the flowers of the high season, while the impact of autumn's reds and yellows would be doubled by suitably coloured glass.

New technology has also encouraged water features, which are virtually essential in the modern garden. Not only will the cooling action of water (along with the splashing sound associ-

ated with refreshment on a hot day) be helpful as global warming continues and water shortages increase, but also there are amazing advances in controlling its flow.

A garden by Piet Oudolf and Arne Maynard, winner of 'Best in Show' at the Chelsea Flower Show in 2000, demonstrated what could be done with arched jets of water that leap from one stainless-steel bowl to the next. *Gardens Illustrated* magazine, which sponsored the garden, judged it 'a novel twist on the seventeenth-century obsession with fountains designed to surprise and amuse'. The treatment and the garden's ripple pool were designed by James Elliott of H2WOW, which specializes in hydrotechnics. We will see more of this kind of collaboration.

It is interesting that *Gardens Illustrated* refers to the constant loop of the history of garden design. That same Chelsea garden was feted for its 'cloud hedge', a technique of carving foliage in billows popularized by Oudolf. This idea is far from new: the Chinese were creating 'dragon' hedges in their walled enclosures six centuries before. It is only now that we are able to appreciate fully the genius of Chinese garden design, for travel has made China little more than twelve hours' flight away, and the country's more relaxed political stance allows tourists to visit its ancient gardens. A likely result will be further globalization of garden design in the coming decades.

Global warming, too, will bring changes to walled gardens. Northern European gardens, rather than being designed to protect plants against frost and snow, will follow the traditions of historic Persia and India and become oases of cool in a hot world, while plants that were inaccessible to gardeners will become available as temperatures increase. Already one man is planting olive trees in south-west England, so walled olive groves will be a possibility, and such eminent designers as Christopher Lloyd have explored the hardiness of such exotics as canna, bananas, palms, agaves and tree ferns. Within protective walls, these bold show-offs could become the norm. Equally, as the world shrinks, new plants will be discovered; recent examples include the Wollemi pine and *Metasequoia glyptostroboides*, both of which a hundred years ago were known only as fossils.

But what goes around comes around: looking at *The Garden Book* (2000), which celebrates five hundred of the world's most influential garden makers, I see that the modern passion for crazy topiary is far from new. The Monasterio de San Lorenzo in Spain has, within its walled cloister, maze-like box bushes that have been clipped by gardeners since the monastery's foundation in the thirteenth century. The walled garden of the future may shock, appal and delight – and there is nothing new about that either.

Left New techniques and discoveries make it possible to grow plants in situations that were previously impracticable. Steve Martino has created the Sanctuary Garden in Phoenix, Arizona.

Above In Dorset, Christopher Bradley-Hole has echoed the shapes of Portland Castle's crenellated walls with clumps of grasses. Increasingly designers feel relaxed about combining the ancient with the modern.

PLANTS FOR WALLED GARDENS

Chimonobambusa quadrangularis is a Chinese bamboo with square stems.

Phyllostachys nigra, with its beautiful black stems, is ideal against a light wall.

Paeonia mlokosewitschii, a complex name for a single – and lovely – peony.

Tulipa sylvestris, a scented tulip originating in central Asia and Africa.

Rosmarinus officinalis is a delightful herb; its flowers are fine in vases.

Lavandula angustifolia 'Hidcote': beautiful, edible, scented, good in drawers.

Plants that are not native to Northern Europe are listed with their country of origin.

ORIENTAL
Bamboos
Fargesia murielae: archetypal, hardy, but not invasive. China.

Pleioblastus pygmaeus: dwarf, elegant, invasive. Japan.

Chimonobambusa quadrangularis: curious square stems, less hardy. China.

Phyllostachys nigra: chic black stems, ideal against walls, less hardy. China, Japan.

Sasa veitchii: medium height, broad leaves bleached at edges. Japan.

Indocalamus tessellatus: medium height, biggest-leaved variety. China.

Peonies
Paeonia mlokosewitschii: splendid foliage, flower like a huge buttercup. Herbaceous. China.

P. delavayi ludlowii: single lime-yellow flowers. Shrub. Tibet.

P. suffruticosa 'Reine Elisabeth': pink-and-white flowers, scented, bronze foliage. China.

Chrysanthemums
Chrysanthemum 'Emperor of China': rose pink, seen in ancient Chinese paintings. China.

Roses
Rosa glauca: blue, scented leaves, single pink flower. Southern Europe.

R. moyesii: wild and wonderful, with blood-red flowers and huge hips. China.

R. × odorata 'Mutabilis': single flowers varying from apricot to pink; elegant leaves. China.

R. 'Cécile Brunner': tiny blush flowers, scented and elegant. China.

R. 'Ispahan': damask rose, scented, clear pink. Middle East.

R. 'Madame Hardy': damask, exquisite white flowers. Middle East.

Tulips
Tulipa acuminata: eccentric spiky, whorly flowers in scarlet and yellow. Turkey.

T. clusiana 'Sheila': red with yellow edges. Iran, Tibet.

T. fosteriana: scarlet. Central Asia.

T. kaufmanniana: glaucous foliage, lemon flowers touched with scarlet. Central Asia.

T. pulchella: rose and green. Turkey.

T. sylvestris: yellow and green, scented. Central Asia, Africa.

T. turkestanica: ivory white with gold centre. Turkestan.

T. vvedenskyi: sturdy, deep-red striped leaves. Central Asia.

T. whittallii: dark orange, elegant cup. Turkey.

Cherry
Prunus × yedoensis: profuse sprays of white flowers. Japan.

FORMAL GARDENS
Quercus ilex (holm oak): evergreen. Can be topiarized.

Pinus pinea (umbrella pine): signature evergreen Mediterranean plant for shade. Clip to shape.

Cupressus sempervirens (Italian cypress): evergreen; pencil shape.

Buxus (box): evergreen. Dwarf forms for edging; taller versions for hedges and topiary. Essential.

Taxus baccata (yew): the ideal topiary and hedging evergreen. Not as slow-growing as often believed.

Hedera (ivy): evergreen. Best to choose non-variegated varieties with leaf forms to suit the situation – small leaves for clipping, large leaves for background texture.

Intersperse formal parterres with brightly flowered bulbs, annuals and herbaceous plants such as tulips, salvia and geraniums, or with silver-leaved perennials or low-growing shrubs such as lavender.

FLOWER GARDENS
Unlike island herbaceous borders, the walled garden allows you to bank up perennials and shrubs from the smallest at the front to the largest at the back. The walls also provide a milder climate than the rest of the garden, so that some risks are worth taking: plants not hardy in the main garden may survive in the walled flower garden. This garden's walls should also be covered with climbers, from decorative vines to wisterias both purple and white, and roses and clematis.

It is worth considering any of Gertrude Jekyll's carefully annotated schemes (see Further Reading, p. 190) for herbaceous borders that could be adapted with shrubs. She also put marigolds with crocosmia, golden anthemis and such dark-leaved dahlias as 'Bishop of Llandaff'. At Little Cumbrae in Ayrshire, Scotland, bronze ricinus was teamed with canna and *Dahlia* 'Bishop of Llandaff' in a scheme that was as bold as (and fifty years earlier than) Christopher Lloyd's garden at Great Dixter. Jekyll used *Echinops ritro* 'Veitch's Blue' as an architectural foreground to walls at Hestercombe, and teamed *Lilium candidum* and *Linaria purpurea* 'Canon Went' with wallflowers and roses. She also let all sorts of flowers self-seed in the crevices of the stone walls.

Angelica archangelica is an imposing herb with green cow-parsley flowers. Its stems can be candied.

Dahlia 'Bishop of Llandaff' is prized for its fiery flowers and near-black leaves.

Knautia macedonica is a tall, elegant perennial beloved of garden designers.

Alliums come in all sizes and shades of pink and purple; their flowers are essential in the flower garden.

Viola cornuta, a good contrast to grasses, is used by grass expert Piet Oudolf.

Miscanthus adds movement to borders and looks good in winter. This is *M. sinensis* 'Kleine Silberspinne'.

Roses and clematis are essential climbers in a flower garden: visit the National Trust's Mottisfont Abbey in Hampshire, where the British national collection of old-fashioned roses grows up the walls; the collection was made by Graham Stuart Thomas, an expert on the subject. Try such climbers as *Rosa* 'Blairi Number Two', deep pink and pale pink; *R.* 'Blush Noisette', pale pink and scented; *R.* 'Gloire de Dijon', a seductive pale apricot; *R.* 'Madame Alfred Carrière', pinky white; *R.* 'Madame Grégoire Staechelin', pink and scented; and *R.* 'Zéphirine Drouhin', deep pink and prolific. Ramblers, which are bushier and less leggy, should include *R.* 'Albertine', coppery pink and energetic; *R.* 'Félicité Perpétue', small, creamy-white flowers; *R. moschata*, the musk rose, creamy and scented. Gertrude Jekyll's choices included *R.* 'Blush Rambler', *R.* 'Irène Watts', *R.* 'Madame Isaac Pereire' and *R.* 'The Garland'.

Among the clematis, I would certainly have the early and rampant montana, both pink and white, and the early, pinkish-white-flowered *C. armandii* 'Apple Blossom', which is scented and evergreen. In the *florida* group, I love *C. florida* 'Sieboldii', which is almost like a passion-flower blossom. From the *viticella* group, one could include 'Prince Charles', light blue; 'Polish Spirit', deep purple; and 'Black Prince', dark red-purple. 'Princess Diana', a wonderful pink, is in the *texensis* group. All should be encouraged to mingle, and also with roses of complementary shades, up any wall.

VEGETABLE GARDENS

Naturally these walled gardens are planted with the vegetables and fruit that you would want to eat, but I believe they should also be decorative. With this in mind, I grow the uglier but essential vegetables in other areas: rows of potatoes, which, though decorative, take up too much space, and horseradish and Jerusalem artichokes, both of which are too lanky.

When you choose the vegetables you want, pick the most decorative. I love chard with ruby, yellow or white stems, though I never plant them mixed together but in separate rows. I choose lettuces and chicories for their leaf colour: bright green, striped pink and white, bronze and red, and for their leaf patterns: floppy, curvy, cut and bunched. I will choose the beetroot with the darkest-red leaves – taste permitting – and tomatoes that are red, yellow, white, dark crimson and zebra-striped, because these look good both while growing and on the plate.

Variation in size is important, so I always grow glaucous-leaved, dramatic artichokes with the blue leek 'Bleu de Solaise'. I grow climbing haricot beans up bamboo stakes, above – just for the fun of it – creeping courgette plants, which have wonderful yellow flowers, and ornamental gourds.

Flowers can certainly be added, and I like those you can eat, such as marigold (the herb, not the French variety), nasturtium and chives. Some haricot beans have lovely flowers, while others have pink and purple pods, as well as the more common yellow and green.

On the walls, you can grow espaliered fruit trees – apples, pears, peaches and apricots – because the walls will reflect heat and improve their microclimate. I also like the striking effect of fig leaves trained against a wall.

I do not give exact varieties here because the seed packets will help you to decide what you want. Go to a good seedsman and pick varieties by their appeal to tongue or eye.

HERBS

Rosemary

Upright forms of *Rosmarinus officinalis*, such as 'Miss Jessopp's Upright', the one most often seen.

R. officinalis var. *angustissimus* 'Benenden Blue': a wonderful deep blue.

R. officinalis 'Fota Blue': creeping, for ground cover.

Lavender

Lavandula angustifolia 'Hidcote': dark-blue flowers.

L. dentata: fringed leaves, half-hardy.

L. 'Fathead': large pinkish-purple bracts.

L. stoechas: quirky purple flowers.

Mint

There are dozens of versions, with different scents and tastes – including basil, lemon, chocolate, grapefruit, pineapple and apple – but always include the classics: *Mentha* × *piperita* (black peppermint), *M. pulegium* (pennyroyal), *M. spicata* (spearmint; var. *crispa* is used for mint tea in Morocco), and *M.* × *villosa* var. *alopecuroides* (Bowles mint; for mint sauce).

Thyme

There are scores of varieties. I like *Thymus herba-barona*, caraway-scented; *T.* 'Fragrantissimus', white-flowered and scented; *T.* 'Porlock', pink; *T. citriodorus*, lemon-scented; *T. citriodorus* 'Silver Queen', variegated white leaves; and *T.* 'Minimus', creeping, for ground cover.

Sage

As well as *Salvia officinalis*, the common form of the herb, I grow purple sage (*S. officinalis* 'Purpurascens') and purple, white and green *S. officinalis* 'Tricolor', both of which are decorative and edible.

187

Echinops ritro 'Veitch's Blue' has wonderful ball-shaped flowers with spiky edges.

Clematis armandii 'Apple Blossom': an early evergreen with dainty, star-like flowers.

Rosa 'Albertine' is a terrific old-fashioned rambling rose with delicate pink colouring and vigorous habit.

Beautiful purple-podded peas are valuable both in the garden and in the pot.

Not only is ruby chard edible, but its brilliant stalks are also highly ornamental.

Borlotti beans are called 'Tongues of Fire' in Italian for their brilliant pink pods. Good in minestrone.

Other essential herb-garden plants (for the best flavour, always pick the simpler forms rather than the variegated, ruffled, purple and others) include angelica (*Angelica archangelica*), borage, fennel (the bronze-leaved form looks spectacular), hyssop, bay (*Laurus nobilis*), melissa or lemon balm, bergamot (*Monarda didyma*) for Earl Grey tea, *Origanum vulgare*, French tarragon (*Artemisia dracunculus*), annual basil (*Ocimum basilicum*), chives (*Allium schoenoprasum*), flat-leaved parsley and marjoram (*Origanum × onites*).

DESIGNERS' GARDENS

Plants in these gardens are chosen very carefully by specific variety. Some examples follow.

Lawrence Johnston

His red border at Hidcote was backed with purple-leaved hazel trees with, in front, mixed crimson dahlias such as *Dahlia* 'Bishop of Llandaff', orange hemerocallis, purple- and red-leaved heucheras, and bronze grasses.

Christopher Bradley-Hole

Grasses *Festuca eskia*, *Stipa gigantea*, *S. tenuissima*; fennel, *Euphorbia amygdaloides* var. *robbiae* and *Knautia macedonica*; bearded irises (*Iris germanica*) 'Action Front', 'Carnival Time', 'Deep Black Quechee' and 'Sable'. *Iris pallida* spp. *pallida*, 'planted en masse with polished, plastered wall' behind, *Allium cristophii* and *A. sphaerocephalon* with *Stipa tenuissima*; grasses *Festuca glauca*, *Miscanthus sacchariflorus* and *M. sinensis* 'Gracillimus'; bamboos include *Phyllostachys nigra*, *P. aurea* and *Arundinaria murielae*; Mediterranean trees *Quercus ilex*, *Pinus pinea*, *Cupressus sempervirens*.

Christopher Lloyd

Combination of arum lilies, *Gunnera tinctoria* and *Carex elata* 'Aurea'. *Rubus cockburnianus* 'Goldenvale' with *Gentiana asclepiadea*, *Allium cristophii* with *Eremurus × isabellanus* 'Cleopatra' and *Allium hollandicum* 'Purple Sensation' surrounded by lupins.

Arne Maynard and Piet Oudolf

'Best in Show' at the Chelsea Flower Show in 2000. The Persian-carpet effect (backed by a high wall of rusty scarlet) used combinations of *Cimicifuga* var. *simplex* in purples, *Euphorbia dulcis* 'Chameleon', *Astrantia major* 'Claret', *Salvia × sylvestris* 'Mainacht' and the simple purple *Viola cornuta*. Other plants include *Cirsium rivulare* 'Atropurpureum' and *Iris* 'Miss Perry'.

Oudolf's favoured grasses include *Calamagrostris × acutiflora* 'Karl Foerster', *Deschampsia cespitosa* 'Goldschleier' and 'Goldtau', *Hakonechloa macra*, *Luzula luzuloides* 'Schneehäschen', *Miscanthus sinensis* 'Kleine Silberspinne', and *Stipa calamagrostris*, *S. gigantea* and *S. pulcherrima*.

RESTORED GARDENS

Since the birth of the Garden History Society, not only are gardens being restored but also historic plants are returning. If you are restoring a garden, decide on what date the garden was made and also the cut-off point for plants (the later this is, the easier). Many nursery catalogues are helpful on dates: most growers of old-fashioned roses, for example, will give their dates of introduction. Note, though, that some species, such as *Rosa eglanteria*, are natives and so can be used in the earliest of plantings. *R.* 'Maiden's Blush' was established before the fifteenth century, the York rose and the Lancaster rose before 1551, and *Rosa* 'Gloria Mundi' before the sixteenth century. *R.* 'Old Pink Moss' was introduced in 1727 and *R.* 'Old Blush China' in 1789. There are also many old cottage flowers, such as columbine, marigold, sweet peas and lilies, that are authentic in their simplest forms. Meadow flowers dating back to the Dark Ages, such as poppies, ox-eye daisies, cowslips and cranesbills, are highly decorative.

Herbs and medicinal plants designated 'officinalis' were all part of the monks' repertory of healing, dyeing or strewing plants, and date back to the earliest monasteries. There are also varieties of fruit that are either native, such as crab apples and sloes, or early improved versions, such as the warden pear. Walnuts are native, as are cobnuts and filberts, while fig trees were in Britain by the late seventeenth century.

Old herbals and botanical illustrations are a good source of inspiration, as are the Museum of Garden History and the Geffrye Museum, both in London, and various societies that are reviving heritage fruit, flowers and vegetables. Bear in mind, however, that some of these varieties became obsolete for very good reasons.

WALLED GARDENS OPEN TO THE PUBLIC

Gardens are listed alphabetically by name. Opening hours are given only where contact details are not available, and these are subject to change.

Amber Palace, Rajasthan, India
9 am – 4.30 pm

Audley End, Saffron Waldon, Essex CB11 4JF, England
+44 (0)1799 522399
english-heritage.org.uk/audleyend

Broughton Grange, Wykham Lane, Broughton, Banbury, Oxfordshire OX15 5DS, England
Open under National Gardens Scheme; see ngs.org.uk

Château de Bosmelet, Le Bosmelet, 76720 Auffay, Normandy, France
+33 (0)2 35 32 81 07
bosmelet@laposte.net; chateau-de-bosmelet.fr

Château de Villandry, 37510 Villandry, Indre-et-Loire, France
+33 (0)2 47 50 02 09
info@chateauvillandry.com; chateauvillandry.com

Columbine Hall, Stowupland, Suffolk IP14 4AT, England
+44 (0)1449 612219
info@columbinehall.co.uk; columbinehall.co.uk
Open under Invitation to View Scheme; see invitationtoview.co.uk

Downderry Lavender Nursery, Pillar Box Lane, Hadlow, Tonbridge, Kent TN11 9SW, England
+44 (0)1732 810081
orders@downderry-nursery.co.uk
downderry-nursery.co.uk

Dumbarton Oaks, 1703 32nd Street, NW, Washington, DC 20007, USA
+1 202 339 6401
dumbartonoaks@doaks.org; doaks.org

Geffrye Museum, Kingsland Road, London E2 8EA, England
+44 (0)20 7739 9893;
Recorded information: +44 (0)20 7739 8543
info@geffrye-museum.org.uk
geffrye-museum.org.uk

Glin Castle, Glin, County Limerick, Ireland
+353 (0)68 34173; knight@iol.ie; glincastle.com

Great Maytham Hall, Rolvendon, Cranbrook, Kent TN17 4NE, England
+44 (0)1580 241346

Hadspen, Castle Cary, Somerset BA7 7NG, England
+44 (0)1749 813707; hadspengarden.co.uk

Hampton Court, East Molesey, Surrey KT8 9AU, England
+44 (0)870 752 7777; Recorded information (gardens): +44 (0)870 950 4499; hrp.org.uk/hampton

Het Loo, Koninklijk Park 1, Apeldoorn, The Netherlands
het_loo.tripod.com

Iford Manor, Bradford on Avon, Wiltshire BA15 2BA, England
+44 (0) 1225 863146; ifordmanor.co.uk

Läckö Slott, Lake Vänern, Sweden
+46 (0)510 48 46 60; info@lackoslott.se; lackoslott.se

Lindisfarne Castle, Holy Island, Berwick-upon-Tweed, Northumberland TD15 2SH, England
+44 (0)1289 389244; holy-island.info/lindisfarnecastle

Michelham Priory, Upper Dicker, near Hailsham, East Sussex BN27 3QS, England
+44 (0)1323 844224; adminmich@sussexpast.co.uk
sussexpast.co.uk/michelham

Mughal Gardens, Rashtrapati Bhavan, India Gate, New Delhi, India
9.30 am – 2.30 pm Tues–Sun, Feb–Mar only

Rousham, near Steeple Aston, Bicester, Oxfordshire OX25 4QX, England
+44 (0)1869 347 110; rousham.org

Ryoan-ji, 13 Goryoshita-machi, Ryoan-ji, Kyoto, Japan
8 am – 5 pm (Dec–Feb: 8.30 am – 4.30 pm)

Scampston Hall, Malton, North Yorkshire YO17 8NG, England
+44 (0)1944 759111
info@scampston.co.uk; scampston.co.uk

Sissinghurst, near Cranbrook, Kent TN17 2AB, England
+44 (0)1580 710700
nationaltrust.org.uk

Villa Gamberaia, Via del Rossellino, 72, 50135 Settignano, Florence, Tuscany, Italy
+39 05 569 7205 or +39 05 569 7090
villagam@tin.it; villagamberaia.com

Vizcaya, 3251 South Miami Avenue, Miami, Florida 33129, USA
+1 305 250 9133; vizcayamuseum.org

Waltham Place, Church Hill, White Waltham, Berkshire SL6 3JH, England
+44 (0)1628 825517; walthamplace.com

Yuyuan, Anren Jie, Shanghai, China
8.30 am – 5 pm

GARDEN DESIGNERS

Christopher Bradley-Hole
55 Southwark Street, London SE1 1RU, England
+44 (0)20 7357 7666
info@christopherbradley-hole.co.uk;
christopherbradley-hole.co.uk

George Carter
Silverstone Farm, North Elmham, Norfolk NR20 5EX, England
+44 (0)1362 668130

Sir Terence Conran
conran.com

Henk Gerritsen
+31 523 682797
henk@prionatuinen.com

Simon Irvine
Simon Irvine Designs, Eklanda Bäck 60, 431 49 Mölndal, Sweden
+46 31 272 330
info@simonirvine.net; simonirvine.net

Arne Maynard
Clerkenwell House, 125 Golden Lane, London EC1Y 0TJ, England
+44 (0)20 7689 8100
info@arne-maynard.com; arne-maynard.com

Piet Oudolf
oudolf.com

Tom Stuart-Smith
43 Clerkenwell Road, London EC1M 5RS, England
+44 (0)20 7253 2100; tomstuartsmith.co.uk

FURTHER READING

Richard Bisgrove, *The Gardens of Gertrude Jekyll*, London (Frances Lincoln) 1992

Christopher Bradley-Hole, *The Minimalist Garden*, London (Mitchell Beazley) 1999

Jane Brown, *The English Garden in Our Time: From Gertrude Jekyll to Geoffrey Jellicoe*, Woodbridge, Suffolk (Antique Collectors' Club) 1986

Susan Campbell, *Charleston Kedding: A History of Kitchen Gardening*, London (Ebury Press) 1996

William Cresswell, *Diary of a Victorian Gardener: William Cresswell and Audley End*, London (English Heritage) 2006

Reginald Farrer, *On the Eaves of the World*, London (Edward Arnold) 1917

The Garden Book, London (Phaidon) 2000

Mick Hales, *Gardens Around the World: 365 Days*, Boston (Abrams) 2004

David Hicks, *My Kind of Garden*, Woodbridge, Suffolk (Garden Art Press) 1999

——, *Cotswold Gardens*, London (Weidenfeld & Nicolson) 1995

Penelope Hobhouse, *Garden Style*, London (Frances Lincoln) 1988

——, *The Story of Gardening*, London (Dorling Kindersley) 2002

Gervase Jackson-Stops and James Pipkin, *The Country House Garden*, London (Pavilion) 1987

Gertrude Jekyll and Lawrence Weaver, *Gardens for Small Country Houses*, London (Country Life Library) 1914

Christopher Lloyd, *Garden Flowers*, London (Cassell) 2000

Arne Maynard, *Gardens with Atmosphere*, London (Conran Octopus) 2001

Piet Oudolf with Noël Kingsbury, *Designing with Plants*, London (Conran Octopus) 1999

Anna Pavord, *The New Kitchen Garden*, London (Dorling Kindersley) 1996

George Plumptre, *The Garden Makers*, London (Pavilion) 1993

Nori Pope and Sandra Pope, *Colour by Design*, London (Conran Octopus) 1991

Eleanour Sinclair Rohde, *The Story of the Garden*, London (Medici Society) 1932

Vita Sackville-West, *Passenger to Teheran*, London (Hogarth Press) 1926

Norah Titley and Frances Wood, *Oriental Gardens*, London (British Library) 1991

Andrew Wilson, *Influential Gardeners*, London (Mitchell Beazley) 2002

PICTURE CREDITS

l: left; r: right; f: far; t: top; b: bottom; c: centre

Peter Baistow jacket back (tc, tr), 40tr, 88l, 102–105, 113–17, 132, 133bl, 140, 141r, 145t; Clive Boursnell 98–101; The Bridgeman Art Library 12l (The Stapleton Collection), 13r (British Museum, London), 14l (Ca' d'Oro, Venice, Italy), 15t (Museo di Firenze Com'era, Florence, Italy), 16 (Château Bussy-le-Grand, France/Lauros/Giraudon), 17 (Château de Versailles, France/Giraudon), 38–39; The Trustees of the British Museum 12r; Nicola Browne 64, 109t, 142–43, 154–57, 184tr; Château de Villandry 96r; Chris Caldicott 178–81; Corbis 15t (Paul Almasy), 20 (Macduff Everton), 58–59, 60r and 61 (Tony Arruza), 60l (Richard Cummins), 133t (Adam Woolfitt), 136l and r (Kelly-Mooney Photography); Country Life Picture Library 126–29 (Val Corbett), 164 and 173r (Marcus Harpur); Robert de Bosmelet 92 tr; English Heritage Photo Library 162–63, 170–71 (Jonathan Bailey), 172–73; The Geffrye Museum 118–20 (Sunniva Harte), 121 (David Clarke and Marcus Leith); Steven Harris 34–37; Jerry Harpur jacket back (tl), 9b, 18–19, 26–33, 40tl, 44t, 45–48, 49t, 54–57, 66–67, 68tl, 82–83, 106–107, 124l, r, 133br, 134–35, 137, 144r, 160b, 185l, r, 182–83; Hemis.fr 11 (Frank Guiziuo), 22–23 (Fred Derwal); Heritage House Group Ltd/Melbourne Hall 41r; Het Loo Palace 174–75; Historic Royal Palaces 165–69; The Interior Archive 9tr (Christopher Simon-Sykes), 138–139 and 141tl, cl, bl (Fritz von der Schulenburg), 148b and 149tl, tr (Simon Upton); Simon Irvine 77tc, tr, b, 89b; The Japan Architect Co. Ltd 145b (Shinkenchiku-sha); Jardins de Brécy 41l; Caroline Jones 25; Jyothi Karthik 24; Andrew Lawson: jacket back (bl, bc), 8, 9tl, 49b, 62–63, 65, 68–69t, bl, br, 72, 73tr, 78–79, 84–85, 89t, 94–95, 96l, 97, 108l, 108r, 146–47, 148t, 149b, 152–53b, 158–59, 176, 177t, 184b; Le Scanff-Mayer jacket front, 2–3, 40b, 42–43, 86–87, 90–91, 92tl, b, 93, 109b; Marianne Majerus 50–53, 70–71, 73tl, b, 88r, 125, 144l, 152tl, 152–53t, 160t; The Metropolitan Museum of Art, Rogers Fund and Edward S. Harkness Gift, 1920 (20.3.13), photo © The Metropolitan Museum of Art 13l; Clive Nichols jacket back (br), 7, 74–75, 77tl, 80–81, 110–12, 122–23, 161, 177b, 184tl, 186lc, rc, fr, 187, 188fl, l, lc, rc, fr; Photolibrary Group 130–31 (John Miller), 150–51 and 153r (John Glover), 186fl (Morley Read), 186l (Carole Drake), 186r (Didier Willery), 188r (J.S. Sira); Alex Ramsay 15b, 44b; Per Ranung 76; V&A 21.

The publishers have made every effort to trace and contact copyright holders of the illustrations reproduced in this book; they will be happy to correct in subsequent editions any errors or omissions that are brought to their attention.

ACKNOWLEDGEMENTS

I am grateful to my publishers, especially Julian Honer and Rosanna Fairhead, who have allowed me unprecedented freedom in creating this book. I am indebted to Emily Hedges, picture researcher beyond price, who not only discovered all the pictures in this book but also suggested gardens that I should consider. Thanks also to all the photographers whose pictures make this book what it is, especially Marianne Majerus and Peter Baistow, who have provided advice and help as well as beautiful photographs.

INDEX